are you experienced?

AGH
Art Gallery of Hamilton

black dog
publishing
london uk

contents

director's foreword

shelley falconer

the direct experience of an artwork is fundamental to understanding art's social and historical context, meaning and values. This unique encounter enables us to understand the world in deeper and more meaningful ways.

Throughout the development of this project, curator Melissa Bennett's challenge was to transform the gallery into an experience; to move away from the object on the wall to the individual being an essential part of the space. Her task of selection has been rigorous and thoughtful, affirming the experience of visiting an art gallery and directly engaging with an artist and work of art as fundamental to what a museum experience should be. Each work is a revelation inscribing the individual into the space of the gallery, moving the work into something we all share. As Bennett notes "understanding it is experiencing it". The visitor is invited to participate, the artist is a catalyst and we are engaged in a social and affective experience. Intelligent and thoughtful, the result is a transition for the visitor from spectator to participant, the very essence and idea of a direct encounter with art, which defines the work that art institutions do. Artists Nadia Belerique, Jessica Eaton, Olafur Eliasson, Dorian FitzGerald, Hadley+Maxwell and Do Ho Suh invite us to derive meaning from an immersive experience by creating dynamic and charismatic spaces. As artists they become catalysts for fundamentally different ways of thinking about art and institutions. These artists share one vital quality, that of being engaged with the visual arts to create a condition in which we can engage.

This publication is dedicated to all of the artists and contributors who inspire and remind us that one of our primary functions as an art gallery is to serve as a place where participation is fostered as a part of meaningful experience.

are you experienced? is a major undertaking, and would not be possible without the support of many. We wish to thank presenting sponsor TD Bank Group, the Canada Council for the Arts, the Ontario Arts Council and the City of Hamilton. The *are you experienced?* publication is made possible by the generosity of our publication sponsors: Kieran C Dickson, Pierre Karch and Mariel O'Neill-Karch, Robert Munroe and John and Ginny Soule.

are you experienced?

melissa bennett

What is an experience? It's hard to say.

How can we describe an everyday experience in order to talk about its alternatives? Certain contemporary artists have been working in this area, creating pieces that prioritize the viewer's multisensory reception. Working to invoke viewer reactions that may be subtle or intangible, these artists seek to engage with, or just engage, the viewer's consciousness. During the conception phase of their works, the artists featured in this exhibition have sought to appeal to internal or psychological senses —including the visual perception of imagery or sound—or more ephemeral aspects, such as memory. These artists do so in a gentle way; they do not intend to bombard or besiege the viewer, but rather to invite them into a mindful experience.

The idea for *are you experienced?* was influenced by various meaningful personal encounters with art; and my curatorial thesis crystallized when I devised a shortlist of artists who prioritize the viewer experience. One of the significant experiences I had was in 2011 at Tate Modern, where I first saw Do Ho Suh's large sculptural work. Attached to the ceiling of a large room was a translucent red polyester floor, pulled taut to all four corners; hanging from the floor was a staircase, also made of translucent red polyester. The piece seemed fragile yet stable. While the staircase was suspended and seemed to float mid-air, solidity was implied. While Suh's practice revolves around the processing of his own memories through depictions of the domestic spaces from his past, I could connect with the work as if it were representing my own memories.

Beyond the physical presence of the artworks, *are you experienced?* explores subtle themes such as transcendence and the ways in which an artwork can be both immanent and starkly present, while also engaging with conceptual or political undercurrents. The premise of the exhibition is to invite viewers to step outside the familiarity of their surroundings and into altered states of experience and alternative modes of understanding, as proposed by the exhibiting artists: Nadia Belerique, Jessica Eaton, Olafur Eliasson, Dorian FitzGerald, Hadley+Maxwell and Do Ho Suh.

The majority of the exhibition's works are installations, which fits the exhibition thesis given the priority that the medium places on various elements working together, often toward visual immersion. In the present hyper-information age, in which we are constantly bombarded with news reports and images, there is a tendency for artists to act as cultural mediators, gathering and resorting information, which comes from a need to work through it.

As the renowned curator Massimiliano Gioni observed, "It is not accidental that the triumph of installation art has run parallel to that of an economy of spectacles and short attention spans. Installation art reflects the bombardment of data that shapes the mature phase of the information society."[1] The curatorial approach taken by Gioni,

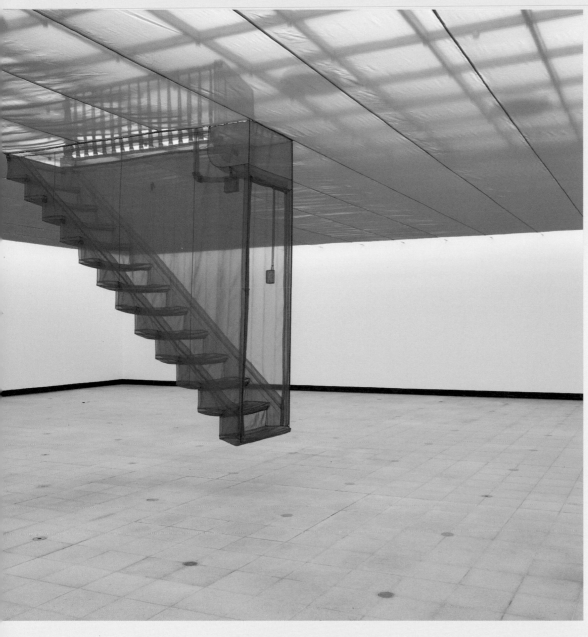

Do Ho Suh, *Staircase-V*, 2008.
polyester fabric, metal armature,
dimensions variable./ installation
view, *Psycho Buildings: Artists Take
On Architecture*, Hayward Gallery,
London, 28 May–25 August 2008./
© Do Ho Suh, courtesy of the artist
and Lehmann Maupin Gallery,
New York and Hong Kong.

Richard Flood, and Laura Hoptman in *Unmonumental: The Object in the 21st Century* at the New Museum, New York City, in 2007 had an influence on *are you experienced?*. That exhibition presented an observation on a wave of contemporary art, looking in particular at sculpture and its recent use of ready-made and found objects, analyzing the popularity of that aesthetic and relating it to global issues.

Similarly, the artists in *are you experienced?* were selected because they prioritize the human experience of an artwork, where experiencing it is understanding it. Increasingly I encounter that the artist's intention is to appeal to an intuitive or subconscious level, whether in the artist herself or in the viewer, so that an experience of the work will offer an alternate, and sometimes otherworldly, encounter.

This artistic or curatorial approach is not against intellectualism. Rather, it validates the use of intuition and aesthetic experience, and it gives weight to affect, which can be described as "emotion or desire, especially as influencing behaviour or action".[2] The topics of body and memory come up in this exhibition as well, with most artists using the body as a relatable point of departure for the exploration of issues such as visual perspective and perception. Though the subject of the exhibition is fundamentally connected to the ethereal, the artists are also concerned with something grounded —that which is universally familiar about art via human interaction with it.

This topic has been explored in art theory before. In 1934, art theorist John Dewey wrote about how art is "remitted to a separate realm" when it is kept apart from everyday experience, and he felt his task as a philosopher was to:

> ... restore continuity between the refined and intensified forms of experience that are works of art and the everyday events, doings, and sufferings that are universally recognized to constitute experience.... In order to understand the meaning of artistic products, we have to forget them for a time, to turn aside from them and have recourse to the ordinary forces and conditions of experience that we do not usually regard as aesthetic. We must arrive at the theory of art by means of a detour.[3]

This exhibition takes us on a detour, exploring the physical presence of a work of art and the experience it induces in the viewer through an oscillation between three-dimensional, two-dimensional, and projected video and light works. All viewers can relate to the uncanny first encounter with an affective or emotionally moving artwork, when our physical and intellectual reactions cannot be explained or conveyed through mere words.

are you experienced? proposes that the space between the viewer's body and the work shall extend further to conspire with the viewer's mind, memory and automatic sensual responses. It explores the threshold of experience, suggesting that the myriad ways to know an artwork pass into the viewer's body via the senses of sight or spatial perception. For the artists in this exhibition, it is their intention to activate this particular way of knowing an artwork. In his studies on the importance of human senses in an architectural environment, Juhani Pallasmaa has written:

> Our bodies and movements are in constant interaction with the environment and the world and they self-inform and redefine each other constantly.... As the eye collaborates with the body and the other senses, one's sense of reality is strengthened and articulated by [the] interaction of the senses. In other words, when the architectural experience becomes multisensory, all the senses are equally experiencing the quality of the space, which will strengthen the existential experience.[4]

A visit to the exhibition begins with a surrealistic representation of the body, via Hadley+Maxwell's video *Ritual for an Untimely Life*, 2009, which is presented on a freestanding screen. The projection depicts a life-size young woman dressed as a flight attendant. Surrounded by shifting colours of light and the image of her body divided vertically by a split-screen video effect, she appears like a changeling. The artists ask viewers to trust in her as an exhibition guide. Her assured gestures, which enact a demonstration of airline safety procedures, invite viewers into the exhibition space. Her graceful choreographed movements are like those of a professional dancer as she beckons people into a familiar yet altered world.

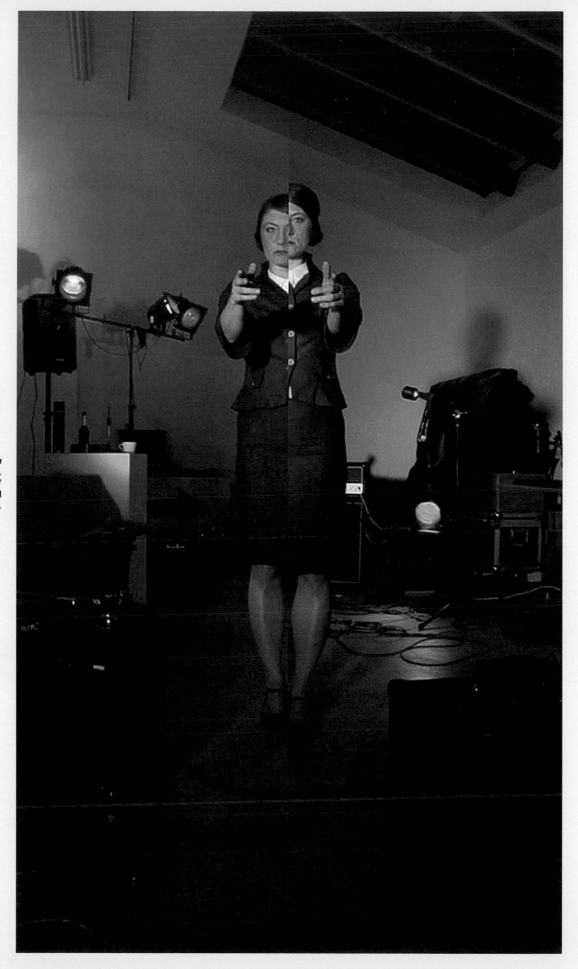

Hadley+Maxwell, *Ritual for an Untimely Life,* video still, 2009. single-channel video, 21:23./ courtesy of the artists and Jessica Bradley Gallery.

While Hadley+Maxwell use the human figure to create an ethereal effect, Do Ho Suh's exhibition work achieves this through his use of a specific material: translucent polyester. His model of a bathroom has a distinct spectral quality. Titled *348 West 22nd Street, Apartment A, New York, NY 10011 (Bathroom)*, 2003, it is named after the actual street address of the bathroom it refers to. Suh's work derives from subjective experience, though the referent (the bathroom) is highly recognizable. His practice is centred on an investigation of his own past as remembered through the forms of the spaces in

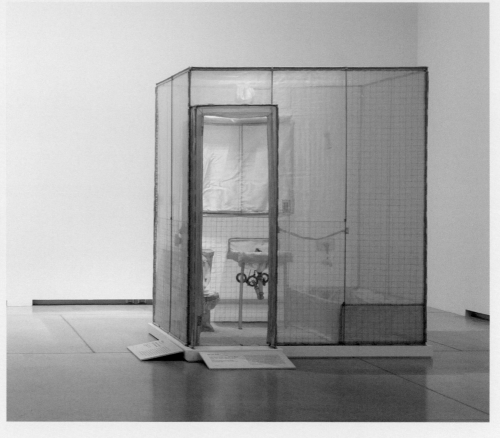

Do Ho Suh, *348 West 22nd Street, Apartment A, New York, NY 10011 (Bathroom)*, 2003. polyester, steel framework, 245 x 211 x 154 cm./ Art Gallery of Ontario, gift of Jay Smith and Laura Rapp and Gilles and Julia Ouellette, 2008, 2008/271./ © Do Ho Suh, courtesy of the artist and Art Gallery of Ontario./ photo by Sean Weaver.

which he has lived. This practice allows him to understand his past—or at least to find consolation in the attempt. Suh's work is effective in its immediacy, both for himself and for the viewers, who can project their own memories onto the spaces he depicts. His use of translucent polyester facilitates that, as the sculpture has a sense of openness. The bathroom sculpture conjures a sense of the familiar and the uncanny at once.

My curatorial interest in immediacy stems from my observation that there is a tendency in contemporary art wherein twenty-first century artists, like their artistic predecessors, become cultural mediators with the aim of offering an interpretation on the visual culture of their time, or as in Suh's case, to understand one's personal history. In *are you experienced?* we see a strain of artistic response, where artists adopt the method of distillation and visual translucency—a simplification of issues, images, and forms that perhaps stems from a desire for serenity. Similarly, the gesture of Do Ho Suh's practice enacts a desire to place order on the disorderly and an attempt to grasp the ephemerality of memories, yet his use of translucent materials suggests that resolution will be difficult—if not impossible—to achieve.

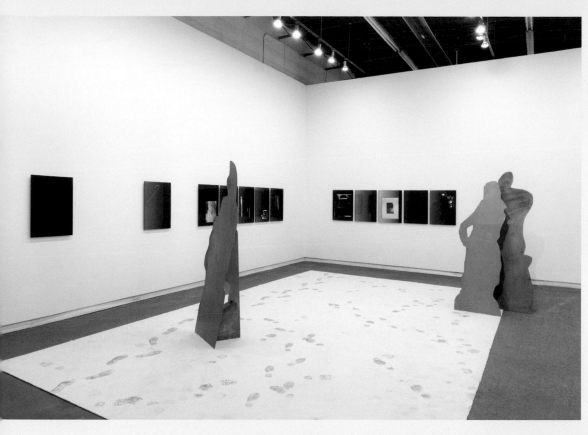

Nadia Belerique,
Have You Seen This Man?, 2014.
installation view, Daniel Faria Gallery,
Toronto, 1 May–7 June 2014./ courtesy
of the artist and Daniel Faria Gallery./
photo by Daniel Faria Gallery.

Nadia Belerique's work similarly looks at positioning, a placing of order on disorder, and suggests an analysis of both present and past: what is here and what has been. Under the guise of an investigator trying to unlock a mystery, her sculptural and photographic installation *I Hate You Don't Leave Me*, 2015, presents recognizable components such as life-size but anonymous figures, similar to Hadley+Maxwell's *Ritual for an Untimely Life* as well as *When That was This*, 2015, and *I*, 2009, two other Hadley+Maxwell pieces in this exhibition.

Belerique positions figural steel cut-outs, which are life-sized, in dialogue with photographs mounted under reflective Plexiglas; she also uses a customized carpet that provides clues to a mysterious narrative. The steel figures are devoid of identifying characteristics, as Belerique is also concerned with presence and absence. They are generalized figures that look like silhouettes, though they aren't shadow-like. The accompanying photographs also contain traces of human life, through fingerprints on the photographs and through the way they act in the space, in that they reflect an image of the figural sculptures that are positioned strategically and compositionally. They also reflect the viewer, which indicates the artist's interest in the viewer's role as performative.

A light-coloured carpet in the form of a long and narrow runner spans the length of the main exhibition space, and continues through several other gallery spaces. Belerique used Liquid Light, a chemical that temporarily turned the carpet into a light sensitive photographic surface. She applied the liquid to the soles of her shoes and walked over the carpet, then switched to boots and other shoes, leaving traces of the various soles due to their exposure to light. For the viewer, it immediately looks like a crime scene, though it is unclear whether the footprints belong to the criminal or the investigator. That ambiguity is of course intentional, and ties the photographs and steel figures into a tripartite mystery.

Belerique is interested in the ambiguity and limitations of photography. She proposes that the photograph is a stand-in for what it depicts. Her photographs are vertical, and their proportions mimic those of a flatbed scanner. Indeed, she used a scanner to create the images, using collages, though there are few traces of those collages; most images only show the blackness that results when the scanner makes an image

of nothing. Fittingly, the cut-out steel figures are stand-ins, or standee characters. Belerique has written that "the 'stand-in' or 'standee' is an almost perfect attempt to marry both the 'image' and 'object'. The form and what it's depicting has such an earnest attempt to be the 'real thing' with such clumsy results." She likes the humour there. Belerique also wants to know how "real spaces (banal, or day to day) and illusionistic spaces (images, the web) meet, cross and blur—and raise fundamental questions around construction of self in a blurred setting."[5] In her installation, the construction of self meets the construction of image.

Like Suh, Belerique attempts to capture a personal yet familiar awareness through her material production. She prioritizes an openness that is not concerned with resolution. Belerique's work also takes a spectral view of the body by exploring traces of human presence in a poetic way, much in the same way that Suh depicts spaces that were once occupied by his own body and so familiar to it. Belerique questions the marks that prove human presence, such as fingerprints left on a window or footprints on a floor, while Suh looks at the shell of what is left behind upon human departure of a space.

Belerique's figures activate an image of the body but also a substrate in their lack of identifying characteristics. On this topic, she writes that she is "creating a new standee which is faithful in scale but distorted in image, calling attention to its real objectness in the world, its image of it, and its substrate—that which keeps it upright, animates it."[6] Belerique's suggestive pieces employ recognizable yet partial elements of the body, which is similar to another exhibition piece, *When That was This*.

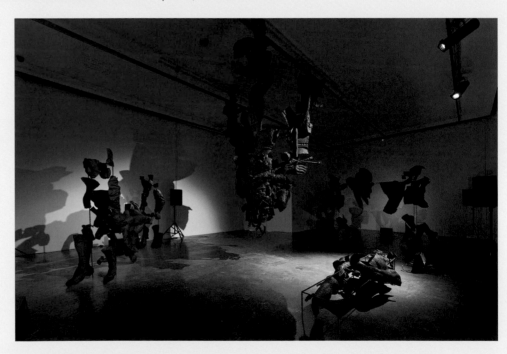

Hadley+Maxwell, *The Queen still falls to you*, 2014. cinefoil, steel, magnets, 6-channel sound, LED light-programming, dimensions variable, 20:54./ courtesy of the artists and Jessica Bradley Gallery./ photo by Ros Kavanagh.

Hadley+Maxwell's expansive installation *When That was This* was created for this exhibition and is made of a central support made of steel rods. Rectangular and architectural, consisting of columns and cross-beams, it emulates the skeletal structure of a stage or a theatrical set. It acts as a magnetic support for over 300 cinefoil impressions (cinefoil is an aluminium foil with an opaque black surface; it's often used

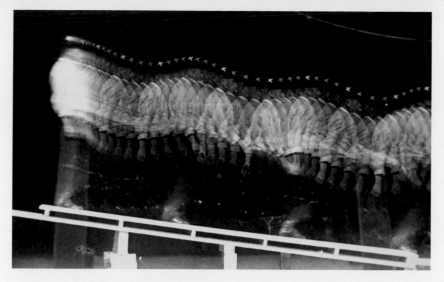

Étienne-Jules Marey, *Marche sur un plan incliné* (*Walking on an incline*). collection of Cinémathèque Française.

in theatre to control lighting). The foil pieces were moulded from parts of figural public monuments, mostly representing legs and arms, but also faces. Moulded from monuments all over the world, they cumulatively represent the desire to immortalize an important figure. The artists' approach of casting only some parts of the monument is one of the ways that they investigate the gesture of, and the principles inherent to, memorialization.

When That was This forms a large mass in the room, and a programmed light show of shifting colours intensifies and illuminates different areas of the piece at various times throughout a timed programme. The piece absorbs white light and glows with each colour that hits its porous surface, while causing colourful shadows on the surrounding walls. Perhaps the most psychedelic-seeming installation in the exhibition, it creates an impression that is somewhat more melancholic than exultant. The foil sculptures are hollow, and convey emptiness and absence.

During the research phase for this work, the artists became interested in the centennial of the outset of the First World War, looking at valorization and public remembrance as expressed by representational means. But the foil components in this work are not restricted to war monuments. The artists also "focus on the use of figuration to represent the absence of humans and the loss of human life, whether they are meant to memorialize individuals of import or generic figures that represent greater social or civic values (soldiers, police, firefighters, etc)."[7]

The fragments of monuments also relate to friezes and facades of buildings, an idea substantiated by the artists' use of the architectural support for the cinefoil casts. Concerned with human knowledge, the artists draw on human experience as a phenomenon of presence, absence and phantasm that is the product of heterogeneous senses of chronological, cyclical and human operational time. Present experience can resonate with memory in such a way that the subject hovers in a looping space where a sense of history overwhelms lived experience, pushing the subject beyond mere presence to the existential, or ecstasy, or in the extreme, a bursting point and potentially breakdown.[8]

Hadley+Maxwell are working within the idea of cyclical time—it is a transhistorical way of working with monuments, as they ask, what is our experience of history in the present, and how do we understand time? Étienne-Jules Marey, the French scientist and chronophotographer, was an inspiration for this work. Marey photographed humans and animals in motion, capturing all the stages of a movement in a single image, beginning this investigation in 1888. Marcel Duchamp worked with paint just over 20 years later to create *Nude Descending a Staircase*, 1912, also an expression of movement in a single frame. *When That was This* similarly depicts serial action through a still piece. The cast body parts have a gestural quality, and their composition creates

a waterfall effect in some areas. Hadley+Maxwell release figures from the tyranny of grand historical narratives, drawing exhibition viewers into an awareness of a current experience of the present, by reworking our relationship to the past.

The coloured lights form a crucial component of the installation, where the viewer's perception of the shape, scope and mood of the piece changes dramatically, depending on the quality of light shining upon the installation. The dimensionality of the black foil pieces also changes with added shadow and chromatics. The moving lights animate parts that are immobile; and there is implied progression in its frieze-like quality, referencing music in terms of the rhythms and sections that occur in the piece. The foil can be read as a dimensional collage, and—fittingly—the accompanying sound piece is also a collage work.

The sound piece created for *When That was This* can be heard in the exhibition space. Hadley+Maxwell composed it as a sonic equivalent to the deconstructed figures that are part of the large sculptural work. They talk about the sound also being the equivalent of the "liminal space, and the area in between frames in a film, or chronophotography".[9] Like the artists' gesture of liberation toward the figural foil pieces, where the components can be seen as freed from historical narratives, the goal with the sound work is to free it from meaning by centring it in an experience.

The sound piece is derived from voice recordings that have been obscured through heavy editing—the words are treated in a collaged way, resulting in an abstract story with recognizable elements. The spoken passages are from two texts: *All Quiet on the Western Front*, by Erich Maria Remarque, and a passage from *The Autobiography of Alice B. Toklas* by Gertrude Stein, in which the author reflects on a specific moment —and her place in it—during the First World War. The text by Remarque, in its original state, is a haunting and poetic piece from the perspective of a soldier moving forward into battle, looking out at his opponents. The visual association to *When That was This* is striking:

> The heads become figures; coats, trousers, and boots appear out of the mist as from a milky pool. They become a column. The column marches on, straight ahead, the figures resolve themselves into a block, individuals are no longer recognizable, the dark wedge presses onward, fantastically topped by the heads and the weapons floating on the milky pool. A column—not men at all.[10]

Like Remarque's text, Hadley+Maxwell's piece is an artistic iteration of a theatrical story; though abstracted, as the narratives are implied. And the structural component of the installation is itself like a theatre set into which the gallery visitor can enter and explore a series of sensorial phenomena that shift and change over time.

The third exhibition work by Hadley+Maxwell is titled *I*, and it can be seen from the room where *When That was This* is installed. An image of a woman dancing and headbanging can be seen from afar; like *Ritual*, it is projected onto a freestanding wooden screen. The piece also uses alluring coloured lights, like *When That was This*, surrounding the silhouetted figure. From the dancer's movements, she seems possessed, demonstrating an intense entrancement with the music. There is sound,

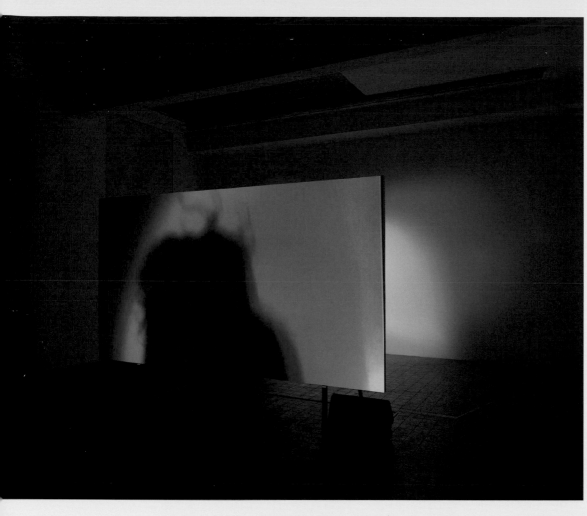

Hadley+Maxwell, *I*, 2009.
single-channel video with sound,
freestanding screen, with red, green
and blue theatre lights, 21:01, 300 x
169 cm (freestanding screen)./ in
collaboration with Emma Waltraud
Howes, music by Meshuggah, "I",
from the album *I, Nuclear Blast*, 2006./
courtesy of the artists and Jessica
Bradley Gallery./ photo by Nick Vees.

though it can't be heard in the space until the visitor dons headphones. The music
the figure dances to is a rare brand of thrash metal that is complex in rhythm and
composition, interspersed with yelling from the vocalist. Displayed in this way, the
work operates like a moving painting, as the artists intend, until it is experienced in
its entirety with the sound.

As a moving image, the figure's bodily gestures are compelling and relate well to the
overall gestural aspects of *When That was This*. With the addition of a headphone
listening experience, *I* becomes more about individual expression. Indeed, the work
prioritizes this, as the creation of music is a means to demonstrate personal creativity;
and making the sound accessible exclusively through headphones, emphasizes the
truly personal experience of listening. With the headphones the sound — with its
many nuances — is heard more clearly, and viewers can then walk by and around the
projection surface, allowing them to become more absorbed in their own experiences.
The music and the dancer's impassioned movements will be recognizable to many
visitors. However, the silhouette of the body again brings up the concept of bodily
presence and absence that is a thematic thread throughout the exhibition.

Hadley+Maxwell present recognizable subjects within sculptural and image-based
installations. Their works contain myriad suggestive representational elements, which
they position as harbingers of topics such as presence and absence, and the understanding
of the present as a transhistorical moment in which we can be both mentally and
physically present during a visual experience, while activating our historical knowledge
— whether personal or not.

In most of the works in *are you experienced?* the artists refer to the body but in a
generalized way; the human body is present but seems anonymous, de-characterized
or universal. The use of figures implies human presence, but also absence or a void.

Dorian FitzGerald explores these contrasts through two large and visually immersive paintings that are positioned opposite each other in a large gallery space with 5.5 metre high ceilings. The works are spectacular and their strong material characteristics are undeniable. FitzGerald is interested in the topic of ostentation—the vulgarity of wealth and luxury—and this concept is underlined through his highly material approach.

His work *Hacker-Pschorr Beerhall, Oktoberfest, Munich,* 2005, is hung at one end of the space, and it measures an incredible 5.5 metres high and 3.6 metres wide. It depicts a fake Bavarian street scene during Oktoberfest. The hall is a place that was constructed for tourists, and inherently maintains all the clichés imaginable. Seven thousand figures fill the hall, which is pictured with a deep single-point perspective. The artist found the source photograph in an old *National Geographic* magazine, and the strong architectural perspective of this work dominates the image. The cloisonné-like technique of adding an incredible amount of detail builds up the image, but it also

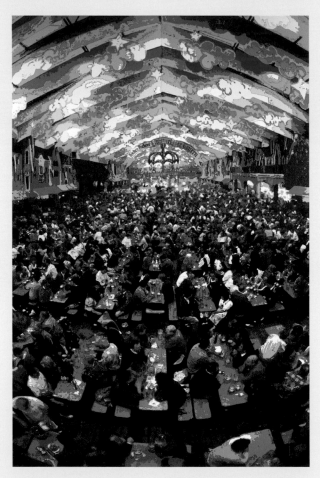

Dorian FitzGerald, *Hacker-Pschorr Beerhall, Oktoberfest, Munich,* **2005. acrylic and caulking on canvas, 549 x 366 cm./ courtesy of the artist and Clint Roenisch Gallery./ photo by Dorian FitzGerald.**

operates in a deconstructive way. His approach is not documentary, but analytical. The intrinsic clichés struck him to reinterpret the scene. For FitzGerald, the idea of authentic experience is a contentious one. It is only fitting that he depicts drinking culture, with its attendant desire for altered experiences. But his works also point to social structure, with *Beerhall* focusing on the tourist class in a hyper-visual way, as expressed through such a large depiction—not as if under a microscope, but certainly under a close eye.

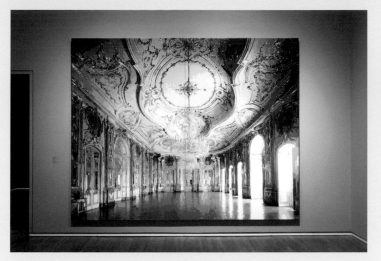

Dorian FitzGerald, *The Throne Room, Queluz National Palace, Sintra, Portugal,* 2009.
acrylic paint and caulking on canvas, 320.5 x 396.6 cm./ The Montreal Museum of Fine Arts, Purchase, the Montreal Museum of Fine Arts' Volunteer Association Fund, in memory of Marjorie D Gawley, an outstanding volunteer, 2010.16.1-2, The Montreal Museum of Fine Arts./ photo by Dorian FitzGerald.

It was no small feat to install it. In fact, this is the work's first public unveiling, as no other venue has been able to present it due to its size. The process by which it was created was intricate: FitzGerald printed a version of the photograph onto acetate, transferred that to canvas, which was coated in a thick acrylic, and then he traced the outlines with caulk and filled in the tiny spaces with paint. When viewed up-close, the image is hard to read in its incredible detail. From a distance, the small areas of colour work together to depict the larger scene, and only then can the viewer experience the work as a whole.

FitzGerald's second painting in this exhibition, *The Throne Room, Queluz National Palace, Sintra, Portugal,* 2009, was created using the same cloisonné-like method. It depicts a lavish room within a Portuguese palace, arguably that country's version of Versailles. The room looks like a hall of mirrors, and it is bare of furniture and void of people. Painted in myriad shades of an intense gold, the palace symbolizes a fallen empire — the riches of the palace are in the past. Queluz National Palace is now a major tourist attraction, which links this work to *Beerhall* in FitzGerald's exploration of what a given country chooses to promote to tourists. The commodification of a culture's identity is a rich topic here.

Jessica Eaton's photographs also activate dazzling visual materials, within her colourful geometric photographs that often depict cubes within cubes. Her *Cubes for Albers and LeWitt (cfaal)* series, 2010–ongoing, employs a unique process wherein she photographs grey boxes using colour film, and then she manipulates these images within her camera and in the darkroom. They are experimental and, for the artist, experiential during their creation. When exhibited, the photographs are scaled for a bodily experience, and this assists in an immersive viewing experience. The viewer can subtly oscillate between 2-D and 3-D, focusing on the picture plane but also on the object depicted and its textured surface, which can only be seen upon close viewing and in person.

Eaton's eye and perceptive experience is paramount during the creation of the work. Every decision made during a work's creation may have a major effect on the image, though she may not know it during the moments of its formation. For every image she deems successful, there have been many more that she considers failures. This process of experiencing colour and geometric form is passed on to the viewer, who can experience the works for their beauty, as the philosopher John Dewey encouraged, by means of a detour.

Eaton's works capture multiple forms in one image, similar to how Hadley+Maxwell's works contain multiple visual references. Yet in their static state, Eaton's images do not seem to imply gesture and movement, and they do not seem to reference early cinema as Hadley+Maxwell's work does. To situate Eaton's works within historical photography, we could consider the multiple-image photographs of Marey, Eadweard

Jessica Eaton, installation view, *Jessica Eaton: New Works,* Jessica Bradley Gallery, 1–31 May 2014./ courtesy of the artist and Jessica Bradley Gallery./ photo by Toni Hafkenscheid.

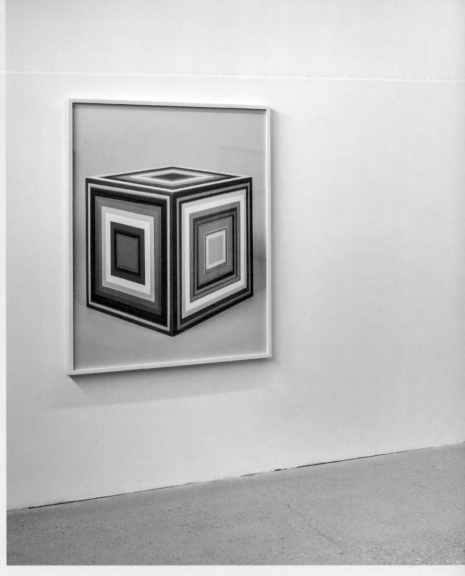

Muybridge, or Harold Edgerton, each of whom also operated with a scientific approach. But the title of Eaton's series reveals her alignment with another group of artists. The reference to Josef Albers points to the use of intense colours, patterns, and an interest in visual perception. The Sol LeWitt reference may suggest the parameters and methods that are a crucial part of Eaton's artistic process. Science is present, as each image is an experiment constructed with predetermined guidelines. Yet Eaton's process, while obviously planned in advance, also rests on immediacy.

For Eaton, the viewer's experience is not a consideration during the work's creation; however, her practice does invoke the methods and parameters of, and for, seeing. An experience of her work creates an emotional and personal response—to be in front of her works, one must be conscious of one's place there.

Olafur Eliasson is one of the leading global artists working in the area of art and personal experience. His approach is distinct from other exhibition artists in that he believes a viewer's response to a work does not occur instinctively. He believes that perception is not a "dispassionate, neutral act, but the product of cultural and

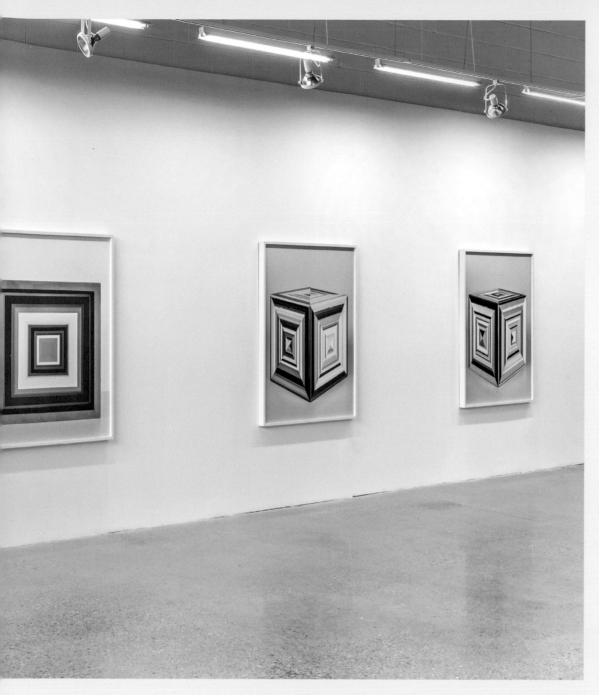

historical conditions." He regards space not as a "naturally occurring substance but as a completely cultural product, which changes as time passes and as it is used in different ways".[11]

Eliasson's exhibition work *Triple ripple*, 2004, like many of the works in his oeuvre, invites viewers to be aware of their body and the space around them. The piece consists of three glass discs that are suspended from the ceiling, and each is made up of concentric rings of mirrors that rotate mechanically. A single light illuminates them, and it casts moving shadows on all the walls of the room; all the shadows are the same size, despite the fact that the glass discs are varied in size. A simple but affective piece, the shadow patterns create a moiré effect, which occurs when parallel lines are placed near to each other but slightly off position.

Eliasson proposes one way of understanding the relationship between a viewer and an artwork. Other exhibition artists, such as Hadley+Maxwell, consider immediacy, or the automatic reaction one has to an artwork, more so in terms of the viewer's intuition—understanding the work instinctively rather than through conscious reasoning.

melissa bennett

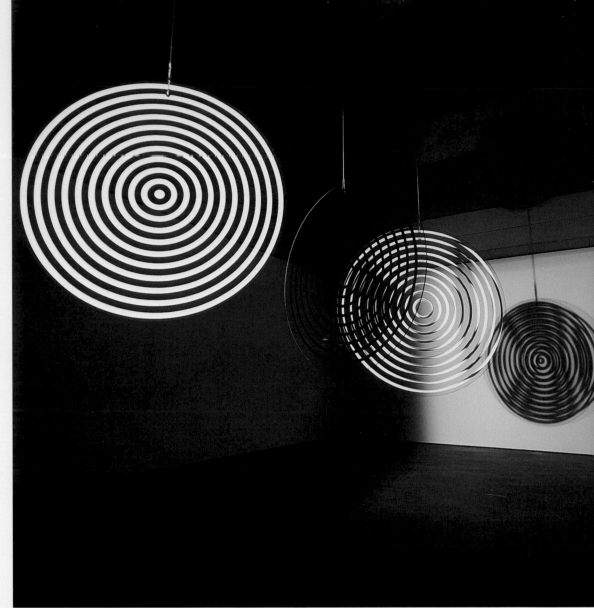

Olafur Eliasson, *Triple ripple*, 2004. glass, mirror, electric motors, spotlight and tripod, dimensions variable./ Albright-Knox Art Gallery, Albert H Tracy, Charles W Goodyear and Charles Clifton funds, by exchange, 2007: 14a-g./ installation view, *ein-leuchten*, Museum der Moderne, Salzburg, Austria, 2004./ courtesy of the artist; neugerriemschneider, Berlin and Tanya Bonakdar Gallery, New York./ photo by Werner Schnelle.

For Eliasson, just like Belerique, the self and the construction of self plays a strong role. The mirrors used in *Triple ripple* are critical to Eliasson's vision: "The mirror is a medium of self-perception."[12] One of Eliasson's works was featured at a recent exhibition at the Belvedere in Vienna, titled *The Other Side—Mirrors and Reflections in Contemporary Art*; the writing on this show cites Michelangelo Pistoletto, who wrote in his *Famous Last Words*:

> Man has always attempted to double himself as a means of attaining self-knowledge. Recognizing one's own image in still water or in the mirror may be one of the earliest real hallucinations man encountered. Moreover, the mirror works as a membrane between the real and virtual worlds and, in an increasingly secular world, brings into play the level of transcendence and magic without referring to religion.[13]

Further, *The Other Side* exhibition posits that "in contemporary art, reflecting surfaces are not only aesthetic artefacts, but also instruments of social penetration and of attaining a knowledge of the world, thereby confirming a phrase formulated by Joseph Beuys in 1972: according to him, the brain is a reflective organ, as hard and smooth as

a mirror."[14] As one of the curators Edelbert Köb wrote of *The Other Side*, the pieces in it "either play with the magic of illusion and deception in the form of reflection, refraction, multiplication and distortion of space or invite beholders to sensuously experience materials and processes".[15]

Many of these elements comprise the fundamental concepts of *are you experienced?*. The use of translucent materials—in the video by Hadley+Maxwell, in the bathroom piece by Suh, and in the reflective surfaces in Belerique's installation—suggest an invitation for personal engagement and reflection. While each of these three pieces focuses, in varying degrees, on an individual, the artists intend for "social penetration", with the goal of promoting knowledge of the world. Personal memories and subjective experiences of the world are starting points for thinking about universality and social exchange. Suh's practice may come from a very specific and personal memory of home, but he produces an object that many can relate to as a familiar and affective site.

Ultimately, the *are you experienced?* artists invite the viewer's mindfulness. While this exhibition had its source in my long-felt goal to convey an ephemeral yet visceral reaction that one has when experiencing an artwork, this objective may not be felt by all. Yet, as the artists intend to promote consciousness, their practices shall extend —in a social and living way—to carry my, and their, intentions forward.

1 Gioni, Massimiliano, "Ask the Dust", *Unmonumental: The Object in the 21st Century*, London: Phaidon, 2012, p 65.

2 "Affect", accessed 10 January 2015, http://www.oxforddictionaries.com/us/definition/american_english/affect

3 Dewey, John, *Art as Experience*, New York: Minton, Balch & Company, 1934, pp 3–4.

4 Pallasmaa, Juhani, "The Eyes of the Skin—Architecture and the Senses", London: Academy Editions, 1994, p 27, quoted in: Hadjiphilippou, Panagiotis, "The contribution of the five human senses towards the perception of space", Cyprus: University of Nicosia, 1994, accessed 10 December 2014, http://www.academia.edu/2460561/The_contribution_of_the_five_human_senses_towards_the_perception_of_space_by_Panagiotis_Hadjiphilippou

5 Belerique, Nadia, *The Counselor*, unpublished artist statement, 2014.

6 Belerique, *The Counselor*.

7 Hadley+Maxwell, unpublished artist statement, 2014.

8 Hadley+Maxwell.

9 Hadley+Maxwell, interview by the author, 3 December 2014, Hamilton.

10 Remarque, Erich Maria, *All Quiet on the Western Front*, Boston: Little Brown and Company, 1930, p 57.

11 Ursprung, Philip, "From Observer to Participant in Olafur Eliasson's Studio", *Studio Olafur Eliasson*, Cologne: Taschen, p 13.

12 "'The Other Side: Mirrors and Reflections in Contemporary Art' on view at the Belvedere", ArtDaily.com, accessed 10 December 2014. http://artdaily.com/news/71455/-The-other-Side--Mirrors-and-Reflections-in-Contemporary-Art--on-view-at-the-Belvedere#.VJrekV4AAB[/url]

13 Pistoletto, Michelangelo, "Famous Last Words", 1967, quoted in "'The Other Side: Mirrors and Reflections in Contemporary Art' on view at the Belvedere", ArtDaily.com, accessed 10 December 2014. http://artdaily.com/news/71455/-The-other-Side--Mirrors-and-Reflections-in-Contemporary-Art--on-view-at-the-Belvedere#.VJrekV4AAB[/url]

14 "'The Other Side: Mirrors and Reflections in Contemporary Art' on view at the Belvedere".

15 "'The Other Side: Mirrors and Reflections in Contemporary Art' on view at the Belvedere".

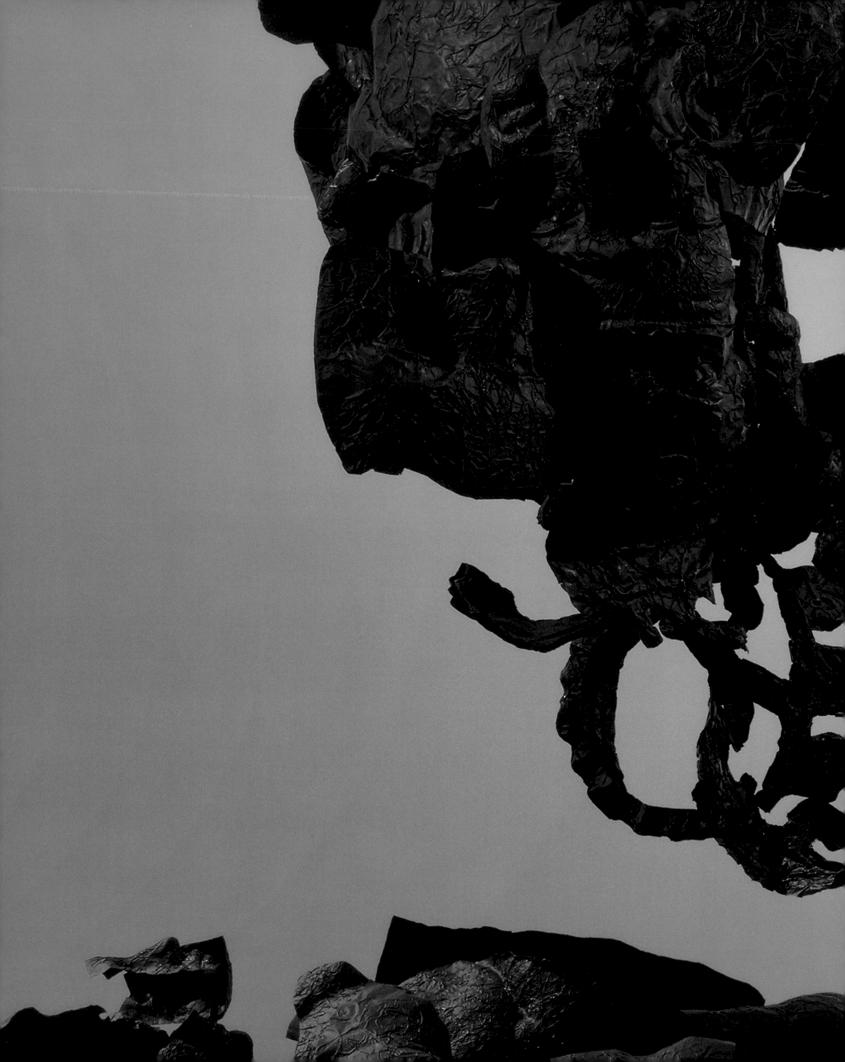

1

hadley+maxwell: backstage in the phantasmagoria

jennifer fisher jim drobnick

Entering a Hadley+Maxwell installation is a decentring experience. Instead of focusing on isolated artworks, visitors find themselves immersed in a matrix of shifting and chaotic sensations: the multilayered sounds of applause and discordant bits of music; flashing lights, prismatic video projections and dancing shadows; and an assembly of seemingly makeshift objects and sculptural fragments. One does not contemplate the works, *per se*: one tumbles into a carnivalesque space of dizzying and contradictory commotion. Such a sensory overload undermines the expectation of a singular standpoint and fractures the desire for a comprehensive perspective. Every perception is partial and ephemeral. Walking through the duo's installations engages viewers' peripheral perceptions, enmeshing them in a synaesthetic interplay between objects, reflections, images, music and bodies. Aesthetic distance yields to a kaleidoscopic fusion of self/other as the lights and sounds wash over and confound the boundaries of everyone and everything in the space. As disorienting as the artists' installations feel in the pristine geometry of the white cube, the atmosphere of hallucinatory stimulation carries a familiar tinge. The sound of hardcore guitar riffs suggests a thrash metal concert, while the oscillating colours recall psychedelic light shows and esoteric mind-altering techniques (for instance, Brion Gysin's dream machine).[1] No band of musicians occupy the space, yet visitors seem to have found themselves backstage at a show in progress, with all of the stage-like accoutrements of a performance. This invests the gallery with the powerful intensity of rock subcultures, reverie-inducing drugs, and the visionary transcendence of trance states. An affect of mystery combines with estrangement, as viewers negotiate rooms filled with incongruous and paradoxical multisensory elements where lights, sculptures and sound convey a sense of fullness and absence simultaneously.

Hadley+Maxwell's work participates in what could be called the *phantasmagoric turn* in contemporary art, in which the irrational and uncanny are foregrounded and explored.[2] In the Ur-form of phantasmagorias, magic lanterns projected macabre apparitions and clever optical illusions that frightened and fascinated audiences in the late eighteenth and early nineteenth centuries. Often critiqued as deceiving the credulous and fuelling supernatural beliefs, these entertainments arose during the era of the Enlightenment and presented phantoms apparently floating in mid-air, dissolving, moving about and morphing into skeletons, accompanied by disorienting and otherworldly music. Despite the claims made by the proprietors of these early entertainments that their displays held scientific, educational and even demystifying value, for Karl Marx and Theodor Adorno their illusionistic capacities became a notorious trope for explaining how capitalism (and ideology in general) misleads populations while hiding its own machinations.[3] Like the

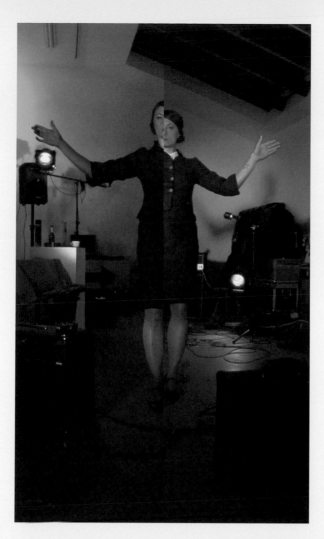

Hadley+Maxwell, *Ritual for an Untimely Life*, video still, 2009. single-channel video, 21:23./ courtesy of the artists and Jessica Bradley Gallery.

operation of the modern spectacle, which occludes its workings through engulfing sensory stimulation and the suspension of rational judgment, the format of the phantasmagoria epitomizes the use of technology to both enchant and delude.

Originating contemporaneously with the discovery and 'scientific' demonstrations of electricity, phantasmagorias have been heralded as proto-cinematic and the distant forebears of media art. The practice of staging the entertainments in darkness, with flashing lights and bewildering music, bears more than a resemblance to the work of Hadley+Maxwell, who project lights and figures on screens throughout the gallery space, and otherwise derange the senses to approximate being in an altered state. But does this experiential similarity suggest a return to the trickery of the phantasmagoria? Below, we reflect on how the duo's work revives the phantasmagoric within a postmedium aesthetic experience.

ritual for an untimely life: instructions from an alienated muse

Visitors arriving at *are you experienced?* are greeted by a figure of a flight attendant who ushers them into the exhibition. *Ritual for an Untimely Life*, 2009, features a woman in a mid-length skirt and crisp jacket, with pulled-back hair and a concentrated expression. Projected life-size, she hovers over the viewer, performing a pre-flight safety demonstration at a snail's pace. The meditative and hypnotic choreography—recognizable to anyone who has ever flown in an aeroplane, yet enigmatic because of the silent, slow-motion tempo—causes one to pause. It is unclear what instructions are being conveyed or how the gestures should be interpreted. Which emergencies are visitors being prepared for—delays, turbulence, hijackings, crash landings, lost luggage? In the art gallery where literal emergencies are rare, this work speaks more to the metaphorical dangers of mixed messages, contradictory sensations, or aesthetic aporias.

jennifer fisher jim drobnick

Universal survey museums often mount figurative sculptures to imbue their entryways with symbolic importance. For example, Auguste Rodin's priapic figure of Jean d'Aire from *The Burghers of Calais*, 1887, at the doors of Montreal Museum of Fine Arts, codes the museum with creative or generative power. Such encounters typically fall below the level of consciousness, yet are understood kinaesthetically as one ascends the steps to the sanctum of art. Carol Duncan refers to this performance of museum architectures as a liminal state of time-out-of-time, whereby visitors transition from the realities of the everyday life to a secular ritual.[4] Likewise, Hadley+Maxwell's flight attendant is placed at the threshold of art's sacred space. At various moments, she appears as solid and imposing as a statue. Yet when in motion, her "safety precaution" gestures resist any particular meaning, the movements seem more perplexing than signifying, anticipating uncertainty in the journey ahead.

The flight attendant occupies her own power as cultural icon. A welcoming hostess, caring nurse, efficient member of the military corps, glamorous fashion model, or alluring embodiment of airline brand identity, she bears multiple, intersecting roles and character traits.[5] That Hadley+Maxwell compare entering an exhibition to a plane taking off yields a complex of associations between museums and aircraft; gallerygoing and flying; art aficionados and world travellers; and exhibitions as journeys or destinations. In the context of the museum, however, whom does the flight attendant stand in for? Is she a surrogate for the docent, the curator, or the artists themselves? The video's central position forces visitors to reckon with her commanding presence and apparent position as, variously, interpreter, mediator, creator. She leads gallerygoers to two types of elevations—the physical altitude of flight, and the moral uplift of aesthetic experience. In regard to the latter, the museum's function as a training and educational apparatus, engrained since the nineteenth century when the rise of masses of workers in cities represented a social crisis to the bourgeois and managerial elite, is relevant. The 'civilizing' imperative of the museum strategically countered the supposed threat of the 'unruly' poor and working class. If *Ritual for an Untimely Life*'s flight attendant performs as an emissary of the museum, she initiates those who enter the exhibition into social ideals that have been reconceptualized by the artists.

The flight attendant's movements, performed by collaborator Emma Waltraud Howes, are low-key and unobtrusive; for all of their relation to precautions against danger and information about survival, the gestures remain inconspicuous. Travellers regularly ignore the safety demonstrations, and since flight attendants perform the routine so often, they often look bored or distracted. If one were to compare the choreography in the video to styles of dance, they could be described as embodying the slowness of Butoh (without the intensity), the minimalism of Lucinda Childs (without the stagecraft), and the everydayness of Judson or Grand Union (without the critique of conventional dance). There is, however, another sense in which the flight attendant's motions are ritualistic: as repeated behaviour, a rite of modern technology.[6] By appropriating the gestures normally found in an aircraft cabin, translated through the body of a professional dancer, and transported into the gallery, Hadley+Maxwell underscore the ritualistic nature of exhibition-going. Through looping, the video plays continuously. Visitors, rather than being buckled into their seats, stand to watch and proceed at the timing of their choice. As much as the choreography of the safety demonstration is slowed down, repeated, and silenced, its recontextualization within the gallery space points to the shadow of mortality that hangs over every human activity, even those within the protected walls of the museum. As an "untimely death", a phrase alluded to

by the "untimely life" of the video's title, the dance subtly updates the art historical tradition of vanitas through the threat of aviation mishaps.

"Untimely life" also conjures up the state of being out of sync with one's era. The most dramatic element of the video is that the flight attendant's face and body are uncannily bifurcated. Shot twice and juxtaposed, the figure's countenance is composed of two halves. When the movements coincide and are in sync, her body appears whole; at other points, she appears fractured and out of phase. This doubling confirms the repetitiousness of her choreography (its ritual nature), but also its non-coherence (untimeliness)—a split subjectivity that confounds singularity and wholeness. Red and green lighting alternately shroud the figure to accentuate the mismatched, off-register, imperfect melding of the two cameras and performances. Like an unbalanced stereoscopic view, the expectation of a single, three-dimensional perspectival scene is visually destabilized. Surrounding the flight attendant are the odds and ends of a studio/rehearsal space: stage lights, amps, equipment cases, microphone stands, cords, and a beer bottle and coffee cup. Far from the aerodynamic and engineered interior of a contemporary aircraft, the video's background portrays the elements of post-media, interdisciplinary art practice.

The scattered technology in the background offers more than just context, it provides a link to the phantasmagorias of two centuries ago. The stagecraft for rock and metal concerts descends from the painted slides, mirrors and candle-lit lanterns of the pre-electric age. The flight attendant, then, amidst the clutter of audio and video gear, could be said to be performing *within* the apparatus of the phantasmagoric spectacle. Visitors, witnessing both the hovering, spectral figure as well as the technical means for producing the projection, are privy to both the illusion and the means of its production. Unlike the original viewers of phantasmagorias, seated in darkness and unaware of the technology manufacturing the ghostly appearances, those watching *Ritual for an Untimely Life* have the apparatus fully visible. Such a context defuses the deceptiveness of the phantasmagoric and alerts viewers to its patent constructedness.

Still, the flight attendant conveys an eerie affect. The meaning of "untimely" in the title may refer to the leap of an eighteenth-century visual trope to the present day, but it also bears associations to the "unhomely", the literal translation of Freud's term for the uncanny. The figure, made phantom-esque by the prismatic lighting, beckons gallerygoers with familiar but mysterious gestures. If she does stand in for the ritualistic marker of the threshold, the museum's muse, or the information-laden docent, the schizoid image casts doubt upon her venerability and trustworthiness. As much as the magic of the phantasmagoria is neutralized, her riven expression shows a figure alienated from herself and ruptures any singular authority.

received ideas (cinefoil series): phantoms of authority

Hadley+Maxwell's cinefoil series reworks gestural impressions drawn from iconic sculptures from museum collections and public monuments—ranging from imperial statues of Queen Victoria, to devotional icons of the Buddha, to architectural details from civic landmarks. Cinefoil functions like the dark matter of cinematic and theatrical lighting, a flexible matte aluminium material that "sucks up light" to eliminate leaks and diffuses reflections. Its malleability accurately records the volumetric dimensions of the host object. Pressed onto the hard surfaces of sculpture to form a second, skin-like shape, the artists select elements—a hand, face, crown, drapery, foot—

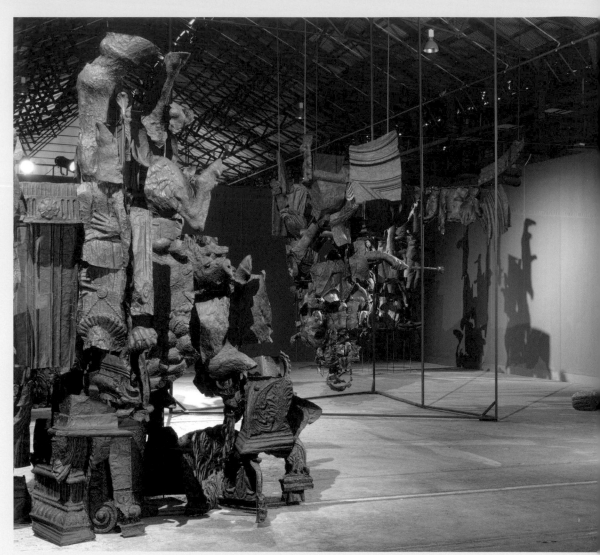

jennifer fisher jim drobnick

Hadley+Maxwell, *The Queen still falls to you*, 2014. cinefoil, steel, magnets, 6-channel sound, LED light-programming, dimensions variable, 20:54./ courtesy of the artists and Jessica Bradley Gallery./ photo by Ros Kavanagh.

that are re-assembled into multifaceted installations. The jagged edges of the foil lend the composite figures a grisly affect as they simultaneously revere and subvert the original objects.[7]

Such a method of casting fractures public monuments into partial views that appear to have been exploded and then reconstituted in meticulous detail. For Walter Benjamin, such scrupulousness in recording the past was important when recontextualizing it in new configurations. Susan Buck-Morss describes how Benjamin's method of "dialectical images" illuminates the role shock plays in blasting open the linear continuum of history:

> As a historian, Benjamin valued textual exactness not in order to achieve a hermeneutical understanding of the past "as it actually was" —he called historicism the greatest narcotic of the time—but for the shock of historical citations ripped out of their original context with a "strong seemingly brutal grasp", and brought into the most immediate present. This method created "dialectical images" in which the old-fashioned, undesirable, suddenly appeared current, or the new, desired, appeared as a repetition of the same.[8]

The discontinuity of Hadley+Maxwell's composite sculptures become particularly relevant in a contemporary culture that routinely experiences shock. The unfolding of history is punctuated each day with news of plane crashes, tsunamis, and terrorist

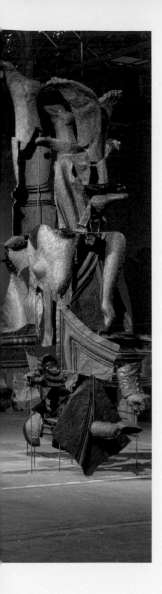

attacks that rapidly kaleidoscope on billions of screens, Twitter feeds, email and Instagram pages. It is telling that these sculptures are seen in counterpart with light shows, demonstrating a shift away from the prior content of the historical statues to the speed of the screens that currently oscillate culture's mediation. The artists' hypnotically cycling colours amplify the sculptures' dialectical fragmentation, particularly when used phantasmagorically to throw tinted shadows beyond the objects themselves and onto the surfaces of the gallery.

These works convey tactile and gestural impact. In one sense the feeling of being 'impressed' is to be 'affected', as Eve Kosofsky Sedgwick has written of the intimacy underlying the relationship between textures and emotions. At the same time, the cinefoil series' formal aspects of production is simultaneously 'printed' and 'imprinted', articulating the interactive affordances of touch that resist binary conceptions of action and reception. Proximity, likewise, plays a role in the visual perception of texture. Seen from a distance the cinefoil series appears as figures, while closer up, body protuberances, fabrics and architectural elements are recognizable as disparate parts. Indeed, they present texture in ways that put into crisis and fracture the monolithic ideologies presented in public statuary. The impressions carry the traces of what Kosofsky Sedgwick (after Renu Bora) would call *texxture,* a haptic recording of process that lends substantive information about their coming into being.[9] Along with the details of the monuments, the wrinkles in the pliable cinefoil preserve imprints of the artists' fingers and the gestures performed.

Insofar as Hadley+Maxwell's cinefoil series works to receive—or take in—the imprints of monuments, it can be understood to function by *introjection* in that the 'impressions' accumulate and are redeployed in newly signifying arrangements. As counter-monuments, then, they function differently than Krzysztof Wodiczko's metonymic projections, in which subversive images are projected on existent sculptures or facades in order to critique the ideologies of nationalism, heroism, militarism, and so on. In contrast, the logic of introjection in Hadley+Maxwell's cinefoil series operates more synecdochically. The static monumentality of the original landmark sculpture is first disassembled and then rearticulated into counter-monuments. The fragmentation of ideological superegos are further overturned by the artists' decision to literally invert the statues and the colonialist legacy they represent. Dehistoricised and reconfigured, the composite sculptures are illuminated by a vivid spectrum of digital lights and nihilistic sound.[10]

Combining fragments lends a curatorial aspect to Hadley+Maxwell's practice. The cinefoil pressings are archived in an inventory that the artists reconfigure into distinctive constellations in different venues. Sometimes hung on walls, they can appear like laundry on a metallic clothesline;[11] at other times they are affixed to freestanding armatures. Each new arrangement confers another set of juxtapositions, contexts, value and significance, not unlike how curators function.[12] The artists refer to the sculptures as "haunting space" and indeed there is a gloomy darkness to these works akin to the nineteenth-century Victorian mourning etiquette of wearing elaborate black gowns and jet funerary jewellery as a public display of personal loss.

A massive installation at the Sydney Biennale completed the refutation of colonialist British power. The central component of *Manners, Habits and Other Received Ideas,* 2014, was based on a 1908 monument of Queen Victoria by Irish sculptor John Hughes, which was removed from public display in 1948, languished in storage before being shipped to Australia in 1986, where it was refurbished and installed in front of the

Queen Victoria Building in Sydney. Hadley+Maxwell found the statue when preparing for the Biennale, and their assemblage included cinefoil pressings from it and a range of monuments in the city as well as architectural motifs from the Queen Victoria Building and the adjacent Town Hall. The resulting sculpture, *Mega Queen Victoria*, deposed the symbol of British imperialism with the artists inverting the monument to drain away any lingering imperial formality and authority. Besides being upturned, the queen's jewelled crown, comprised of shards from four different queen statues, hovered just above the ground—centimetres from visitors' shoes.[13] The indignity was heightened when the sculpture was repurposed into *The Queen still falls to you*, 2014, an installation in Dublin, in which the sounds of audience applause and the pre-concert tuning of an orchestra gave the toppling of the monarch a conspicuously theatrical atmosphere.

The overthrown Queen Victoria appears to have exploded, its sculptural surfaces recalling cubist paintings of Picasso, or Duchamp's *Nude Descending a Staircase*.[14] Versions of four monarchical portrait busts have been brought together on a triangular armature, showing the sovereign vividly shattered and reconfigured. The ghastly amalgam confronts idealist conceptions of colonial benevolence and refuses the imaginary 'unity' of the United Kingdom.[15] The only trace of loyalty persists in *Islay*, 2014, named for Queen Victoria's dog, a witty composite of canine parts drawn from a talking water fountain, a local Sydney hound named Biggles, a seeing-eye dog donation box, and a small imperial lion from Sydney's Centennial Park.

Hadley+Maxwell's piecing together of figural fragments alludes to sculptural techniques both classical and modern. It references, for instance, the ancient Greek practice of selecting the most beautiful example of a body part from separate individuals and integrating them into an amalgamated, ideal whole. However, even as Hadley+Maxwell adopt the method, they dispense with classical notions of "beauty", "wholeness", and "ideal" in favour of the grotesque, the incomplete and the ignoble.[16] Their practice is akin to the Surrealist exercise of the exquisite corpse: body sections drawn by different artists without knowledge of the other parts so that the end result is an incongruous and unholy hybrid. Still, there is a dismemberment that goes beyond that of the Surrealist's game, which bespeaks of violence in the reconstituted figures. Like the debris accruing from archaeological excavations, or the rubble left behind by vandals destroying monuments of overthrown dictatorial regimes, the artists render commemorative statues, meant to last the ages, as ruins. While the desecration and levelling may be compensated for by the fragments' subsequent reconstruction into new assemblages, the radical divestment of their former authority creates gaps in how the parts can be understood. After the catastrophe of ruin, what psychic reinvestment will make these monuments whole again? How might their piecemeal state inflect the legacies of colonialist, imperialist or hegemonic civic culture? Symbolically broken apart and upturned, refashioned in the mismatched style of a Frankenstein monster or a cyborg crossbred by Dr Moreau, they become subject of the artists' creative and subversive restoration.

The recombination of monument fragments, the pressing of sheets of aluminium upon stone and bronze, carries uncanny affect into the realm of the phantasmagorical. Like the traditional sculptural casting of living bodies or death masks, the cinefoil hints at a presence beneath, however disintegrated and disconnected the parts. If it were the extremities that were missing, one might invoke the phantom limb anomaly, but since the sculptures are composed of stray appendages but missing the core, they evoke the complementary phenomenon of the phantom body. By jettisoning

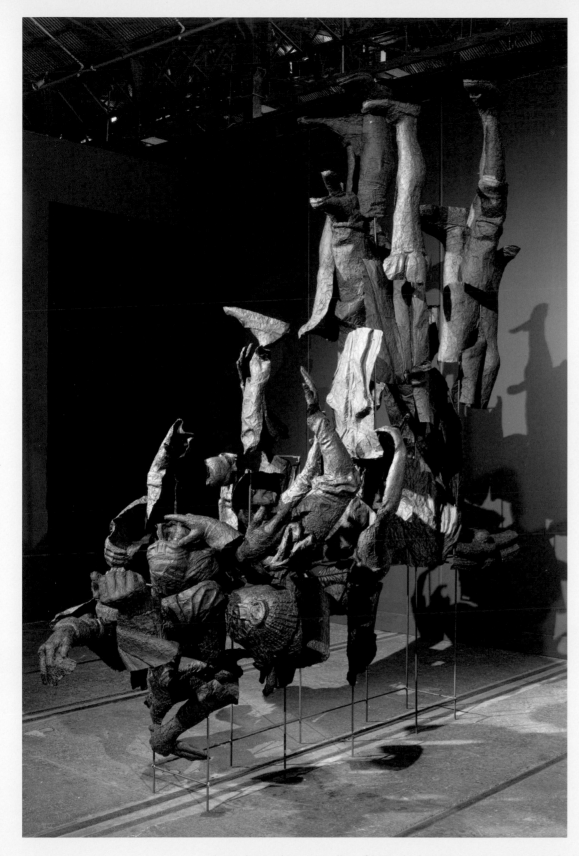

Hadley+Maxwell, *The Queen still falls to you*, 2014. cinefoil, steel, magnets, 6-channel sound, LED light-programming, dimensions variable, 20:54./ courtesy of the artists and Jessica Bradley Gallery./ photo by Ros Kavanagh.

the substantive centrality of historical monuments, reducing their solidity to ethereal entities, Hadley+Maxwell by extension dissemble and render phantasmic the corpus of power. While the reconfiguring of monuments does not advocate an erasure of imperial history, it does pose a challenge to the strength and durability of narratives of Empire. Even as the power commemorated by the monuments continues to haunt the present, these phantasmagoric sculptures surrender imperiousness to processes of re-envisioning.

jennifer fisher jim drobnick

i: fractal illusions

I, 2009, forms one component of Hadley+Maxwell's larger series *The Lemonade is Weak Like Your Soul*, 2009–2010, the title of which originates from an insult spoken in a play by German playwright, poet and philosopher Friedrich Schiller. *Intrigue and Love* (*Kabale und Liebe*, 1784) dramatized how snobbery maintained hierarchical aristocratic structures and undermined the possibility of cross-class relationships. The influence of the play on the artists' series is more associative than literal, but in the full installation, the various parts form a constellation of sculptures that approximate players on a stage. The infighting and humiliation that the play foregrounds, such as the rude comment singled out for the title, could be said to compare to the jockeying for attention and space that artworks figuratively exercise in a group exhibition.

Hadley+Maxwell, *I*, detail, 2009.
single-channel video with sound,
freestanding screen, with red,
green and blue theatre lights, 21:01,
300 x 169 cm (freestanding screen)./
in collaboration with Emma Waltraud
Howes, music by Meshuggah, "I",
from the album *I, Nuclear Blast*, 2006./
courtesy of the artists and Jessica
Bradley Gallery./ photo by Nick Vees.

For *are you experienced?*, *I* stands alone. It transposes Schiller's critical ethos onto the subculture of thrash metal. The title and video bear several links to the metal band Meshuggah, especially their cut *I*, an epic track on the album *Nuclear Blast*, 2006, whose lyrics express a nihilistic contempt for civilization.[17] Hadley+Maxwell's artistic investigation explores the gestures, music and intensity of thrash paradigms. The single channel video appears to be back-projected on a freestanding screen, but actually is an illusion created by casting red, green and blue lights upon the video image. Featured again is dancer Emma Waltraud Howes, who for this piece carefully studied the movement repertoire of head-banging fan culture. Recorded to coincide with the 21 minute song in one continuous take with no post-production editing, viewers see the silhouette and multi-hued shadows of the dancer's undulating head and torso.

Here Hadley+Maxwell's chromatically nuanced light washes recall the lightshows of stadium rock, yet are more subtly hued and less high contrast than the illumination of a typical Meshuggah concert. At moments strobe lights fracture and even obliterate the shadowy image of the dancer's body, shattering it into the phantasmagoric intensities

approximating the plays of light of a thrash metal concert. At other times a glimpse of Howes' actual hand or hair enters the screen. Interestingly, Meshuggah, a Swedish band, adopted their name from the Yiddish/Hebrew word *meshuga* which means "crazy" or "insane" — deliberately making a virtue of denigrated mental states, and by extension, the band's outsider cachet. The soundtrack of *I* reveals Meshuggah's underground musicianship as complex, technically sophisticated and distinguished by a high-speed tempo and impeccable polyrhythmic drumming. Guitarists, playing signature model custom-made 8-string instruments, combine elements of jazz with death, thrash and progressive metal. Frontman Jens Kidman overlays unrestrained, guttural, atonal vocalizations resembling those of an anti-Christ of the cinematic horror genre, an exorcism, or a shaman rousing a crowd into frenzy.

Howes' dancing initially appears to be that of the 'fan' intoxicated in movement. Yet what becomes evident in comparison with the audience at a Meshuggah concert is that the fans are so densely packed in front of the stage their only range of movement is to hold up their hands and nod their heads. Howes' movements, by contrast, are more aligned with those of the guitarists on stage whose heads drop, throwing their long hair forward and then backward in a sweeping arc. Repeatedly their tangled manes touch the floor and then are flung back (akin to the signature gesture of Canadian dancer Margie Gillis, heir to romantic expressionist choreography of Isadora Duncan, Martha Graham or even Mary Wigman). The guitarists rock together in a rhythmic back-and-forth motion energizing the crowd. Given the preoccupation with hair swinging, it is striking that lead singer Jens Kidman is completely bald. Nevertheless, his facial expression and roughly textured baritone growls stir the crowd into a convulsive excitement.

Where the pelvic thrusts of rock 'n' roll (imagine Elvis Presley) originate in the genitals and are patently sexual, the thrash metal to-and-fro head-banging begins in the forehead and causes the neck and spine to flex. This vertigo-inducing motion stimulates both the cerebrospinal fluid and pineal gland, intensifying the interoceptive perception of the inner body, and forcing energy up the spine. The rise of vitality can trigger ecstatic states. Viewing such enactments in the gallery can have similar implications. Recent accounts of neuroaesthetics have outlined how mirror neurons transmit non-linguistic knowledge in performative artworks, and that viewing an action can result in the same cognitive response as actually doing it.[18] Following this logic, beholding the motion of Howes' performance of the head-banging spinal flex impacts the same neuropathways and can potentially impel an altered state.

A question remains about the nature of the frenzied dancing: is the visitor empathizing with gestures of ecstasy or suffering? If one listens to the almost incomprehensible lyrics of Meshuggah's *I*, the overwhelming affect concerns despair, dread or deterioration. References to Armageddon, ruin and chaos convey an apocalyptic vision of eternal devastation.[19] Yet the installation's combination of the mesmerizing lights, undulating dancer, and thrash soundtrack creates an energetic buzz that is stimulating on multiple sensory registers, visually, aurally, and kinaesthetically. In some ways it does not matter whether the spectacle visitors participate in is joyful or agonizing. As Michel de Certeau remarks, "all experience that is not a cry of pleasure or pain is recuperable by the institution".[20] Whether the dancer's exertion implies happiness or discomfort, what is most important is that it is *extreme*, that it defies appropriation and instrumentalization. The altered state such gestures induce, presumably in the dancer and the band members she channels, and vicariously in the viewer through empathetic neuroaesthetics,

differentiates Hadley+Maxwell's installation from the phantasmagoria proper. Although both employ audio and visual shocks, *I* operates on a corporeal level to exaggerate the experiential jolt.

While the title *I* pays homage to the song comprising the installation's soundtrack, it also confounds the visitor's sense of being in the space. Just voicing the word "I", even internally, inaugurates personal identification. One's subjectivity becomes entwined with that of the pronoun of the title, the content of the video, and the music. Further, the multicoloured shadows that flit across the screen are not much different than those cast by the visitors as they traverse the gallery and get hit by spotlights of varying hues. The identification occurs on linguistic, visual and spatial levels as the phantasmagoric acts subtly upon and through visitors. The significance of "I" multiplies as the visitor's role gradually slides from the real to the spectral: from "I am a visitor in an art installation", to "I am a fan watching a metal concert", to "I am a band member of Meshuggah", to "I am a performer dancing in a video", to "I am a shadow being cast on the screen", to "I am a phantom in the phantasmagoric". Even though "I" is

Hadley+Maxwell, *I*, 2009.
single-channel video with sound,
freestanding screen, with red, green
and blue theatre lights, 21:01, 300 x
169 cm (freestanding screen)./ in
collaboration with Emma Waltraud
Howes, music by Meshuggah, "I",
from the album *I, Nuclear Blast*, 2006./
courtesy of the artists and Jessica
Bradley Gallery./ photo by Nick Vees.

the most concrete of pronouns whereby speakers can confirm their existence by uttering it, here the effect of *I* is one of gradual depersonalization.[21]

Walking amidst the psychedelic components, visitors lose the sense of their boundaries by being assimilated into the phantasmatic apparatus, which approximates the condition of psychaesthenia, Roger Callois' term for being unable to distinguish oneself from the environment.[22] Such confusion, combined with the depersonalizing shift in subjectivity, is where the self becomes abstract and ethereal. Meshuggah's lyrics for *I*, the phrase "fractal illusion", posits existence in a post-death state of estrangement. For Hadley+Maxwell's version of *I*, the illusion lures visitors into losing themselves at the very moment that every sensation is intensified.

Hadley+Maxwell's installations arise out of a distinctive theatricality of the senses and affect. Their stagecraft hearkens back to the origins of new media art, telescoping the phantasmagoric through a thrash metal sensibility laced with historical and artistic references. Visitors become immersed in a field of sensations whereby the illusionistic

is mapped onto altered states and the revisioning of public monuments. Yet, one's subjectivity is complicated by the fact that no singular or master viewpoint exists as would have been found in a traditional phantasmagoria. The suspension of disbelief, necessary for the functioning of the magic lantern, relied upon a distanced position from which to reflect on the otherness of the illusions. Instead, beholders become enmeshed in Hadley+Maxwell's spectacles as a mirage of sensations are being manufactured.

This perspective foregrounds a view from within the spectacle. Visitors stroll through the equipment as if they are backstage at a concert, whether during, about to occur or just concluded. While the actual proscenium is out of view, the installation is populated by apparitions—a flight attendant bisected and twinned, a head-banger multiplied into prismatic silhouettes, figurative sculptures fragmented and recomposed in monstrous assemblages. As lights sweep across the room, gallerygoers intermittently add their own shadows to the troupe of apparitions. With this deployment of the phantasmagoric, viewers become aware of the workings of the apparatus, as they observe its effects. Backstage with Hadley+Maxwell is a place of incipient possibility where technology and superstition, criticality and enchantment, co-exist.

1 See Hoptman, Laura, *Brion Gysin: Dream Machine*, New York and London: New Museum and Merrell, 2010.

2 We choose phantasmagoria specifically, rather than "gothic" or "psychedelic" that other art commentators utilize, because of the integration of technology, the senses and aesthetics. On the gothic in contemporary art, see Grunenberg, Christoph, ed, *Gothic*, Boston and Cambridge, MA: Institute for Contemporary Art and MIT Press, 1997, and Williams, Gilda, ed, *The Gothic*, London and Cambridge, MA: Whitechapel and MIT Press, 2007. For the psychedelic in art, see Johnson, Ken, *Are You Experienced: How Psychedelic Consciousness Transformed Modern Art*, New York: Prestel, 2011, Schimmel, Paul, et al, *Ecstasy: In and About Altered States*, Los Angeles and Cambridge: Museum of Contemporary Art and MIT Press, 2005, and Perpère, Antoine, *Sous Influences: Artistes et Psychotropes*, Paris: Maison Rouge, 2013.

3 See Gunning, Tom, "Illusions Past and Future: The Phantasmagoria and Its Specters", accessed 13 July 2007, Mediaarthistory.org. http://www.mediaarthistory.org/refresh/Programmatic%20key%20texts/pdfs/Gunning.pdf.

4 Duncan, Carol, *Civilizing Rituals: Inside Public Art Museums*, New York and London: Routledge, 1995.

5 The cultural role of flight attendants involves a set of stark contrasts: the mostly female workers are often typified, commodified and exploited bodies, yet accomplished one of the early successful victories in 'workplace' feminism. See Barry, Kathleen M, "'Too Glamorous to Be Considered Workers': Flight Attendants and Pink-Collar Activism in Mid-Twentieth-Century America", *Labor: Studies in Working-Class History of the Americas*, 3(3), 2006, pp 119–138.

6 Schechner, Richard, *Between Theatre and Anthropology*, Philadelphia: University of Pennsylvania Press, 1985.

7 The specifics of Hadley+Maxwell's cinefoil installation for *are you experienced?* were not yet available at the time of this writing, so we have chosen to write about earlier, but similar, works. For *are you experienced?*, the artists' work, *When That was This*, 2015, responds to the tragic experience of the First World War by incorporating limbs and faces drawn from monuments in Toronto, Dublin and Sydney. Emails from the artists, 7 and 30 January 2015.

8 Buck-Morss, Susan, "The Flâneur, the Sandwichman and the Whore: The Politics of Loitering", *New German Critique*, 39, 1986, p 100.

9 Kosofsky Sedgwick, Eve, "Texture and Affect", *Touching Feeling: Affect, Pedagogy, Performativity,* Durham and London: Duke University Press, 2003, pp 13–22.

10 Taking into account the importance of music in the work of Hadley+Maxwell, one might consider their sculptural recombinations a kind of 'remix' that uses pre-existing forms to make a new statement. A number of their assemblages include cinefoil pressings of disparate monuments from around the world.

11 *Graces and Exemplars*, 2013, deploys the armature like a clothesline, upon which collected forms are organized taxonomically.

12 For more on the curatorial aspect of the artists' practice, see Reed, Patricia, "Hadley+ Maxwell", *Art Papers,* November 2009, p 58.

13 The installation also contained other freestanding figures such as "Folly", along with inverted versions of "Atlas" and "Caryatid". The upending of the latter two, who are normally used as load-bearing architectural elements, defeated their ability to hold up the heavens or any other weight, thus upsetting the conventional allegorical attributes of heroism and grace conferred by former ideological regimes.

14 While the 'exploded' aspect present in Hadley+Maxwell's fragmented and assembled versions of monuments recalls progressive overturning of dictatorial regimes, such as the destruction of Saddam Hussein's statue in Baghdad in 2003, it also references acts of terror and vandalism unleashed upon public sculptures, such as the bombing of Rodin's *The Thinker* outside of the Cleveland Museum of Art in 1970.

15 Twins, twinning, and duality run throughout the works of Hadley+Maxwell, no doubt as a trope of their own collaborative practice. In the case of the sculptures, it is interesting to note the role of the magnets, and their force of attraction, which enables the connection of separate parts (the + in their artistic moniker performs like a magnet, holding together the artists' creative egos).

16 For an examination of the body fragment in modern art, see Elsen, Albert E, *The Partial Figure in Modern Sculpture From Rodin to 1969*, Baltimore: The Baltimore Museum of Art, 1969.

17 Meshuggah's *I* was released as an EP by Fractured Transmitter Records in 2004, and debuted on the *Billboard* 200 chart in June 2005 at number 170.

18 See McKay, Sally, *Repositioning Neuroaesthetics Through Contemporary Art*, PhD Dissertation, Department of Art History and Visual Culture, Toronto: York University, 2013.

19 The lyrics are difficult to discern from the music itself and thus we relied on the posted text of the song at http://www.darklyrics.com/lyrics/meshuggah/i.html#1 (accessed 15 January 2015).

20 de Certeau, Michel, *The Practice of Everyday Life*, Steve Rendall, trans, Berkeley: University of California Press, 1984, p 149.

21 We could also call this process, after Deleuze and Guattari, *becoming-phantasmic*. Interestingly, there are individuals on- and back-stage who are present and invisible, somewhat like phantoms—ie, roadies. They conduct their work in full view of the audience, yet are for the most part ignored. Hadley+Maxwell nodded to this phenomenon with their endurance performance *Smells Like Spirit*, 2010/2012, where the roadies to a non-existent Nirvana concert are given primacy.

22 Callois, Roger, "Mimicry and Legendary Psychaesthenia", *October*, 31, 1984, pp 16–32.

hadley+maxwell

are you experienced?

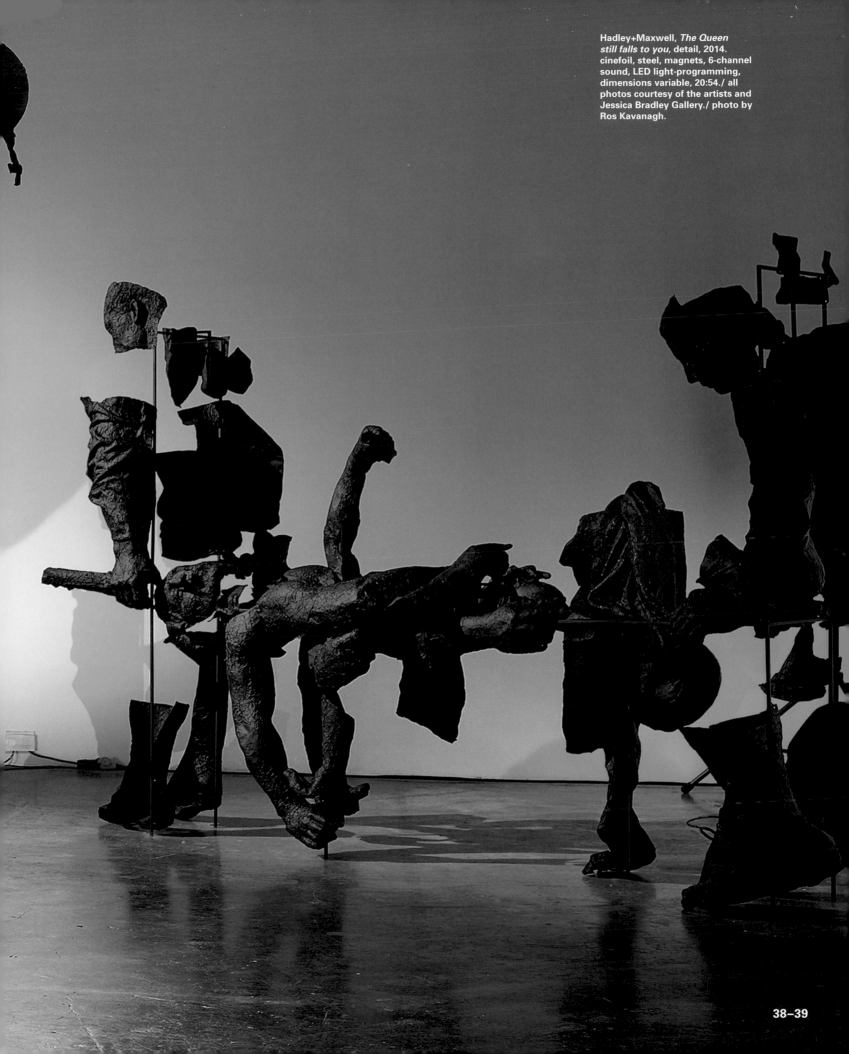

Hadley+Maxwell, *The Queen still falls to you*, detail, 2014. cinefoil, steel, magnets, 6-channel sound, LED light-programming, dimensions variable, 20:54./ all photos courtesy of the artists and Jessica Bradley Gallery./ photo by Ros Kavanagh.

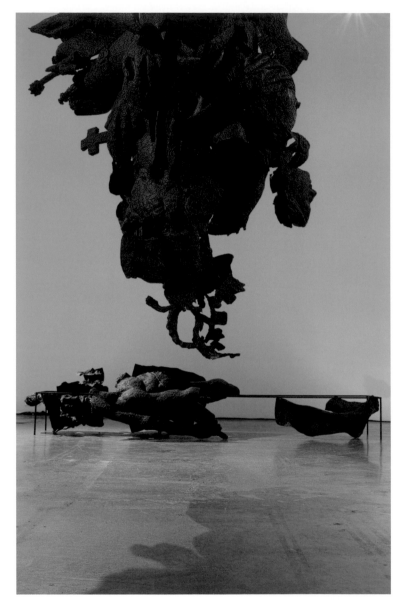

are you experienced?

The Queen still falls to you,
details, 2014.
photos by Ros Kavanagh.

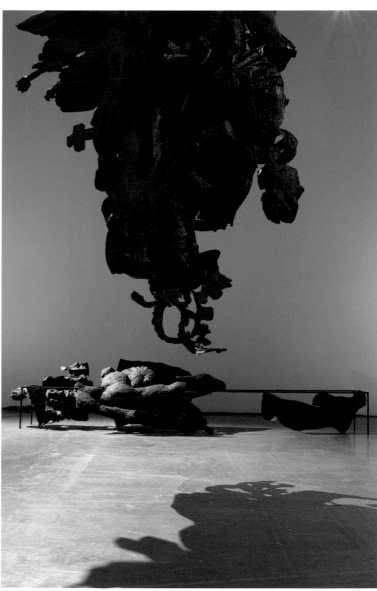

The Queen still falls to you,
details, 2014.
photos by Ros Kavanagh.

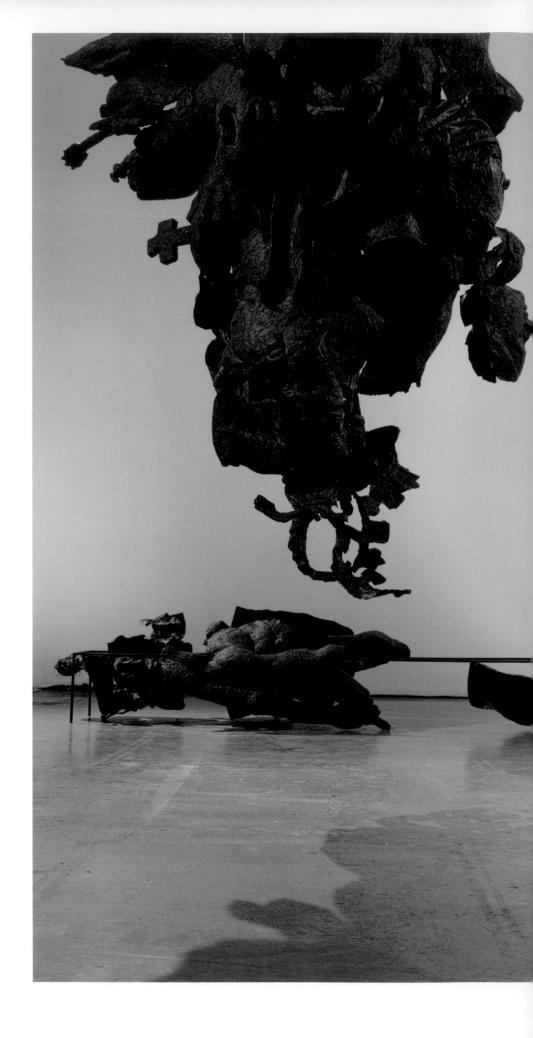

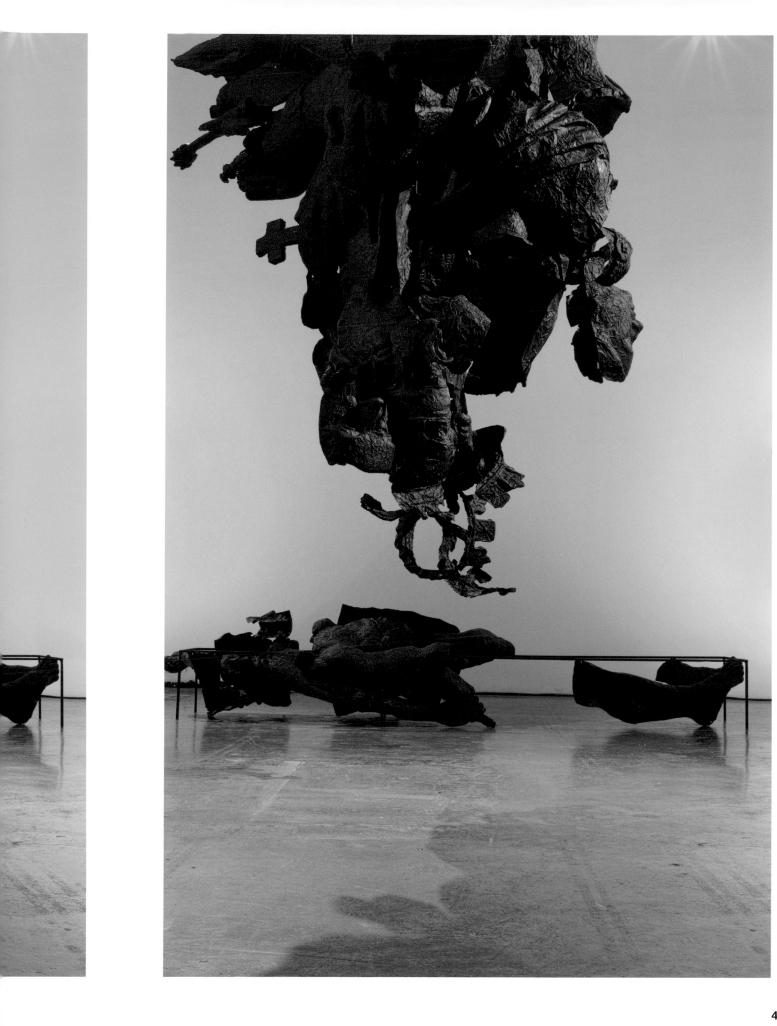

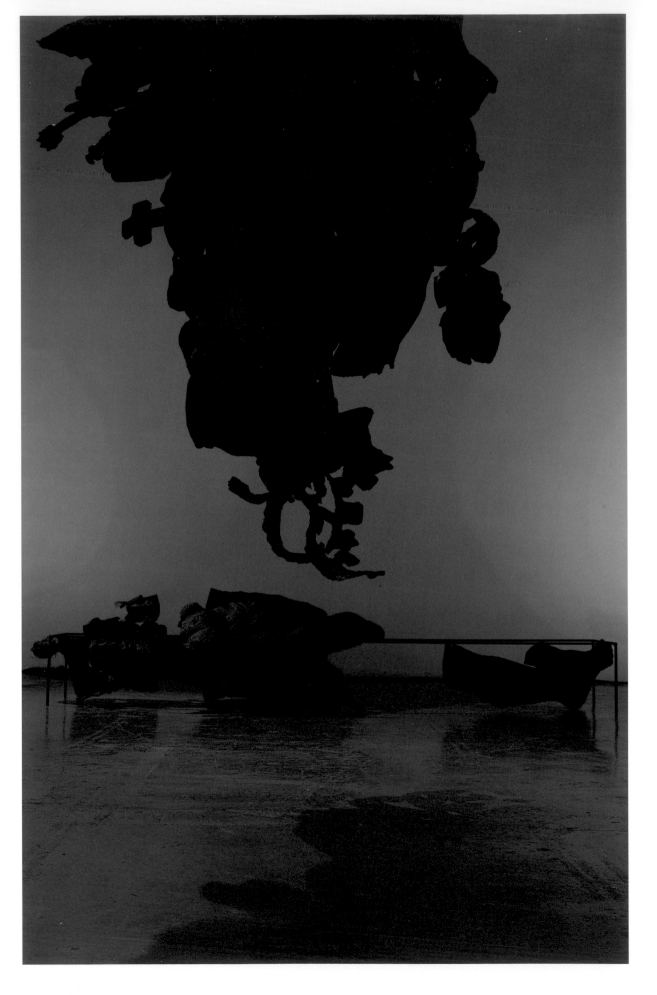

are you experienced?

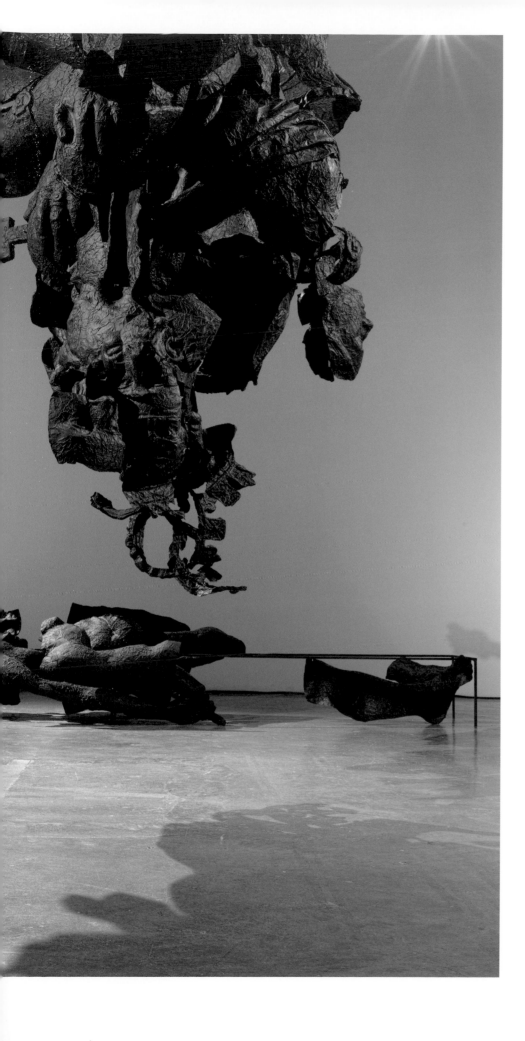

The Queen still falls to you,
details, 2014.
photos by Ros Kavanagh.

44–45

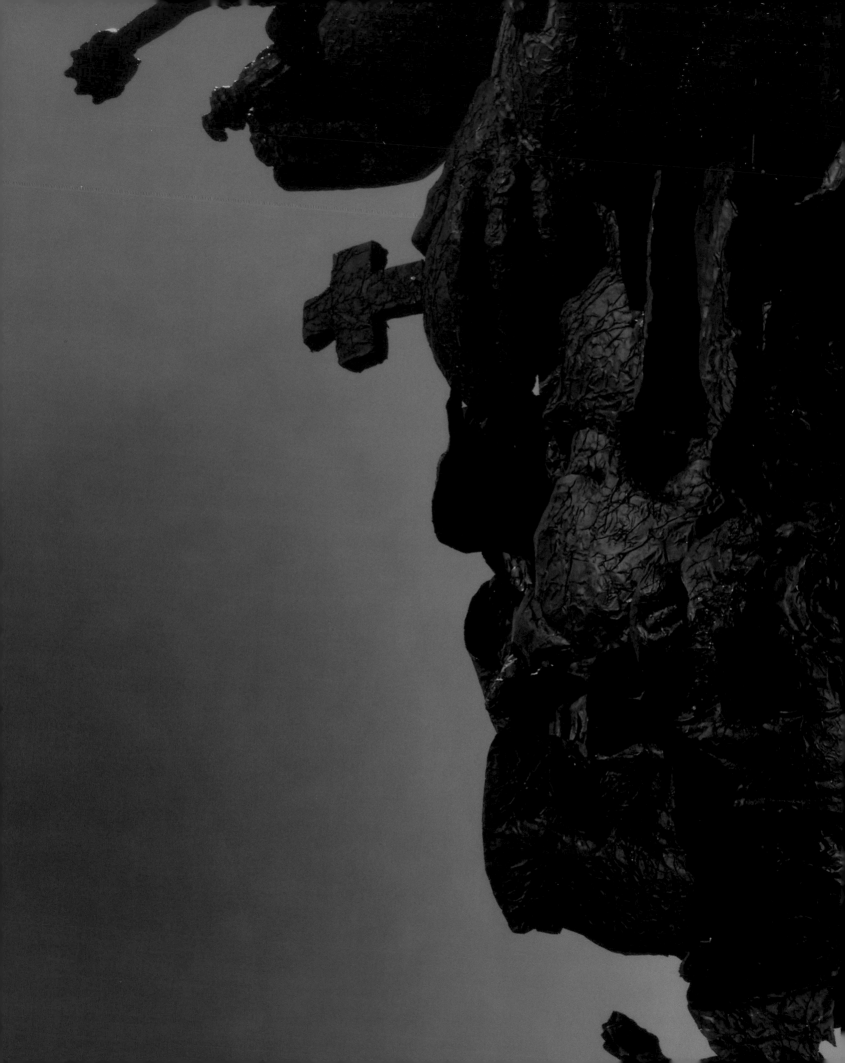

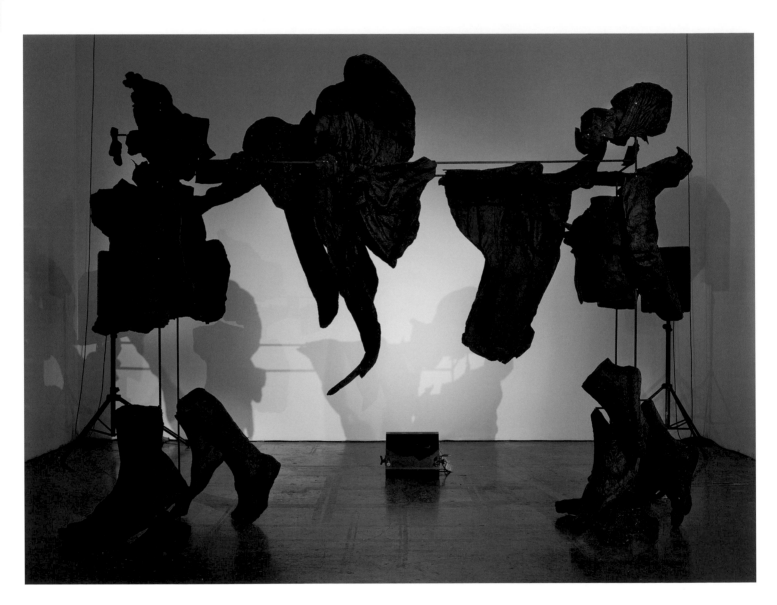

are you experienced?

The Queen still falls to you,
details, 2014.
photos by Ros Kavanagh.

48–49

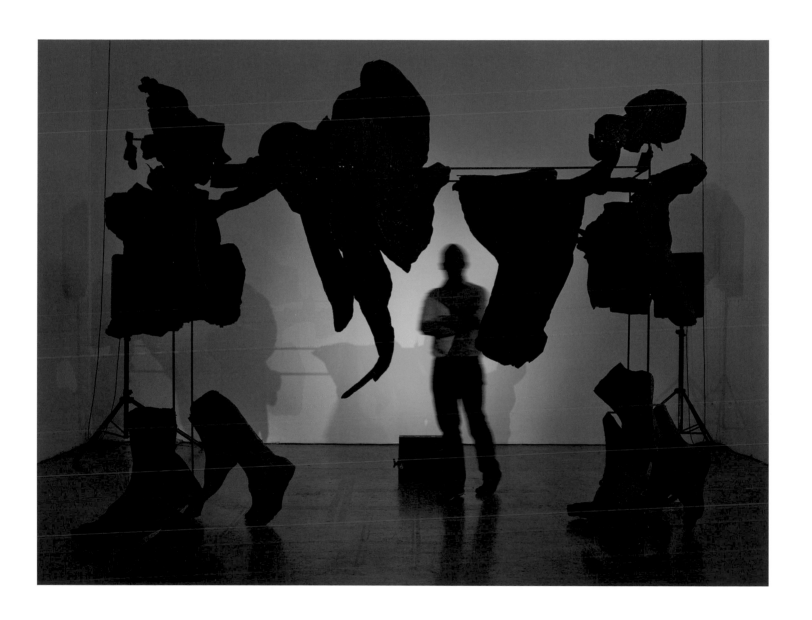

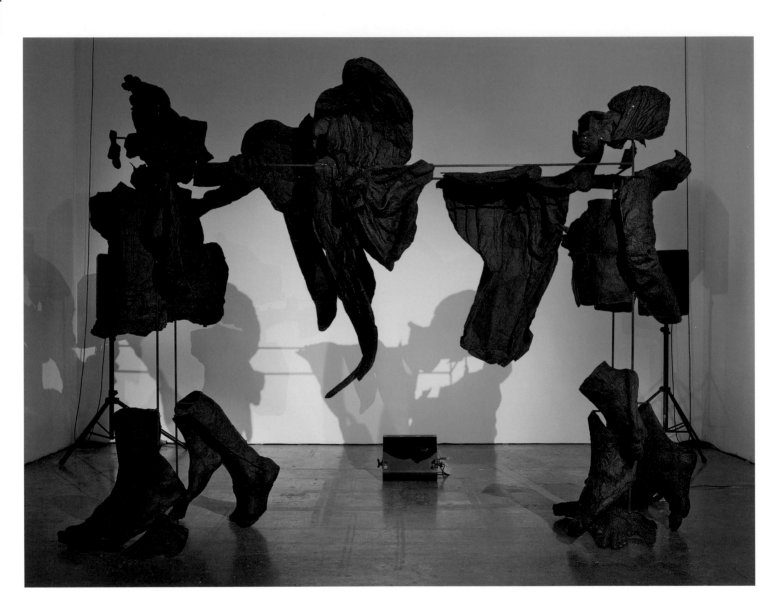

The Queen still falls to you,
details, 2014.
photos by Ros Kavanagh.

50–51

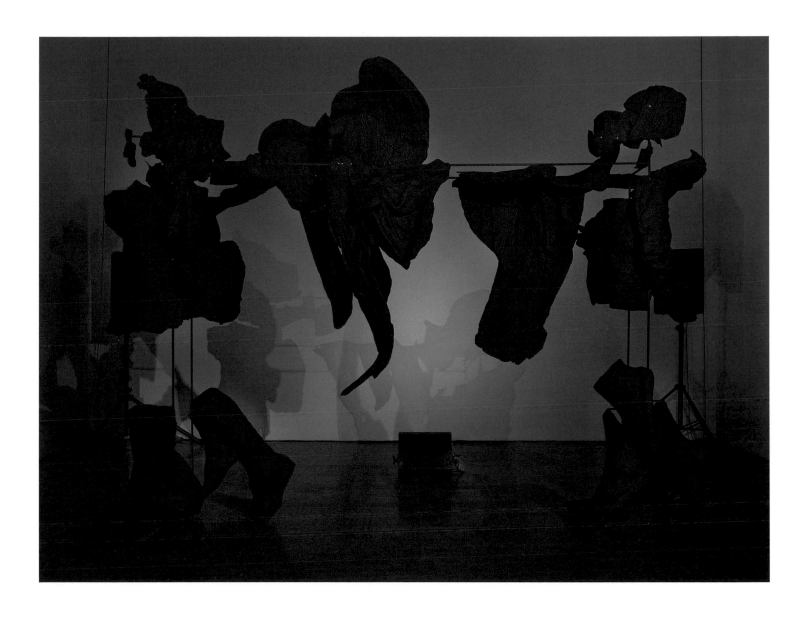

hadley+maxwell

are you experienced?

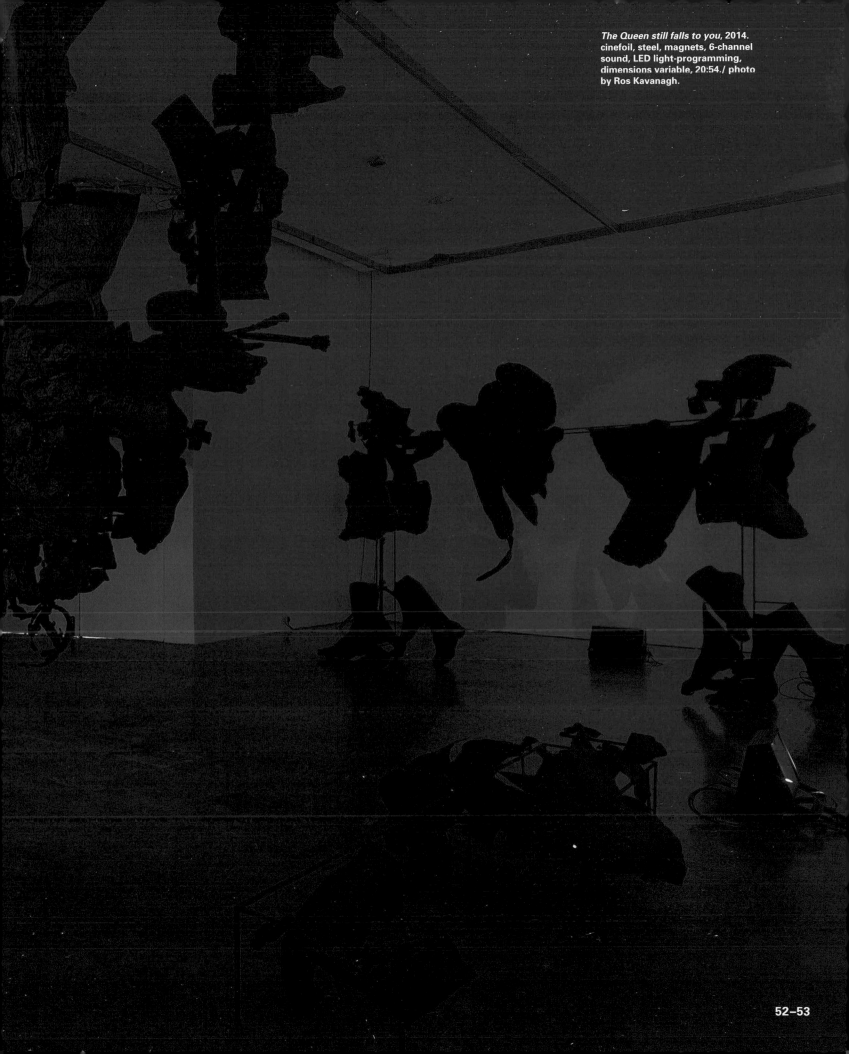

The Queen still falls to you, 2014.
cinefoil, steel, magnets, 6-channel
sound, LED light-programming,
dimensions variable, 20:54./ photo
by Ros Kavanagh.

below/opposite *I*, 2009.
single-channel video with sound,
freestanding screen, with red,
green and blue theatre lights, 21:01,
300 x 169 cm (freestanding screen)./
in collaboration with Emma Waltraud
Howes, music by Meshuggah, "I",
from the album *I, Nuclear Blast*,
2006./ photos by Nick Vees.

hadley+maxwell

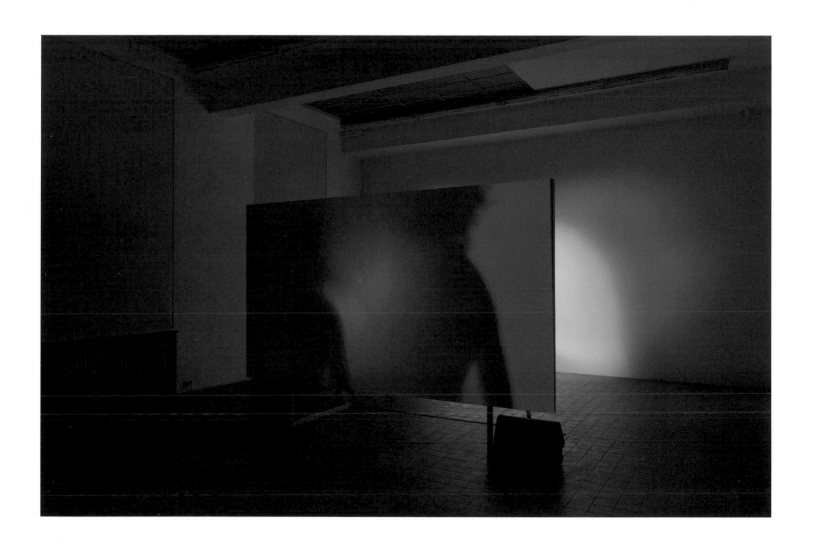

are you experienced?

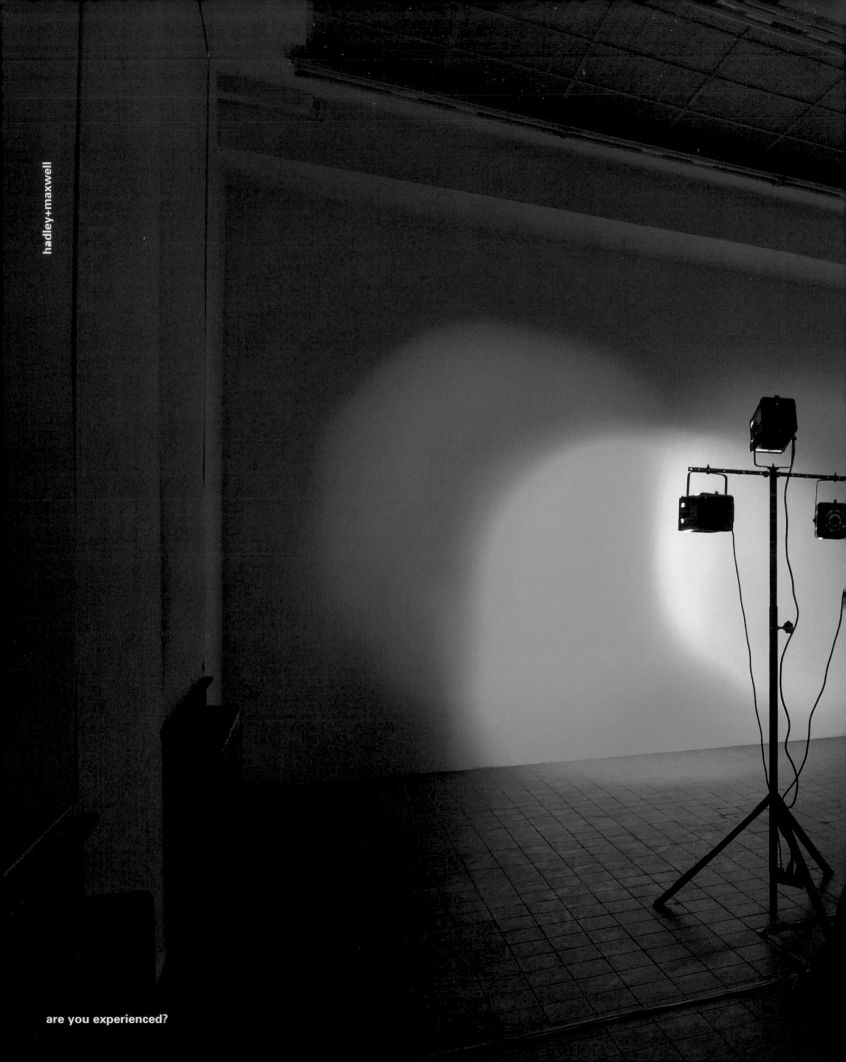

hadley+maxwell

are you experienced?

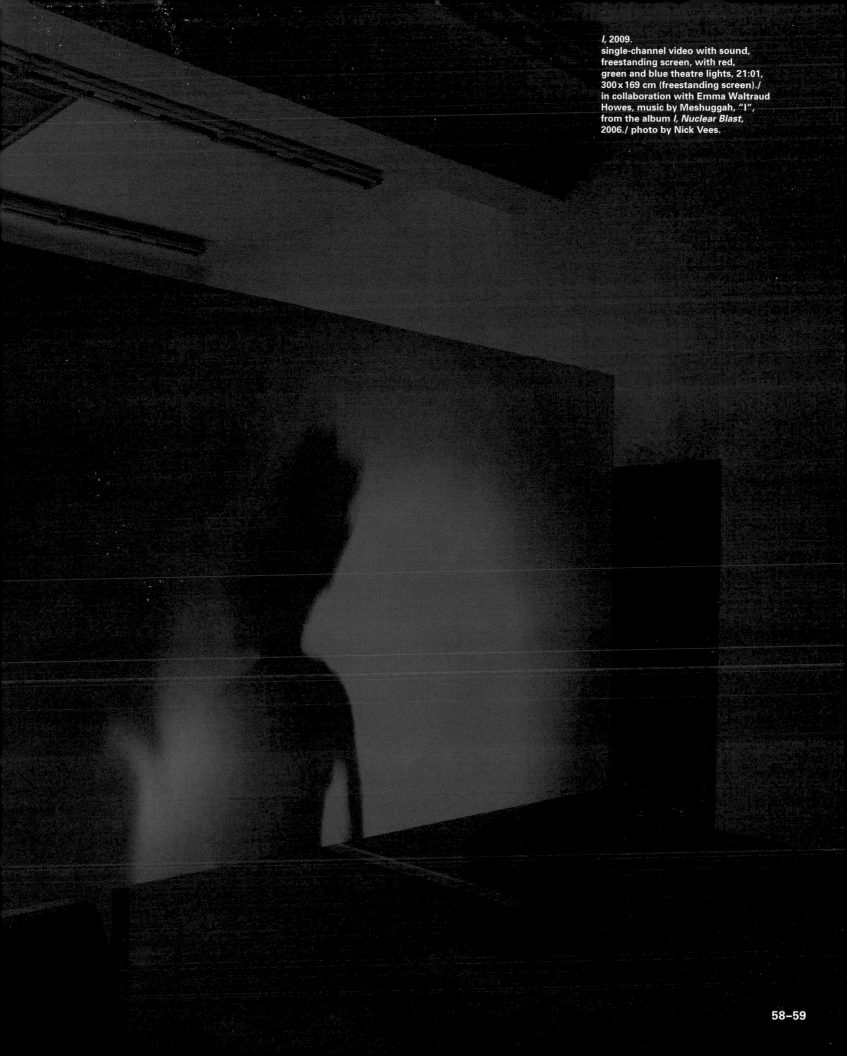

I, 2009.
single-channel video with sound,
freestanding screen, with red,
green and blue theatre lights, 21:01,
300 x 169 cm (freestanding screen)./
in collaboration with Emma Waltraud
Howes, music by Meshuggah, "I",
from the album _I, Nuclear Blast_,
2006./ photo by Nick Vees.

hadley+maxwell

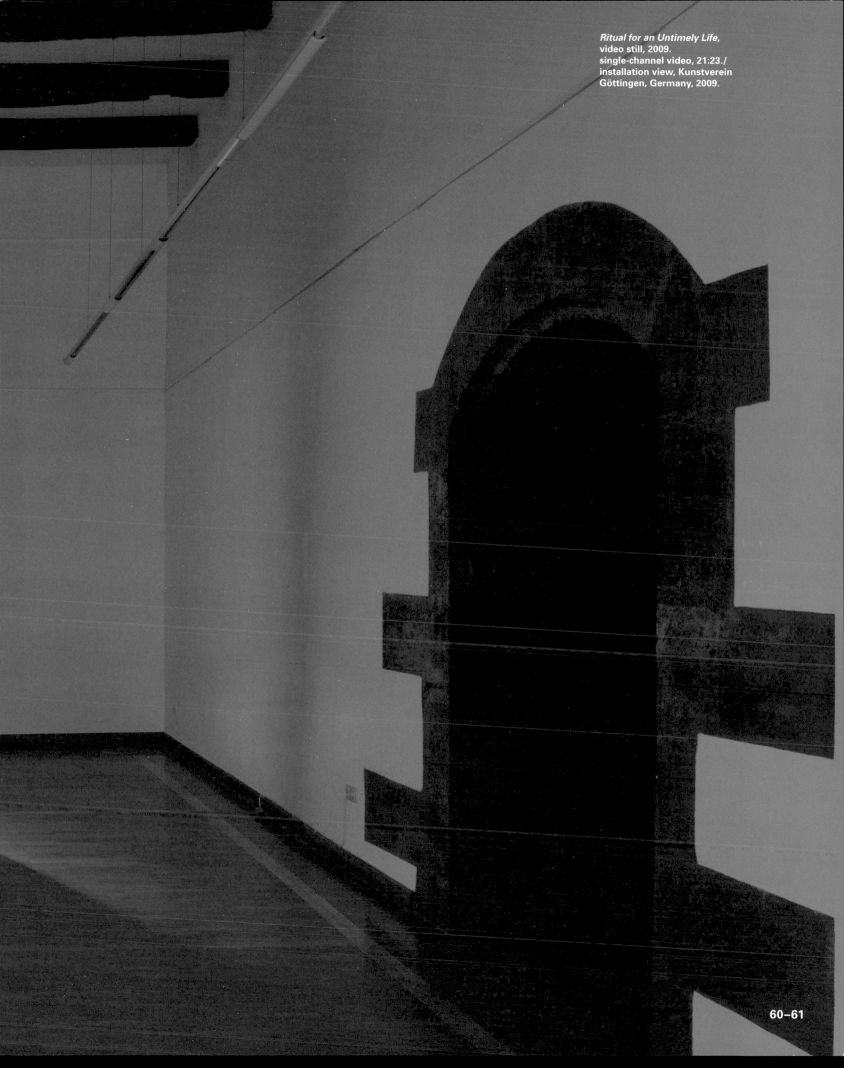

Ritual for an Untimely Life,
video still, 2009.
single-channel video, 21:23./
installation view, Kunstverein
Göttingen, Germany, 2009.

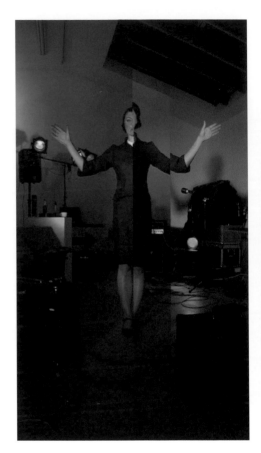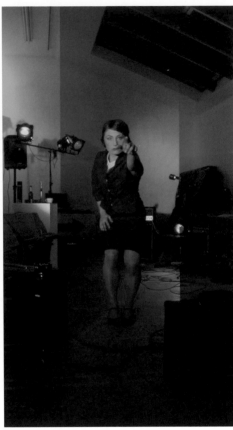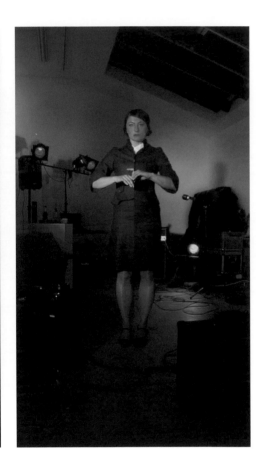

are you experienced?

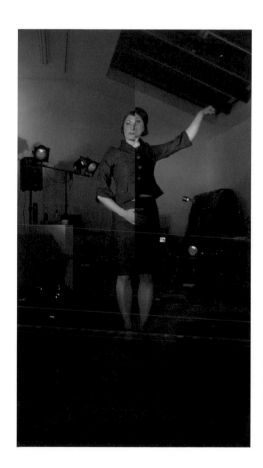
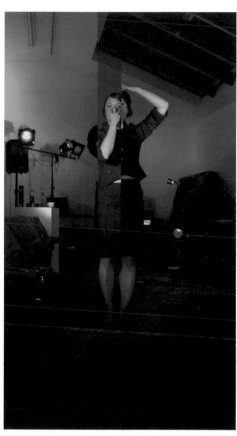
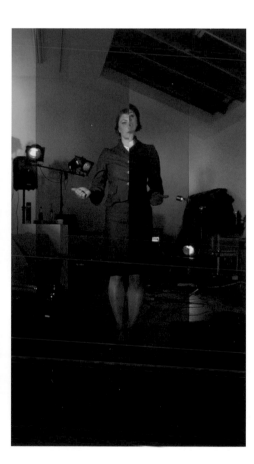

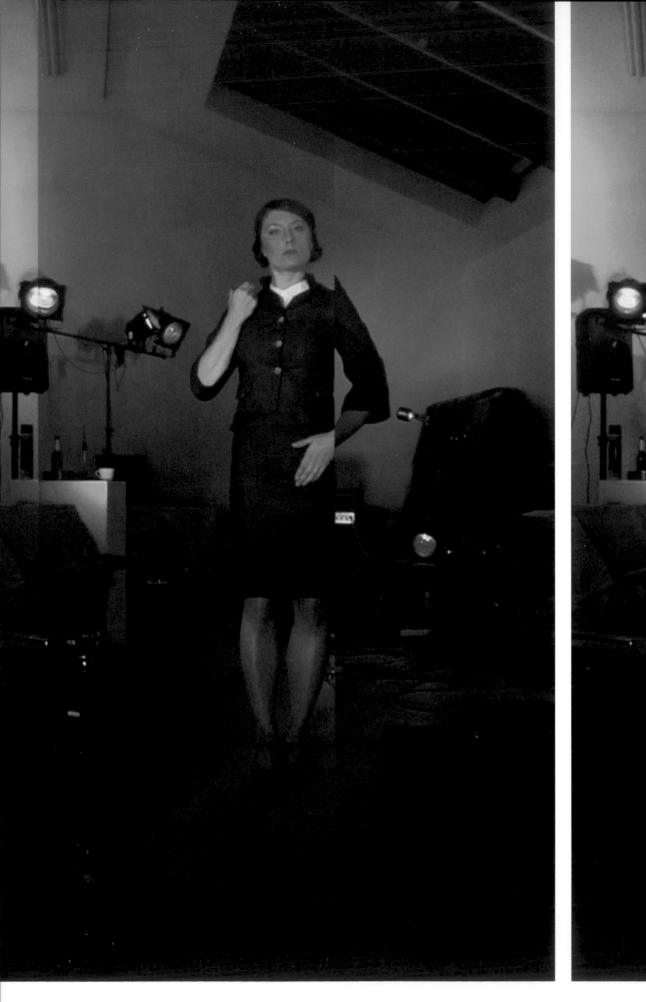

are you experienced?

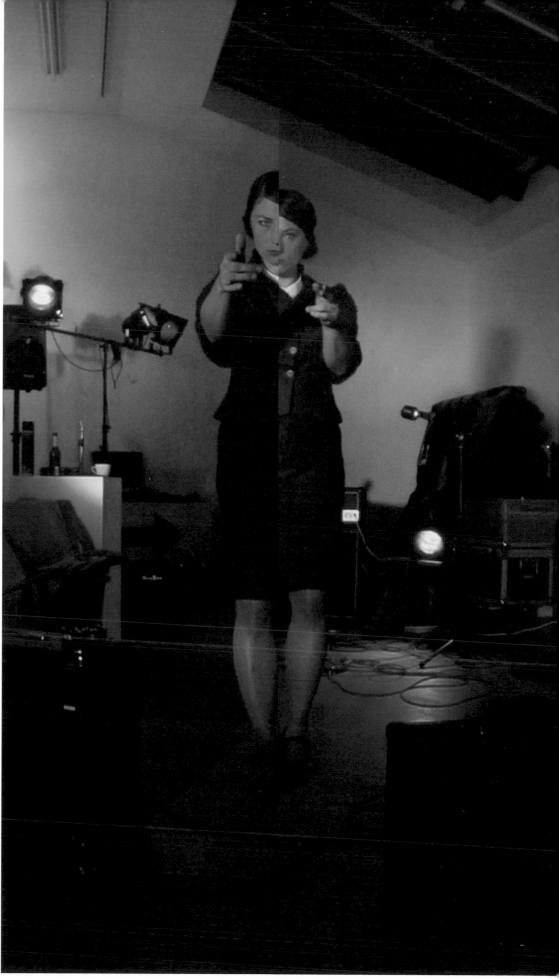

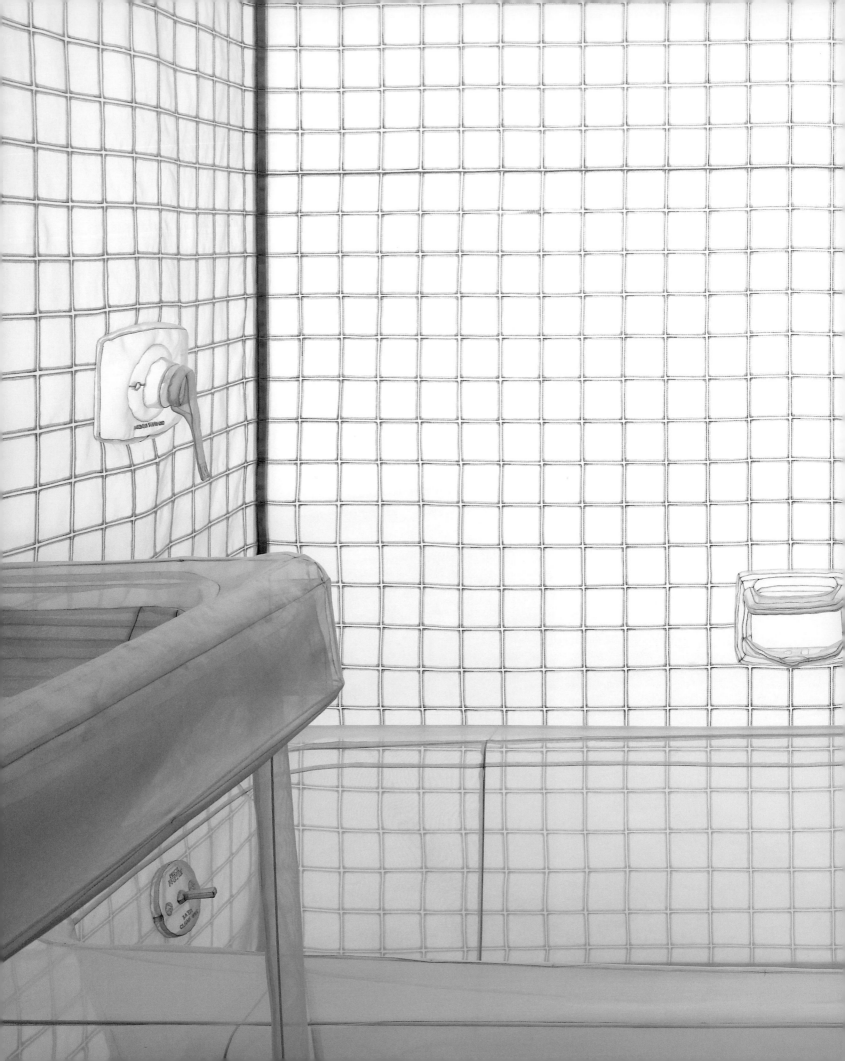

the likeness of home: do ho suh

melissa bennett

PRICE PFISTER

are you experienced?

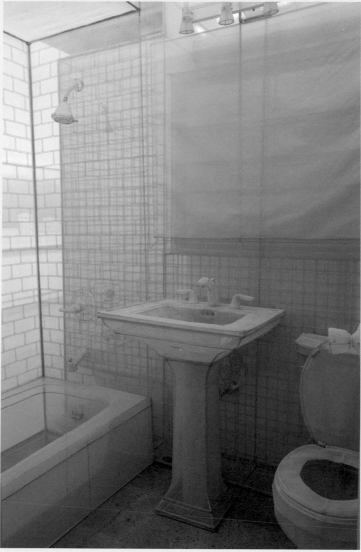

Do Ho Suh, *Apartment A, Unit 2, corridor and staircase, 348 West 22nd Street, New York, NY 10011, USA*, detail, 2011–2014. polyester fabric, stainless steel, 3230 x 430 x 245 cm (Apartment A), 1073 x 580 x 244 cm (Unit 2), 1240 x 168 x 245 cm (corridor and staircase)./ installation view, *Do Ho Suh*, The Contemporary Austin—Jones Center, Austin, 2014./ © Do Ho Suh, courtesy of the artist and Lehmann Maupin Gallery, New York and Hong Kong./ photo by Brian Fitzsimmons.

do Ho Suh was born in Seoul, South Korea, in 1962. He moved from Seoul to New York City in 1991 to study art and now spends time living in New York City, London and Seoul. Place and identity are pervasive themes in his works. Whether he is making three-dimensional fabric sculptures of his former residences, or working on drawings that trace the details of his home's surfaces, he reflects on the concepts of belonging and displacement through the creation of uncanny facsimiles.

Growing up in Seoul, space was at a premium; the same is true for New York apartments. Suh described that his move to New York, "was my first major separation from my family and my country, Korea. My coming to America was both symbolic and dramatic. As a student, I moved every year to find a cheaper place to live. The moving experience was really disorienting and that's when I started thinking about space in a more general sense. In America, the dimensions of a personal space are very different from those in Korea."[1]

are you experienced? includes a 1:1 scale model of the bathroom in Suh's former New York apartment. The piece is made of a light blue translucent polyester supported by tiny structural rods. Titled *348 West 22nd Street, Apartment A, New York, NY 10011 (Bathroom)*, 2003, its moniker refers to the street address. Suh recalls the bathroom in a comprehensive and exhaustive way; he recreated the four walls and floor, and the forms within the room include a detailed light switch, toilet with handle, a sink, a door and knob, and a bathtub. His efforts to duplicate and memorialize the minutiae of that space convey his desire to grasp it; and perhaps to understand his life at the time.

A home's bathroom is a highly intimate and private space. Though this is Suh's rendition of his own bathroom, it is nevertheless recognizable. As familiar as this type of room may be, as a sculptural form it is disorienting, severed from the other rooms to which it would normally be adjacent. Its presentation in a museum context certainly reinforces this. Viewing the work within the gallery, the sculptural bathroom is monumental but also strange: a characterization of a room that is estranged from its home. Further, it is a space you cannot enter, and in its role as a museum piece it is not to be touched or interacted with. Presented to the viewer on a low platform, Suh suggests a divide between public and private space, and between spectatorship and intimacy.

Do Ho Suh, *Seoul Home/Seoul Home/ Kanazawa Home*, 2002–2012. silk, stainless steel, 1457×717×391 cm./ installation view, *Do Ho Suh Perfect Home*, 21st Century Museum of Contemporary Art, Kanazawa, 23 November 2012–17 March 2013./ © Do Ho Suh, courtesy of the artist and Lehmann Maupin Gallery, New York and Hong Kong./ photo by Taegsu Jeon.

Suh's interests also lie in transience and globalization. In 1999, he recreated his entire childhood home at full scale in a ghostly green silk, originally titled *Seoul Home,* 1999. When exhibited it hangs floating in the air, compounding its otherworldly and uncanny qualities. It is held up by thin steel tubes and its interior space is empty. His bathroom piece, like all his apartment works, is made of industrial polyester held up by small rods, and each form within it, whether the outline of the toilet or sink, also uses small rods to hold up and shape the fabric into dimensional form.

On the contrasting effects of these two materials used for the Korean house and his New York bathroom, curator Paco Barragán has written, "if [in the apartment piece] even the most minimum feature has been recreated with the most admirable attention to detail, then there the house has a phantasmagoric aspect; if here the material used reminds us of a system of chain production, there the silk brings about a remission of a craftsmanship society; if here we are firmly anchored in the present, there we can float in the past; if here we speak of nomadism, of being separated from one's roots,

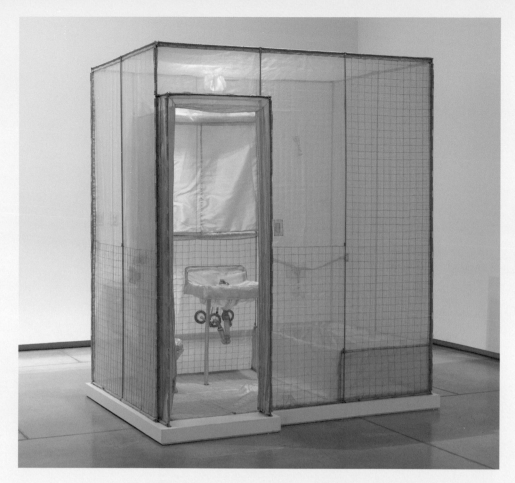

Do Ho Suh, *348 West 22nd Street, Apartment A, New York, NY 10011 (Bathroom)*, 2003. polyester, steel framework, 245 x 211 x 154 cm./ Art Gallery of Ontario, gift of Jay Smith and Laura Rapp and Gilles and Julia Ouellette, 2008, 2008/271./ © Do Ho Suh, courtesy of the artist and Art Gallery of Ontario./ photo by Sean Weaver.

of dislocation, nostalgia, survival, there we can speak of security, identity, family, relations, experience, tradition."[2]

To reinforce the theme of nomadism, the title of Suh's larger house works grow upon each exhibition. For example, when he showed *Seoul Home* for the first time in Los Angeles, its title became *Seoul Home/LA Home*; the title has since evolved to become *Seoul Home/LA Home/New York Home/Baltimore Home/London Home/Seattle Home*, 1999. In fact he was originally drawn to the use of polyester because it can be easily packed; the first time he showed a fabric sculptural work he transported it himself in a suitcase—another gesture to his peripatetic life.

The bathroom piece is a remarkable iteration of Suh's close emotional ties to architectural space, while the translucency of the pliable fabric suggests ephemerality. As curator Bruce Grenville has written of the bathroom, "its presence is marked by a doubling, a repetition, an uncanny presence that links home and away through dread and desire".[3]

If the bathroom work does expound on the emotions of dread and desire when thinking about home and away, and if as Barragán has stated, the piece evokes "dislocation, nostalgia and survival" then Suh's practice is a therapeutic one. The bathroom is a site of personal vulnerability; in *are you experienced?* it serves as a simple yet immanent symbol.

1 Suh, Do Ho, interview by Priya Malhorta, "Space is a Metaphor for History", Tema Celeste 83/2001, 2001, pp 52–55, quoted in Barragán, Paco, "I am the space where I am", Madrid: Galleria Soledad Lorenzo, Lorraine Kerslake trans, 2004, accessed 15 December 2014. http://www.lehmannmaupin.com/artists/do-ho-suh/press/210

2 Barragán, "I am the space where I am", 2004.

3 Grenville, Bruce, "Home and Away: Crossing Cultures on the Pacific Rim", *Home and Away: Crossing Cultures on the Pacific Rim*, Deanna Ferguson ed, Vancouver: Vancouver Art Gallery, 2003.

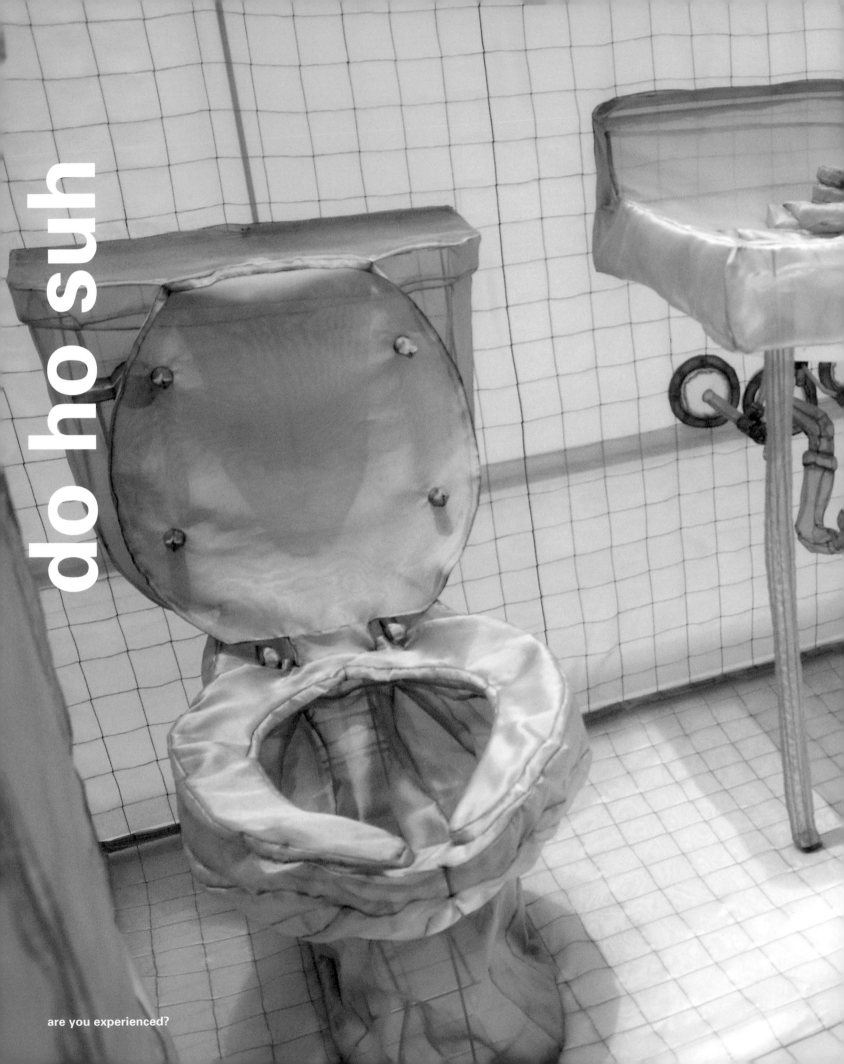

do ho suh

are you experienced?

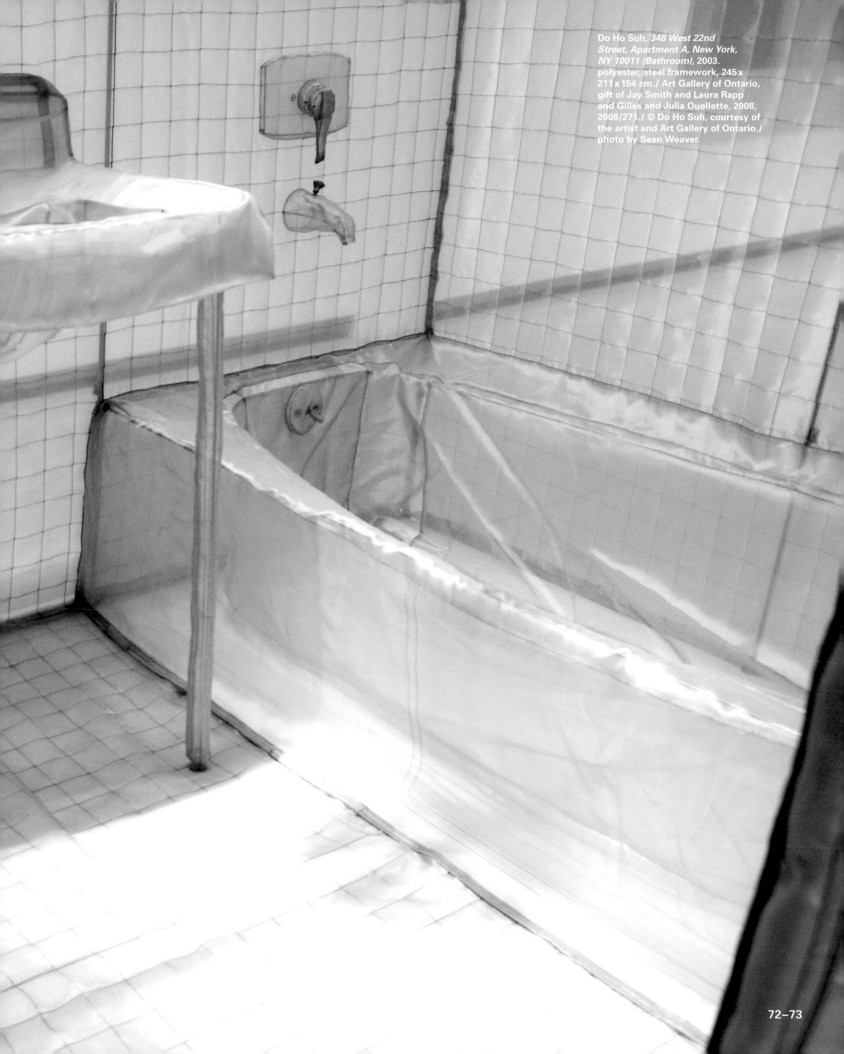

below/opposite *348 West 22nd Street, Apartment A, New York, NY 10011 (Bathroom)*, 2003. polyester, steel framework, 245 x 211 x 154 cm./ Art Gallery of Ontario, gift of Jay Smith and Laura Rapp and Gilles and Julia Ouellette, 2008, 2008/271./ © Do Ho Suh, courtesy of the artist and Art Gallery of Ontario./ photos by Sean Weaver.

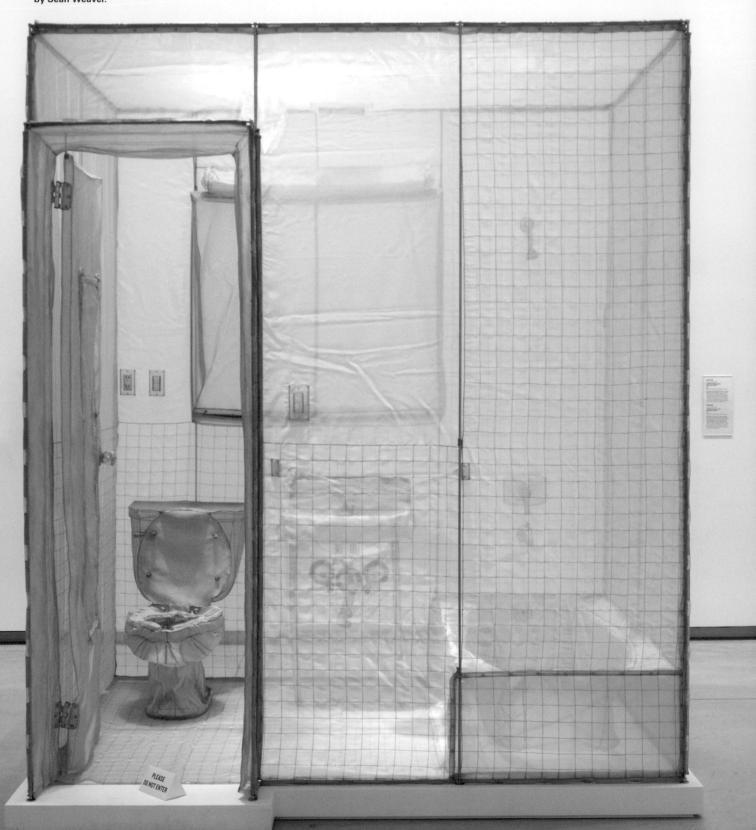

PLEASE
DO NOT ENTER

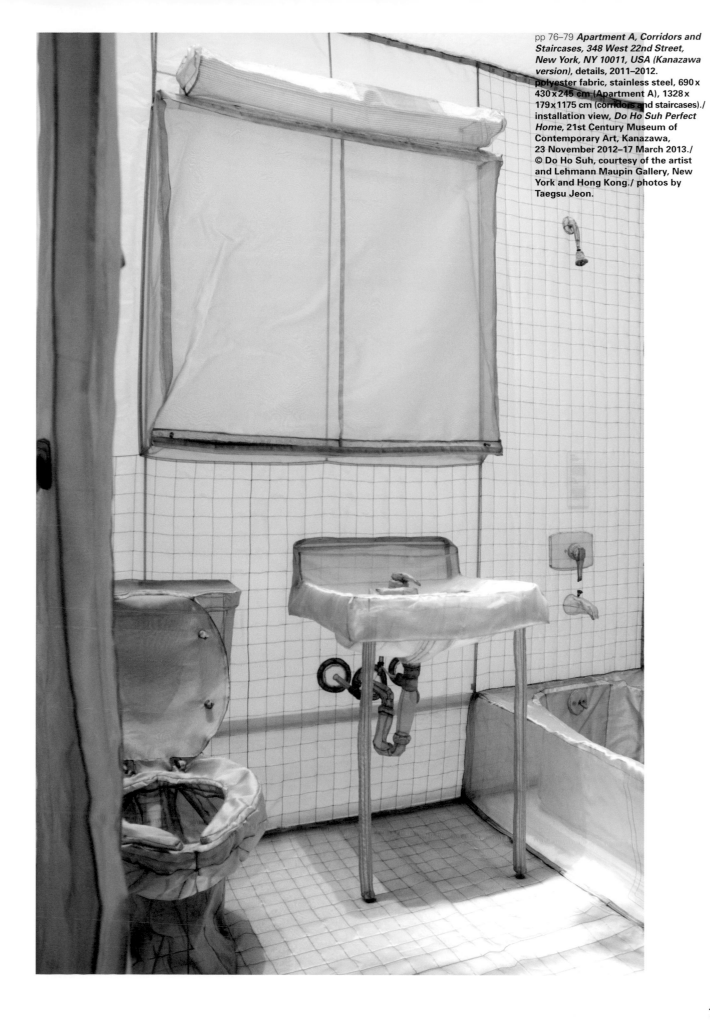

pp 76–79 *Apartment A, Corridors and Staircases, 348 West 22nd Street, New York, NY 10011, USA (Kanazawa version)*, details, 2011–2012. polyester fabric, stainless steel, 690 x 430 x 245 cm (Apartment A), 1328 x 179 x 1175 cm (corridors and staircases)./ installation view, *Do Ho Suh Perfect Home*, 21st Century Museum of Contemporary Art, Kanazawa, 23 November 2012–17 March 2013./ © Do Ho Suh, courtesy of the artist and Lehmann Maupin Gallery, New York and Hong Kong./ photos by Taegsu Jeon.

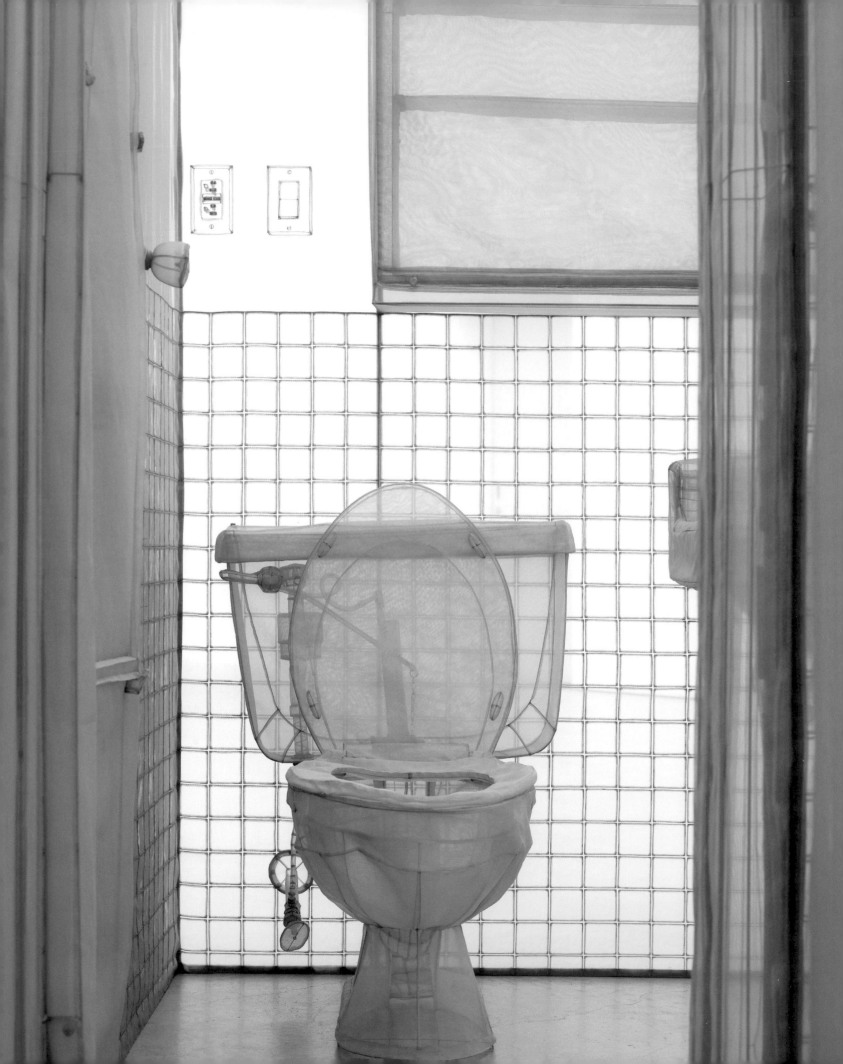

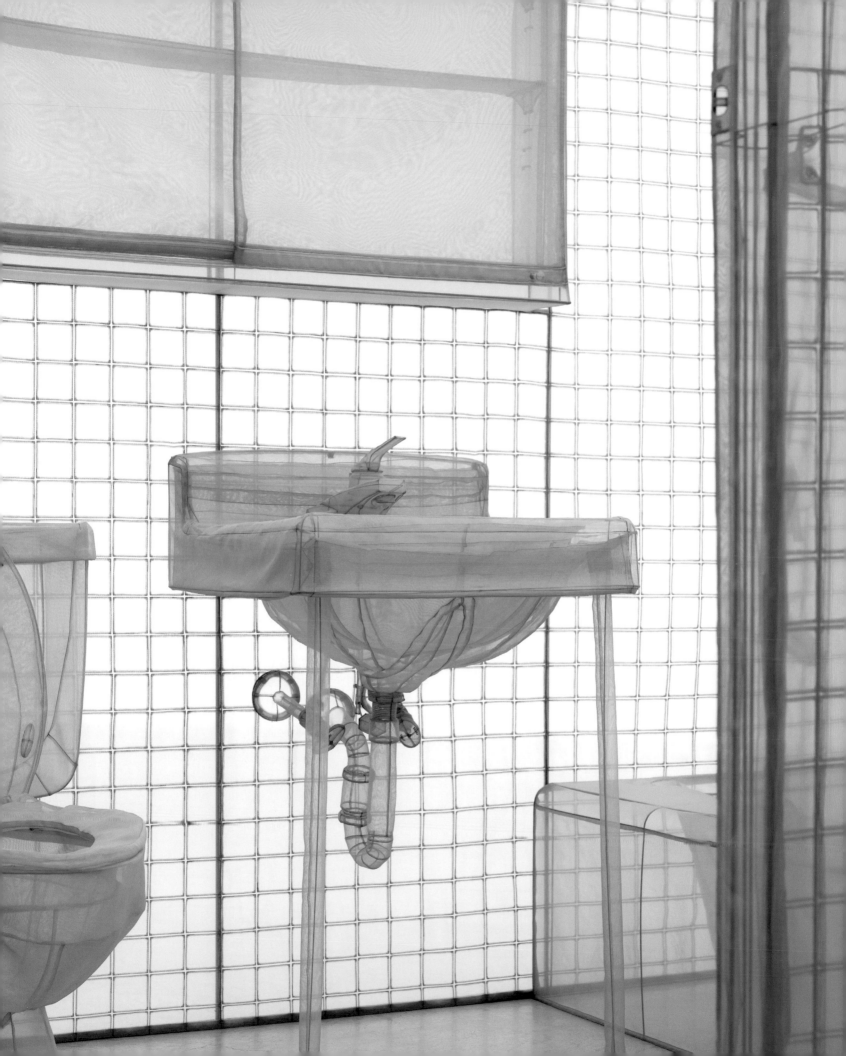

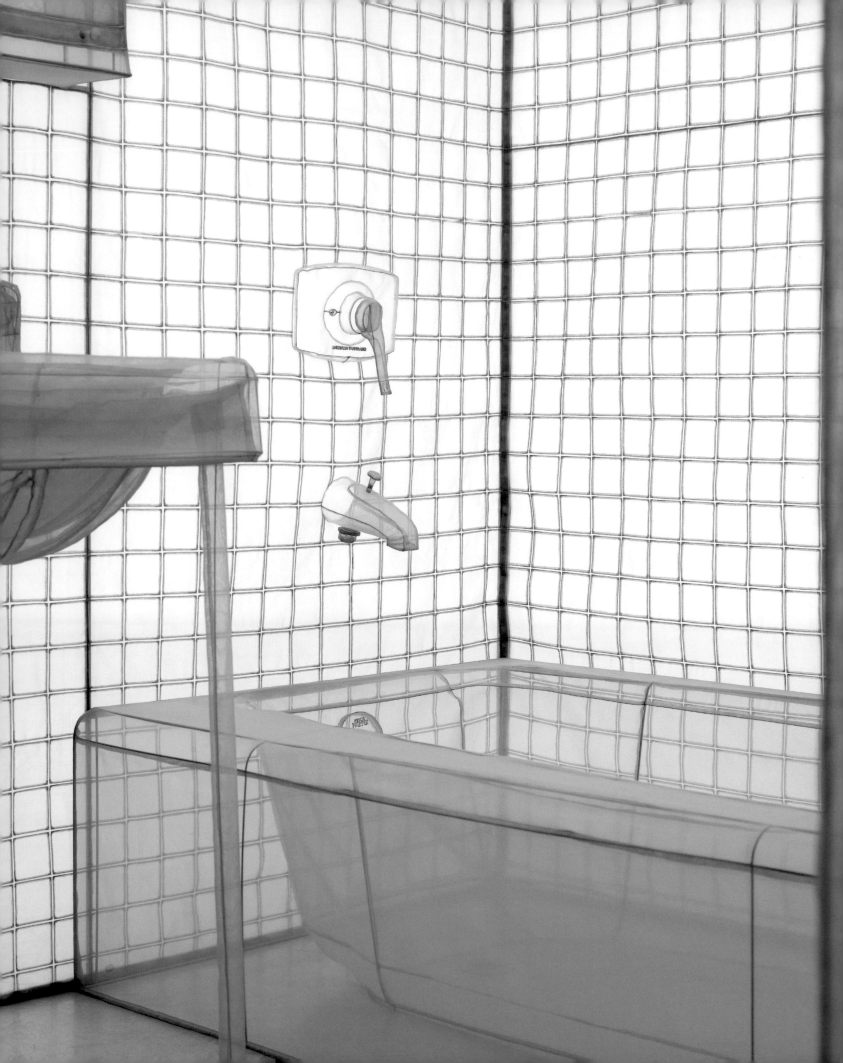

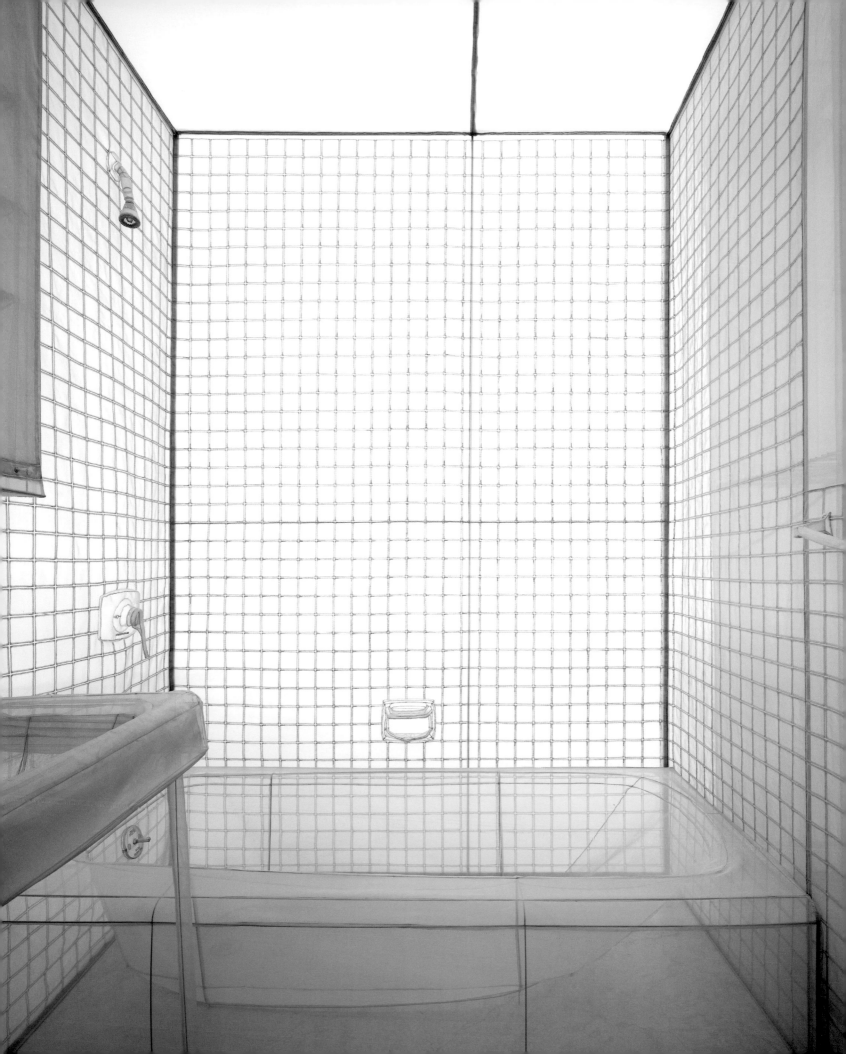

*Rubbing/Loving Project: Stove 1,
Apartment A, 348 West 22nd Street,
New York, NY 10011, USA,* 2014.
coloured pencil on vellum pinned
on board, 55.2 x 52.7 cm (paper)./ all
works © Do Ho Suh, courtesy of the
artist and Lehmann Maupin Gallery,
New York and Hong Kong./ photos by
Elisabeth Bernstein.

*Rubbing/Loving Project: Stove 2,
Apartment A, 348 West 22nd Street,
New York, NY 10011, USA,* 2014.
coloured pencil on vellum pinned
on board, 55.2 x 52.7 cm (paper).

Rubbing/Loving Project: Bathroom,
Apartment A, 348 West 22nd Street,
New York, NY 10011, USA, 2014.
coloured pencil on vellum pinned
on board, 90.5 x 86.6 cm (paper)./
from the collection of Jody and
Gerald Lippes.

Rubbing/Loving Project: Light Switch,
Apartment A, 348 West 22nd Street,
New York, NY 10011, USA, 2014.
coloured pencil on vellum pinned
on board, 34.9 x 27.3 cm (paper).

do ho suh

are you experienced?

Rubbing/Loving Project: Intercom,
Apartment A, 348 West 22nd Street,
New York, NY 10011, USA, 2014.
coloured pencil on vellum pinned
on board, 34.9 x 27.3 cm (paper)./
collection of Joshua and Sara Slocum.

3

nadia belerique: glance, focus, shift and then repeat

alana traficante

are you experienced?

how might we perceive the interior space of a photograph? If we could step inside an image and wander through its components, would figures and objects have depth or might they stand in as flat pictorial screens? Might they become photographs within photographs or images within images, enacting the role of what we see while pointing to that which we cannot? How might vision open new perceptive understandings to bring meaning, or perhaps trick us through its illusions and effects?

Nadia Belerique's installation *I Hate You Don't Leave Me*, 2015, created for the *are you experienced?* exhibition, represents the third iteration in a recent trilogy of artworks, beginning with *The Counselor* and *Have You Seen This Man?*, both produced in 2014. Deeply rooted in a photo-based practice, Belerique works through this series to investigate how the photograph can take up the position of the subject and object of viewership, becoming both the observer and the observed. She works upon the flat picture plane to play with the limits of the conventional object-based encounter. Her photographs are illusory in approach, challenging optical perception and experimenting at the site of an indiscernible boundary between figure, ground and reciprocal gaze. In doing so, she stages the gallery space to augment the variability and indeterminate nature inherent to the process of viewing. Enacting the performativity of images, Belerique activates the wall, the floor and all spaces in-between.

Each work is explicitly mysterious, beginning with a question and marked with a trail of clues and traces of bodies unknown. Implementing strategies of illusion and uncertainty, Belerique experiments with the manner in which we process visual information. We can understand *I Hate You Don't Leave Me* as the latest proposition in this series, and as the artist will perform and create some of the work in situ, the task of this essay is to bring forth analysis of her past works in order to set the stage for her experiment. Consisting of photographs, freestanding cut-out figures and a carpet runner, this new work operates in the same ways that her recent installations have.

Her previous work *The Counselor* consists of two image-objects which are life-sized and freestanding photographs of cardboard cut-outs in the shape of human bodies, mounted to corrugated plastic board. The first depicts a static and flat representation of a woman's body, a photograph of the surface of a figurative cardboard cut-out. The second object is more challenging to discern. At first, it appears as though the cut-out is positioned in duplicate, but simply turned to expose the cardboard support on its reverse. However, closer viewing reveals that this too is an illusion. Visual cues that at first read as dimensional components begin to reveal themselves as flat photographic representations. This flatness becomes visible after carefully approaching and circling the work—an adjustment of the eye, a processing of space. It is as though the photo stands-in for the stand-in itself. The resulting figures are illusory in effect, challenging the eye to recognize characteristics of the surface opposed with the dimensional object it depicts.

In the second iteration of this series, titled *Have You Seen This Man?*, Belerique begins with the picture plane in order to push at the boundaries of its two-dimensional space. The installation can be read as a single work of three composite parts: the walls hung with a series of high gloss photographs, the floor dressed in carpet, and three-dimensional space articulated by life-sized figurative silhouettes. These three components work in concert with one another to build an essence of mood and construct a mystery by activating the materiality of photographic processes and the viewer's embodied response.

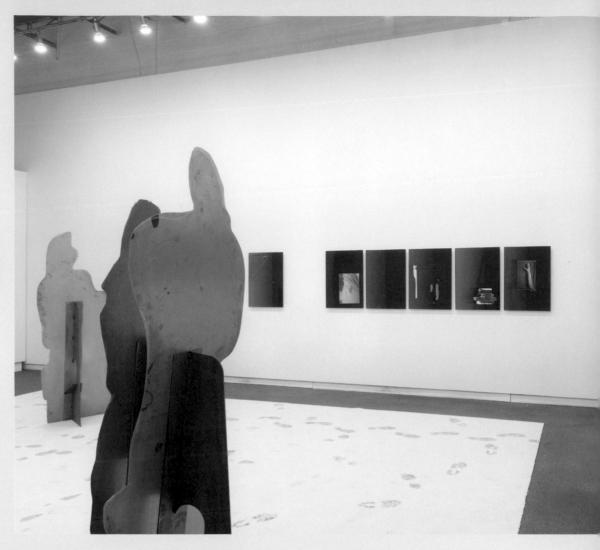

Nadia Belerique,
Have You Seen This Man?, 2014.
installation view, Daniel Faria Gallery,
Toronto, 1 May–7 June 2014./ courtesy
of the artist and Daniel Faria Gallery./
photo by Daniel Faria Gallery.

Various scanner-bed photographs contain collaged imagery of objects: cut paper, tape, a lump of wax. The gesture of cutting, framing and assembling images by hand references now-obsolete methods of manual photo editing. Objects are carefully reproduced against the black ground of the scanner-bed to create an effect of illusory dimension on the otherwise flat image field. Some photos are entirely void of objects, and stand in as moments of an empty and imageless view. Each photograph contains marks of the artist's hand, with visible fingerprints smudged across the picture plane. The prints are face mounted to Plexiglas, creating a reflective surface that when met in the process of viewing, returns a reciprocal gaze.

The last time it was installed, just a short distance from the wall the floor was dressed with an off-white rug that acted to delineate the depth of space occupied by the installation. The surface of the rug was marked with various footprints, appearing as traces of bodies unknown. These footprints were produced by applying a Liquid Light emulsion to the soles of the artist's shoes. Following her movement across the rug, its fibres were altered (or developed) by exposure to light. Atop the floor, cut steel silhouettes of figures stood in as semi-abstracted representations of the body, and also served to block or cut away sight lines and interrupt fields of visual perception. Each sculptural silhouette, slightly larger than life-size, appeared as an apparition of a body in space. Their steel surfaces rough, unpolished and dappled with smudges of fingerprints. Unlike the fingerprints that appear on the surface of the photographs, these marks may not gesture to the artist's hand, but perhaps toward a mysterious subject or subjects who have seemingly come and gone. There is a suggested relationship between these figures and the ground upon which they stand, as though the mysterious walkers have left not only footprints, but also perhaps shadows in their wake.

The interplay between these objects is revealed through a process of active viewing. Participants must lend not only their sense of visual perception, but also their proprioceptive bodies to the process of coming to know. Proprioception is activated through movement and relative positioning in order to arrive at a sense of knowing one's own body in space. In navigating the spatial construction of the installation, the act of positioning and repositioning the body lends to the variability of shifting visual perception. Alternative vantage points result in differing visual data; steel sculptures may cast figurative elements on the reflective surface of photographs, or may serve to cut away sight lines, to block viewing access and produce redacted images across the visual plane. Also present is an activation of the haptic sense with touch occurring through receptors in the feet rather than the hands. By moving onto and off of the carpeted floor, sensations of the ground will vary, indicating slight shifts in mood and the movement inside and outside of the boundaries of the installation.

The space becomes immersive in its psychological construction, engaging a persistent state of questioning, beginning with *Have You Seen This Man?,* and proceeding to build mystery through a trail of indefinite clues. Each component contributes to the arc of an experiential narrative, which employs a process of circular enquiry but not a definitive conclusion. The space begins to read as a site of investigation, a variable and indefinite enigma, a 'whodunit' of sorts. Activating the body through visual, tactile and proprioceptive clues, Belerique constructs sensations that challenge the certainty of identification and allow for us to linger in the process of asking, seeking and awaiting response.

The manner in which we experience this visual-haptic-spatiality lends to a process of embodied perception— a coming to know (or perhaps not knowing)—while seeking the identity of this mysteriously absent mark-maker. Traces of the body sweep across each material surface and urge us to orient and reorient our gaze; to glance, focus, shift and then repeat. It is in this act of looking that we may be suspended between perception and understanding, simultaneously negotiating physical and psychic space. Belerique invites participants to experiment with multisense perception, to alter vision through movement, to navigate, observe and draw connections between composite parts of a whole. She questions: how might this experimentation alter processes of coming to know? How does the photograph work to mediate what we see and what we cannot see, to produce sensations of suspense, anticipating the clarity of knowledge or sitting for just a moment in that flicker in-between? Belerique constructs a site of iterative play across states of knowing and not knowing, an enquiry at the threshold of cognitive perception and embodied sensation. In this space, meaning itself sits rather precariously at the tipping point between certainty and doubt, comprehension and the incomprehensible.

nadia belerique

are you experienced?

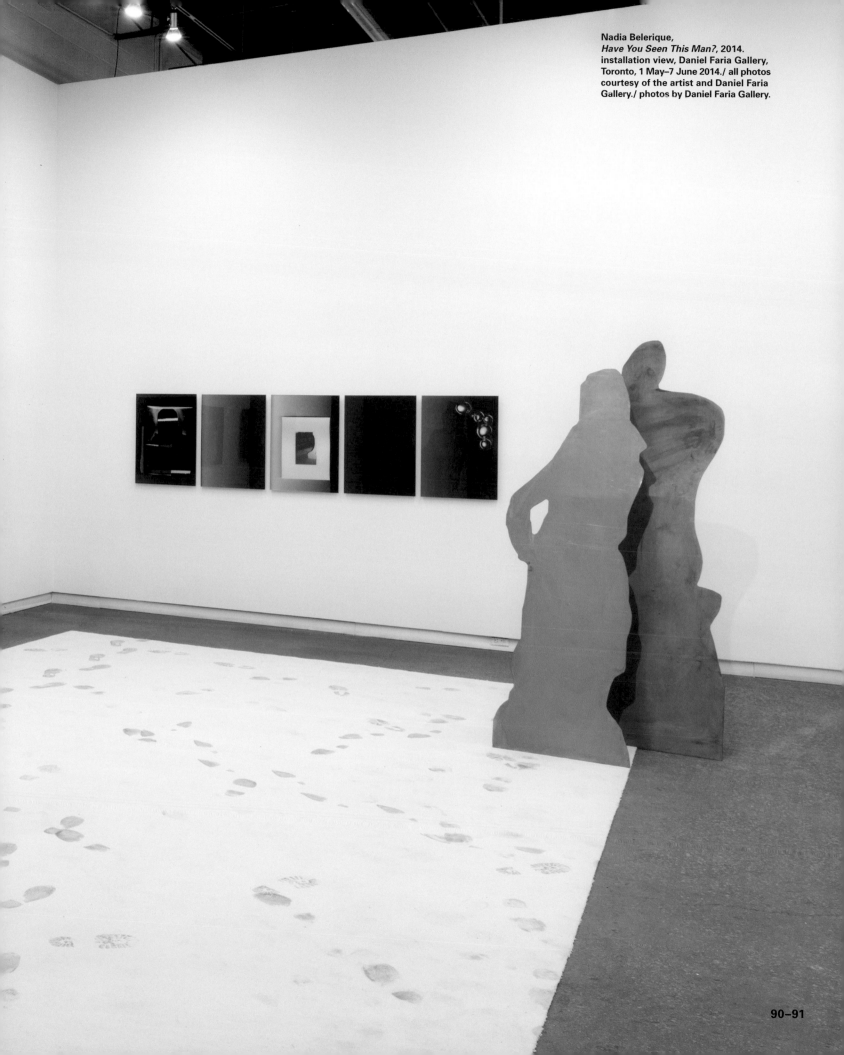

Nadia Belerique,
Have You Seen This Man?, 2014.
installation view, Daniel Faria Gallery,
Toronto, 1 May–7 June 2014./ all photos
courtesy of the artist and Daniel Faria
Gallery./ photos by Daniel Faria Gallery.

Have You Seen This Man?, detail, 2014.
wool rug and Liquid Light.

nadia belerique

are you experienced?

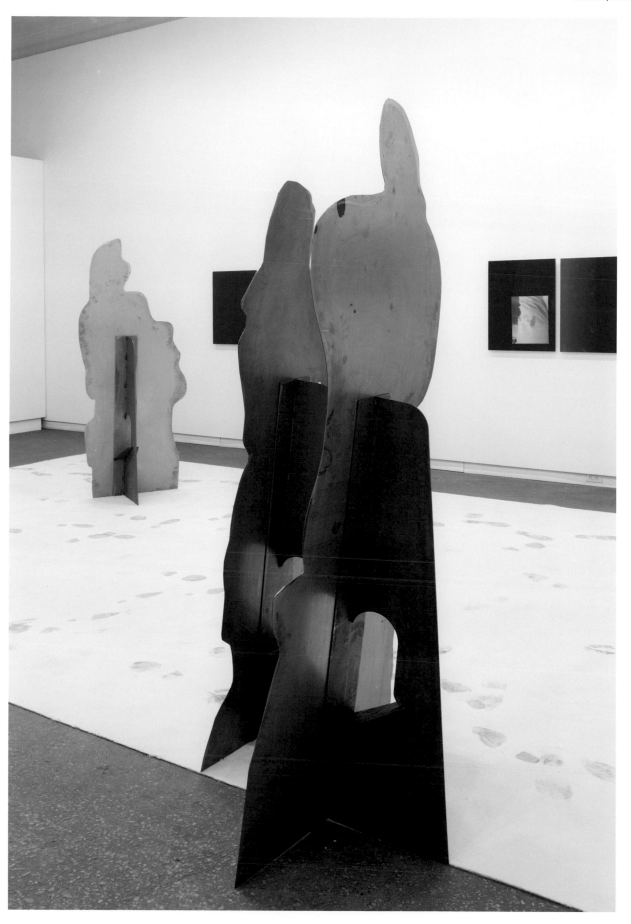

Have You Seen This Man? 3 & 4, 2014.
rolled steel, 184 × 57 cm; 198 × 61 cm.

nadia belerique

are you experienced?

Have You Seen This Man? 1, 2014.
powder coated rolled steel, 180 x 76 cm.

Have You Seen This Man?, 2014.
installation view, Daniel Faria Gallery,
Toronto, 1 May–7 June 2014.

nadia belerique

are you experienced?

The Archer 4, from *Have You Seen This Man?*, 2014. inkjet photograph mounted to aluminum and Plexiglas, 71 x 51 cm.

The Archer 6, from *Have You Seen This Man?*, 2014. inkjet photograph mounted to aluminum and Plexiglas, 71 x 51 cm.

The Archer 7, from *Have You Seen This Man?*, 2014. inkjet photograph mounted to aluminum and Plexiglas, 71 x 51 cm.

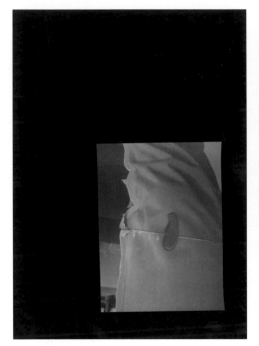

The Archer 4, from *Have You Seen This Man?*, 2014. inkjet photograph mounted to aluminum and Plexiglas, 71 x 51 cm.

The Archer 6, from *Have You Seen This Man?*, 2014. inkjet photograph mounted to aluminum and Plexiglas, 71 x 51 cm.

The Archer 7, from *Have You Seen This Man?*, 2014. inkjet photograph mounted to aluminum and Plexiglas, 71 x 51 cm.

The Archer 8, from *Have You Seen This Man?*, 2014. inkjet photograph mounted to aluminum and Plexiglas, 71 x 51 cm.

The Archer 9, from *Have You Seen This Man?*, 2014. inkjet photograph mounted to aluminum and Plexiglas, 71 x 51 cm.

The Archer 10, from *Have You Seen This Man?*, 2014. inkjet photograph mounted to aluminum and Plexiglas, 71 x 51 cm.

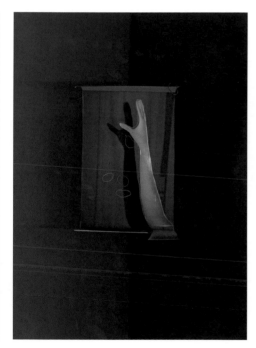

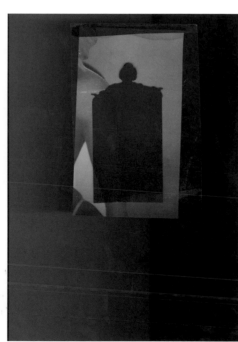

right *The Archer 2*, from *Have You Seen This Man?*, 2014. inkjet photograph mounted to aluminum and Plexiglas, 71 x 51 cm.

opposite *The Archer 3*, from *Have You Seen This Man?*, 2014. inkjet photograph mounted to aluminum and Plexiglas, 71 x 51 cm.

nadia belerique

are you experienced?

nadia belerique

are you experienced?

opposite *The Archer 11*, from *Have You Seen This Man?*, 2014. inkjet photograph mounted to aluminum and Plexiglas, 71 x 51 cm.

left *The Archer 14*, from *Have You Seen This Man?*, 2014. inkjet photograph mounted to aluminum and Plexiglas, 71 x 51 cm.

The Archer 12, from *Have You Seen This Man?*, 2014. inkjet photograph mounted to aluminum and Plexiglas, 71 x 51 cm.

The Archer 15, from *Have You Seen This Man?*, 2014. inkjet photograph mounted to aluminum and Plexiglas, 71 x 51 cm.

radia belerique

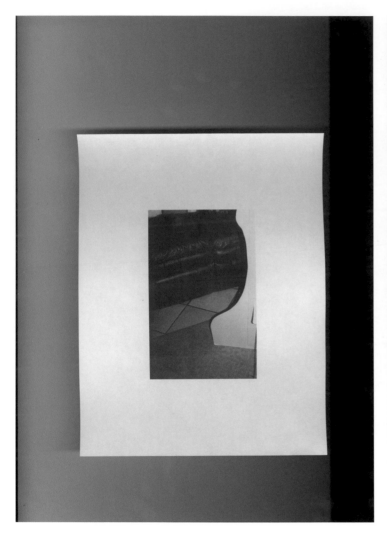

are you experienced?

The Archer 13, from *Have You Seen This Man?*, 2014. inkjet photograph mounted to aluminum and Plexiglas, 71 x 51 cm.

The Archer 1, from *Have You Seen This Man?*, 2014. inkjet photograph mounted to aluminum and Plexiglas, 71 x 51 cm.

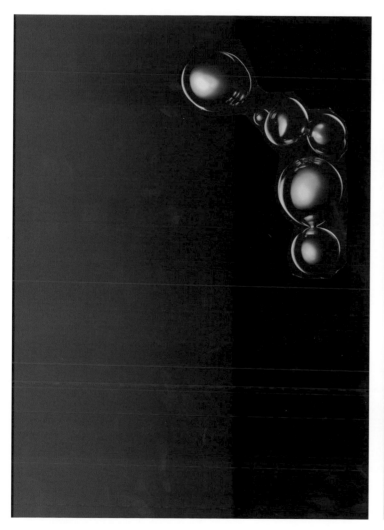

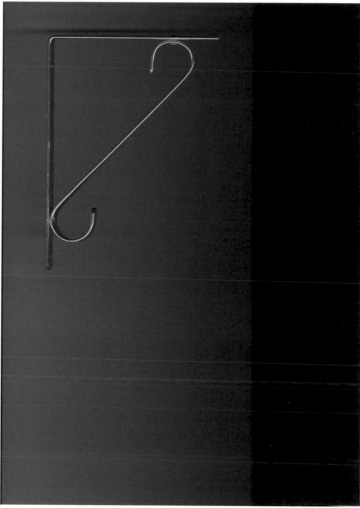

an interview with dorian fitzgerald

melissa bennett

Dorian FitzGerald's paintings *Hacker-Pschorr Beerhall, Oktoberfest, Munich*, 2005, and *The Throne Room, Queluz National Palace, Sintra, Portugal*, 2009, comprise his participation in the *are you experienced?* exhibition. Situated across from each other in a cavernous space, the *Hacker-Pschorr Beerhall* looms at 5.5 metres tall while *The Throne Room* draws viewers into its mesmerizing pictorial space of over 3 x 3.7 metres. Though opposites in subject matter—the *Beerhall* depicts 7000 people drinking in a fake German street scene during Oktoberfest in Munich, while *The Throne Room* shows a vast and sumptuous though empty palace—they each use a deep single point perspective. FitzGerald's signature material technique is an adaptation of cloisonné, with found photographs used as source material. Though the paintings form a contrast between the spaces of low and high classes, boisterous, and stolid atmospheres, the artist seems to equalize those environments as one and the same. Each is a theatrical space, constructed to display certain identities, whether that of a stereotypical German pastime or an upper class austerity.

melissa bennett **What led you to create the painting *Hacker-Pschorr Beerhall, Oktoberfest, Munich*? Where and when did you see the source photograph?**

dorian fitzgerald I was attracted to the formal qualities of the photograph, which is from a *National Geographic* article on alcohol from the 1980s. I was going through hundreds of the magazines—my sister used to have a subscription—along with other childhood fragments, as my mother had moved out of our old home. At the time I knew very little about Oktoberfest and its structures, so once I started researching it the image quickly took on more meaning—an elaborate, massive, but temporary structure with a rotating bandstand, an idealized Bavarian village facade designed by an Oscar-winning set designer, erected for coach loads of alcohol tourists, apparently particularly popular with Americans as the bandstand hosts a rock band at night.

mb **Beyond the formal qualities, what interests you about the subject matter? The structure of the Bavarian facade may be idealized, but what about the everyday drinking culture going on within it?**

df It's not really an everyday drinking culture though, is it? Admittedly I have never been to an Oktoberfest, but it appears to be as commodified as any other Western holiday or ritual. I'm not completely cynical about a bunch of people assembling and drinking alcohol, it's something of a personal and family tradition—which is why I was reading the article—but I think that the image represents, if anything, a corrupted idea of communal drinking.

mb **During a studio visit, you used terms like "fractal", and "bilateral symmetry" to describe the *Hacker-Pschorr Beerhall* piece—can you explain this further?**

df The bilateral symmetry is a pretty consistent aesthetic thread through the large paintings that I have done, along with the use of one point perspective—with the exception of *VIP Room, Casa de Musica, Porto, Portugal, Rem Koolhaas*, part of the appeal of which was the absence of symmetry. It's no surprise, really, as that is a combination that is often used in architectural photography, which is the source of many of the images I have worked on. The combination of the rigid perspective with the symmetry often results in a kaleidoscopic, psychedelic quality, especially when combined with regular and dense clusters of information—all of which was present in the *Hacker-Pschorr* photograph and made it immediately compelling. Although it is a bit of a stretch

melissa bennett

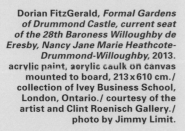

Dorian FitzGerald, *Formal Gardens of Drummond Castle, current seat of the 28th Baroness Willoughby de Eresby, Nancy Jane Marie Heathcote-Drummond-Willoughby,* 2013. acrylic paint, acrylic caulk on canvas mounted to board, 213×610 cm./ collection of Ivey Business School, London, Ontario./ courtesy of the artist and Clint Roenisch Gallery./ photo by Jimmy Limit.

to call it "fractal", it does have a degree of self-similarity, the large grid of picnic tables echoed in the smaller arrays of people clustered around and on the benches, and as they recede into the distance the painting quite quickly dissolves into noise.

mb How do you see the material and psychedelic aspects of your paintings working together?

df That's not really something I have in mind when I'm working—but if there are elements that I find psychedelic, they are the results of processes largely beyond my control, the results of the paint curing and contracting. These are elements that are present in all paint application to some extent, but with pouring there are additional artefacts that arise; crazing, whorls from incomplete mixes or variations in medium density, bubbles that surface as pools dry—and evidence of the order and pattern in which the paint is poured, which is largely hidden until the paint dries through.

mb Thanks for the description—it's great to get a sense of the work up-close, especially from you having spent so much time with those tiny whorls, bubbles and pools. That makes me think of the individualized perspective you have on your work—and in turn, the way that the pieces are received by the public. They are spectacular, and theatrical, if I may say so.

There is the theatre within the *Beerhall*, in terms of tourists gathered within a facade of Bavaria—everyday culture of Bavaria is turned into a spectacle. But we've also talked about the theatre of painting, and painting itself as a spectacle—this is undeniable given the scale of your *Beerhall* painting. Can you elaborate on your interests here?

df My interest has primarily been in ostentation, which I suppose is by nature theatrical —a display for others. The *Beerhall* doesn't fit with my later works very neatly in terms of content, but as you say it was certainly meant to be a spectacle. For me it was about artifice, and what might be lost when packaging an experience and greatly increasing the number of participants—the idea that someone might enjoy drinking or working in that environment was something I couldn't imagine at the time.

mb But *The Throne Room* was motivated by the idea of ostentation too, wasn't it?

df Well, I thought of the room as melancholic—empty of furniture and purpose, a testament to the collapse of an empire; certainly if it's still a symbol to the Portuguese of their glory, it's a nostalgic one. The ornamentation of the room was the main appeal aesthetically, certainly; the ceiling in particular. I had hoped that people would notice the room was empty, but there is too much intense pigment in the work to make that initial feeling of melancholy evident; I wanted to make it a compelling painting, so I can understand if that ambivalence is not apparent to someone viewing the work.

mb In a previous statement you described yourself as a "contemporary court painter, documenting on a grand scale the material and spatial excesses of our time". But you do more than this—you invite conversation on class, consumerism, excess, our material world…. Do your paintings offer a socio-political statement?

df I'm not sure that the paintings offer much of an explicit socio-political statement on their own. I would like to believe that if one were to see a few years' worth of my paintings together that my stance would be clear—I think it's encapsulated in the word "excesses", which is not a neutral word—but as it stands they rely pretty heavily on the context in which they are shown. The two works in the show are not the most pointed, the *Beerhall* in particular I think of as quite apolitical, but I have generally been cautious of being overly didactic. This might leave the work to be seen as simple celebration, and I do find it disappointing when that occurs. This has had the predictable effect of pushing me to find more complex or conflicted subjects, although once I choose an image or object that I find succinct, the treatment of it remains quite faithful. The titles are unambiguous, and contain enough information to allow someone who wants to investigate further a good place to start.

Dorian FitzGerald, *Hacker-Pschorr Beerhall, Oktoberfest, Munich*, 2005. acrylic and caulking on canvas, 549 x 366 cm./ all works courtesy of the artist and Clint Roenisch Gallery./ photo by Dorian FitzGerald.

dorian fitzgerald

are you experienced?

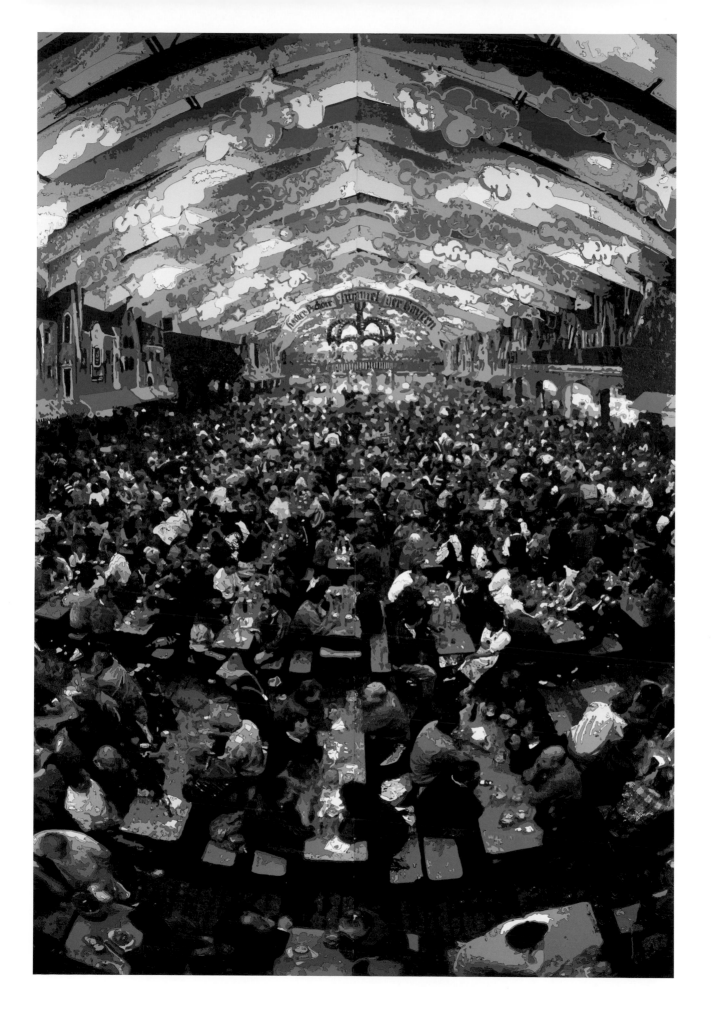

Fabergé Egg (Rose Trellis), 2009.
acrylic paint, acrylic caulk on canvas
mounted to board, 244 × 183 cm./
collection of Moira and Alfredo
Romano./ photo by Toni Hafkenscheid.

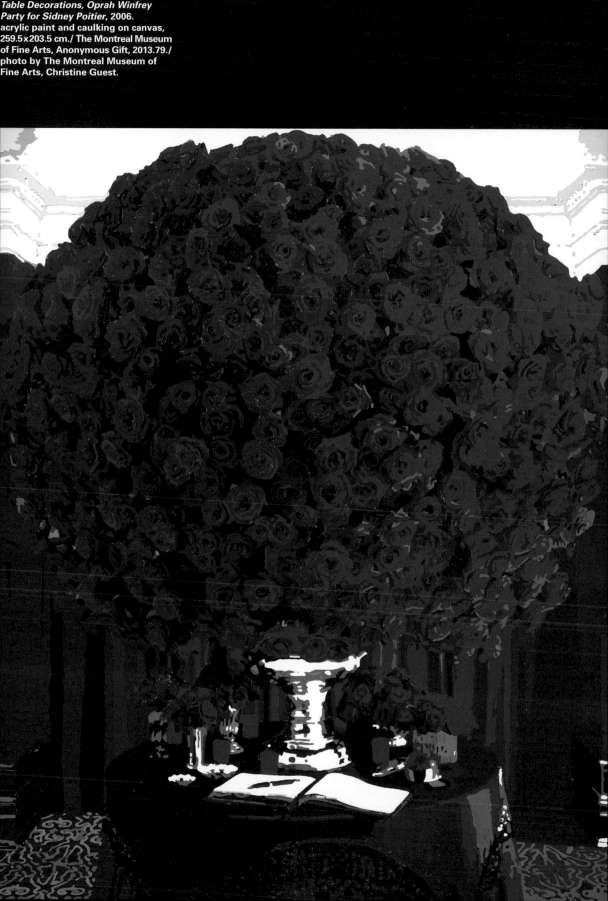

*Star of the Most Noble Royal Order
of the Garter (King George VI)*, 2011.
acrylic paint, acrylic caulk on canvas
mounted to board, 244 x 183 cm./
The Donald Collection./ photo by
Toni Hafkenscheid.

are you experienced?

*Lot No. 5235—Blue and White
Porcelain Meiping, Qianlong Mark,
Late Qing/Republic Period,* 2011.
acrylic paint, acrylic caulk on canvas
mounted to board, 264 x 193 cm./
collection of Susanna Vorst./ photo
by Toni Hafkenscheid.

The Throne Room, Queluz National Palace, Sintra, Portugal, 2009. acrylic paint and caulking on canvas, 321 x 397 cm./ The Montreal Museum of Fine Arts, Purchase, the Montreal Museum of Fine Arts' Volunteer Association Fund, in memory of Marjorie D Gawley, an outstanding volunteer, 2010.16.1-2./ photo by The Montreal Museum of Fine Arts, Christine Guest.

dorian fitzgerald

are you experienced?

Henry Cyril Paget, 5th Marquess of Anglesey, Earl of Uxbridge, circa 1900, 2015.
acrylic paint on canvas mounted to board, 91 x 61 cm./ private collection./
photo by Jimmy Limit.

The Dining Room of the Regina d'Italia (Stefano Gabbana's Yacht), 2008. acrylic paint, acrylic caulk on canvas mounted to board, 198 x 396 cm./ private collection./ photo by Steve Krug.

VIP Room, Casa de Musica,
Porto, Portugal, Rem Koolhaas
(Architect), 2010.
acrylic paint, acrylic caulk on canvas
mounted to board, 259 x 396 cm./
collection of Fasken, Martineau,
DuMoulin LLP./ photo by
Toni Hafkenscheid.

dorian fitzgerald

are you experienced?

Elton John's Sunglasses, Woodside Estate, Old Windsor, England, 2010. acrylic paint, acrylic caulk on canvas mounted to board, 274 x 274 cm./ collection of Donald R Sobey./ photo by Toni Hafkenscheid.

dorian fitzgerald

are you experienced?

"beauty is both inevitable and irrelevant": a conversation with jessica eaton

gabrielle moser

gabrielle moser I was a bit skeptical about your work being described as immersive when Melissa Bennett first told me the premise for the exhibition. *are you experienced?* proposes that, "to experience the work is to understand it". Yet your photographs offer a perceptual experience that is quite different from logically understanding the process that created them. That distance is something many art critics and curators latch onto when they write about your work, spending a great deal of time explaining how you produce your images and less time describing the experience of looking at them. Do you see immediacy playing a role in the work, or in the viewer's experience of it?

jessica eaton Yes, I mean in that it is a photograph, it is not reading a text. Anything visual, in a very loose interpretation, offers an immediate experience.

gm The scale of your work also feels immersive, because your prints are larger-than-life-sized, in the *Cubes for Albers and LeWitt (cfaal)* series especially. There is a bodily relationship between the viewer and the cubes, in the way that minimalist artists like Donald Judd wanted to create an embodied connection with their sculptures.

But I think your point is more nuanced than that, which is to say that images are always assumed to be immersive in a way that is different from language or even sculpture because we don't have to translate them or interpret them in the same way.

je I've been thinking about this a lot lately because I often get asked what photographs have influenced me and, in a way, *all* photographs have influenced me. Ever since I started making photographs, I have always looked at a photograph as something that I could 'read', regardless of the content of the image: to try to read what makes it appear as such. Even if it is the most banal wedding photograph, I would look at it to try to understand how it was made: what lens is this? How is it projecting three-dimensional space into two dimensions?

It is also a question of the work that goes into making even the most common images. A curator recently asked me about the labour that goes into my work, and suggested it was necessary but invisible, and I countered that by saying that that was not really the case. I could point to small details in my images that are technically errors or mistakes, but they act as clues that point to the process of making them.

gm And those are also the details that get lost when a viewer encounters your work online. The handmade clues that are there — like the fact that some of the corners of the cubes are dented, or the textures where the paint has been applied — which help the viewer to understand how material these images are, are much less obvious in the digital reproductions. We think about online space as providing another kind of immediacy, but I'm always astonished by how much more detail I can see when I see your images in person, and by how different the photographc look.

je Yes, I hear that constantly. When people see a full-size exhibition print of my work in the gallery for the first time and they have only been familiar with it online, there is often a moment of revelation, a sort of "Ohhhhhh...." reaction. The images look digital online, as though they have been manipulated in Photoshop. In a way, I feel a sense of validation whenever this happens, because a 72 dpi jpeg has a limited amount of information in it. But I think that is a good thing: far too often, now, I'm having the opposite experience. I become familiar with works through their photographic documentation online and then I see the real-life print and am disappointed by its quality.

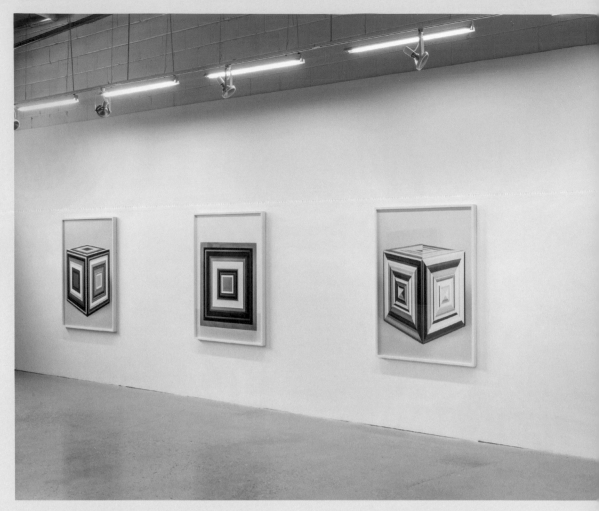

Jessica Eaton, installation view, *Jessica Eaton: New Works*, Jessica Bradley Gallery, 1–31 May 2014./ courtesy of the artist and Jessica Bradley Gallery./ photo by Toni Hafkenscheid.

As an object, it can't hold up. It just disintegrates. In my work, I operate with complete understanding that my production is going to end up as an object on a gallery wall. There's no delusion about what the end work is.

gm **Maybe that is where the role of immediacy in your work becomes clear, in that the materiality or object-ness of your work prompts an immediacy that a jpeg cannot.**

je It completely transforms your understanding of any artwork, to see it in person. We've come to think of what we see on the computer as this mirror for reality, but it is actually a very compressed space of information.

gm **I wonder, too, if that is what is motivating this exhibition: using immediacy to reject the effects of digital distraction, or to emphasize the distancing and flattening that happens through screens.**

I wanted to ask, too, about the role that beauty might play in your work. There is a perception, perhaps a stereotypical perception, that conceptual art is not beautiful, or that it is not supposed to be aesthetically pleasing. Your work, and your *cfaal* series in particular, references Sol LeWitt, one of the godfathers of conceptual art, who once famously said that conceptual art should "engage the mind of the viewer rather than [her] eye or emotions".[1] How does beauty fit into your work in relation to concept and process?

je For me, beauty is both inevitable and irrelevant. I have been thinking about this lately in relation to some of my influences from the history of photography. If photography has both a William Faulkner and an Ernest Hemingway reference point, I see them in Lee Friedlander (in terms of a very stylized, chaos of information and outside-the-rules composition), and in Bernd and Hilla Becher (through their very stripped-down attempt to make typologies where the camera becomes irrelevant).

I was re-reading the catalogue for the *New Topographics* exhibition,1975, and in it the curator, William Jenkins, writes that, "these works eschew beauty, emotion and point of view". And looking at it now, that is laughable. Even the Bechers' work is, *of course*, a) beautiful; and b) as stylized as any example from Friedlander would be. They have created a language that only the camera is capable of, but there is no avoiding that becoming aestheticized. The work follows its own logic and once it is an object, you can engage with them as images, and appreciate their colour and texture and composition.

I don't even attempt to define what beautiful is: it is the last thing that I would have as an impetus into the work, but at the same time, it is kind of inevitable. With some of the cube photographs that use the concentric striping, for instance, it was motivated by a strategy game where no matter how many exposures I made, with me rotating the cube, the goal was to make the final image come back to a balance of neutral as a sum total so that the background, which is grey, returns to a real-life colour balance. But then the cube, with different concentric stripes of tones of grey is constantly being rotated and swapped for other cubes, sometimes being photographed up to 40 times on a single negative. In that work, I have no control or even ability to map the colour combinations that are going to result. They're kind of making themselves. And the result of those steps sometimes produces something that at first makes me think, "ugh, that's a horrid colour combination", according to classic colour theory, at least. But then there is even something appealing about those.

gm Of course that is what has happened with all those minimalist, bare-bones conceptual projects of the 1960s and 1970s....

je They're stunning!

gm Yes, they just end up initiating a new kind of aesthetic. They're still beautiful to look at, even with all the rules put in place to limit subjectivity or beauty from entering the work.

je It is a great premise to be able to work from, and to make work from, but as an existing truth, it completely—in my mind—backfires. To make an object, it is pretty impossible to strip it from subjectivity, or to prevent it from becoming beautiful.

gm I often think of your works as invitations to slow down our speed of looking: to spend more time with the image, as a counterpoint to the short attention span we seem to have for images in everyday life. I was curious about what kind of temporal experience you would want the viewer to have in front of one of your photographs?

je I don't even consider wanting anything from the viewer. I work from the premise of satisfying myself and then, once it is out there in public view, it is not mine anymore. To have any desire for how someone else views your work can be a paralyzing thought.

gm Yet at the same time, much of the writing about your work focuses on the amount of time, and the amount of labour, that goes into producing your images.

je Yes, but I think that that insistence on time and labour in the writing about my work speaks volumes to what people think a photograph is. Sure, there is an immense amount of labour invested in my images compared to setting up a tripod and making

a single exposure, but would you ever focus on that if you were talking about a painting or a sculpture? Maybe. But probably not. That the labour that goes into my work is of such interest to people is connected to a very narrow definition of photography. Photography is assumed to be a form where a technology, the camera, makes the image of the world or outside existing thing that requires no intervention on the part of the artist. And it is hogwash. Even within photography, yes, there is a certain amount of labour that goes into any of my photographs, but it is not nearly as much time as what goes into a Jeff Wall, for instance. I don't spend three months casting, constructing a reproduction of a nightclub in Vancouver in a studio, shooting hundreds of negatives and compositing them together, pixel by pixel. Compared to that, my photographs take very little time: sometimes an hour or two.

gm **You have recently been making vivid, Technicolour images of flowers and cacti. The descriptions of your past work often claim it is "abstract photography"….**

je Or "geometric minimalism". There is no way that one is going to be thrown on me with the baroque florals I'm making now!

gm **Yes, this new work is different in that it is an immediately recognizable subject.**

je I am toying with colour reproduction in this new work, and in that way it is not much different from the cubes, but now there is a readable subject. I'm building back up from stripping things down. To have too bare an image was never a problem for me, but this work has shown me there must be something a bit baroque in my soul.

gm **I remember in an earlier conversation, you mentioned feeling frustrated that modernist photographers, like László Moholy-Nagy or Man Ray, could do portraiture *and* vortographs, or other highly technical, experimental forms of photography, and that both were taken seriously.[2] Does this new work try to push at this distinction?**

je Yes, that you couldn't do one and then the other was never a question for them. That is why I am so excited about this new body of work. There is such a direct, conceptual basis for my decisions with the shift in subject matter. With the cube project, using LeWitt's methodology about using a modular system and self-imposed sets of limitations, the base form subject—the cube—just disappears through repeated use, so that the idea becomes the subject itself. But then you go into flowers, and you no longer have the simplest, most unobtrusive form that can ostensibly disappear. Instead you have this subject that is completely readable, completely loaded in terms of signifying connections for viewers, including issues of gender, and it becomes a very complicated subject.

It doesn't feel different for me to work this way because it is a perfect, logical continuation of certain questions the *cfaal* series raised, but for the viewer, it just stops them dead. And to me, that is fascinating.

1 LeWitt, Sol, "Paragraphs on Conceptual Art", *Artforum*, June 1967, pp 79–83.
2 Popular among modernist photographers and Vorticists (the British equivalent of the Cubist movement), vortographs were one of the first examples of abstract photography, "composed of kaleidoscopic repetitions of forms achieved by photographing objects through a triangular arrangement of three mirrors." http://www.britannica.com/EBchecked/topic/632963/vortograph

jessica eaton

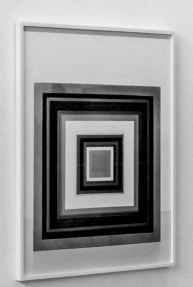

are you experienced?

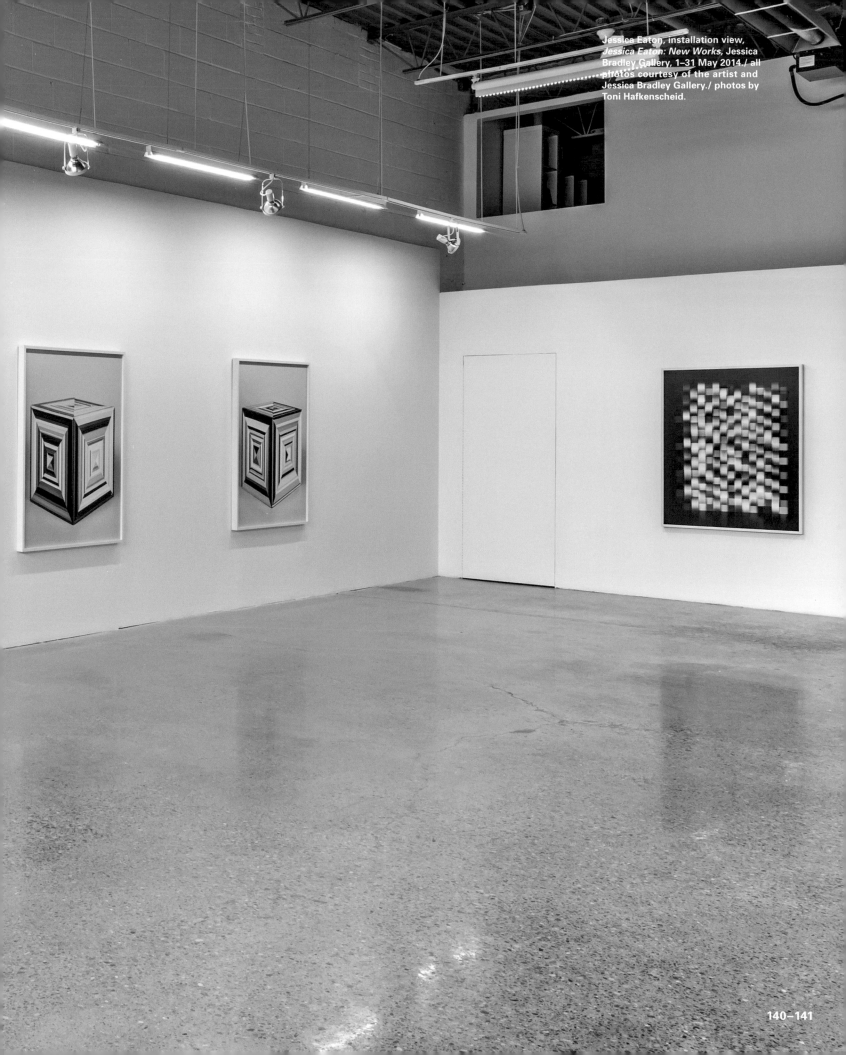

Jessica Eaton, installation view, *Jessica Eaton: New Works*, Jessica Bradley Gallery, 1–31 May 2014 / all photos courtesy of the artist and Jessica Bradley Gallery./ photos by Toni Hafkenscheid.

jessica eaton

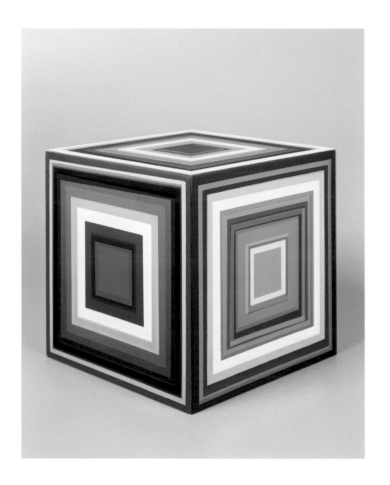

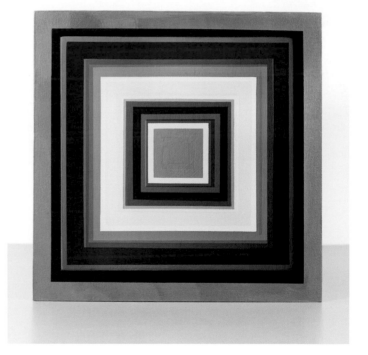

are you experienced?

cfaal 352, 2013.
archival pigment print, 127 x 102 cm.

cfaal 358, 2013.
archival pigment print, 127 x 102 cm.

jessica eaton

are you experienced?

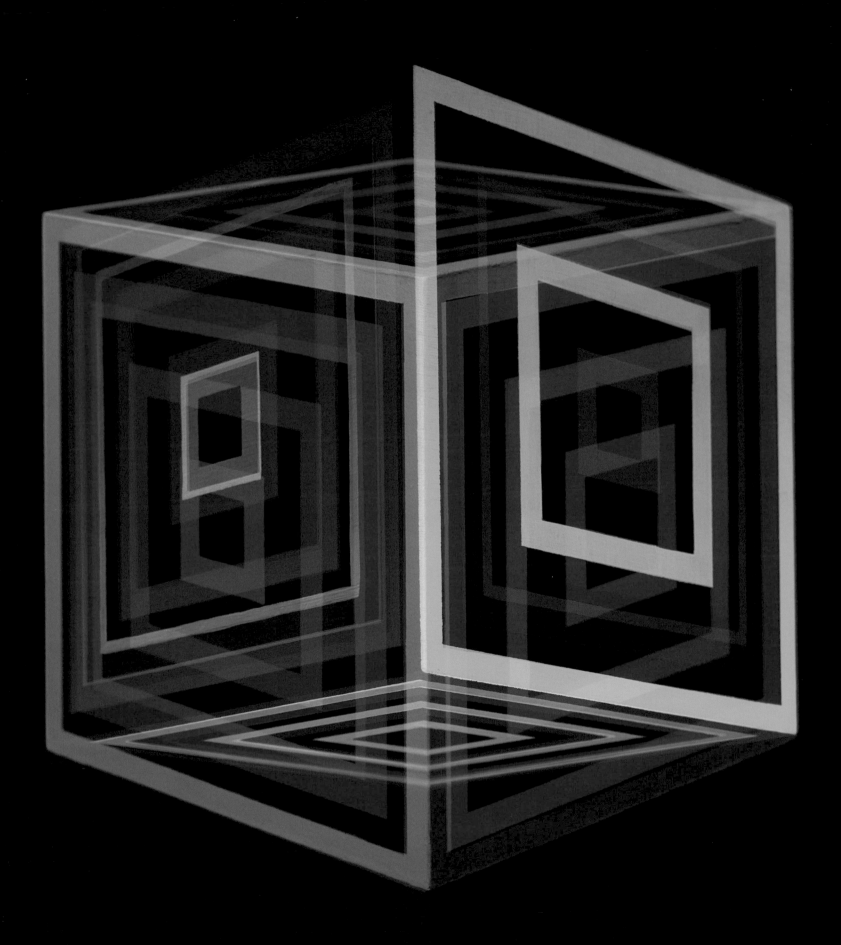

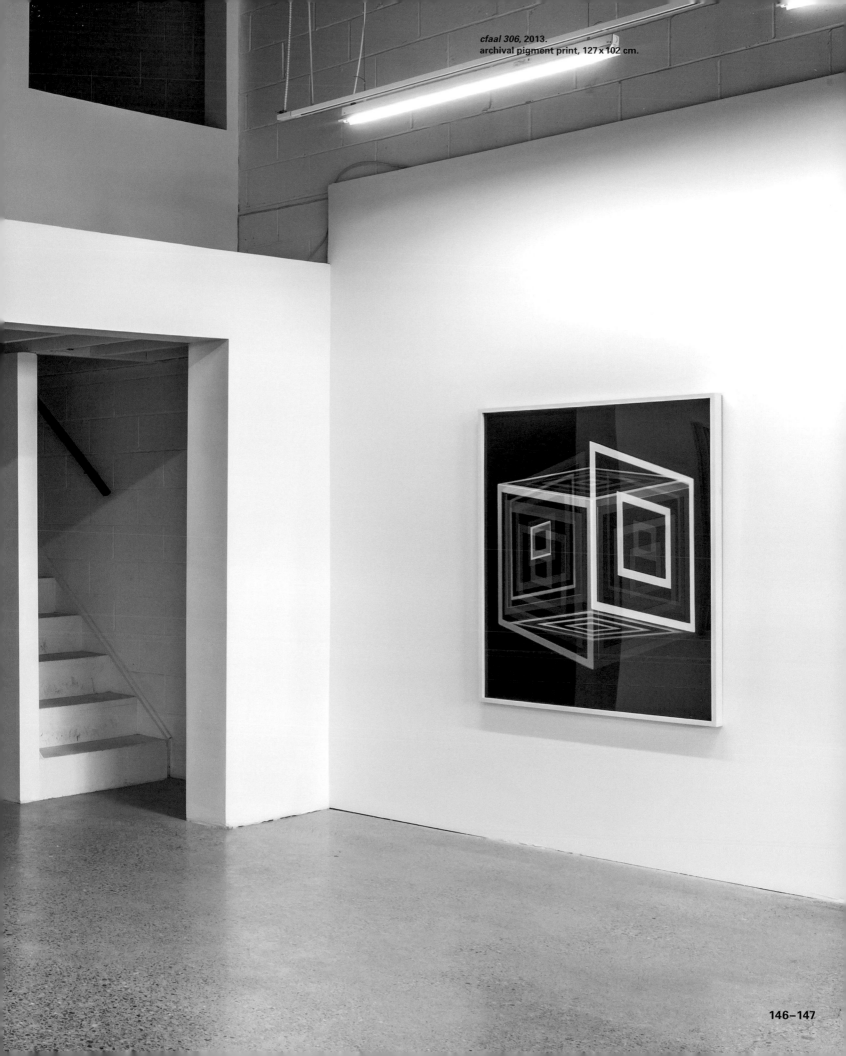

cfaal 306, 2013.
archival pigment print, 127 x 102 cm.

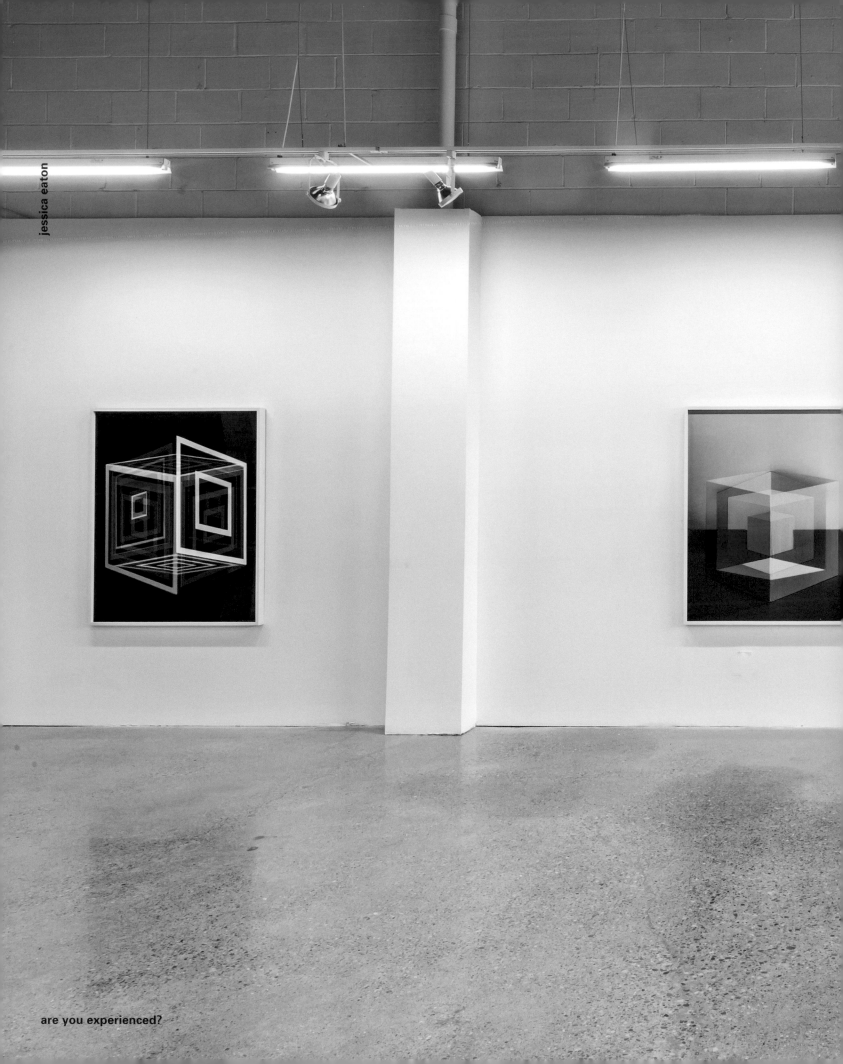

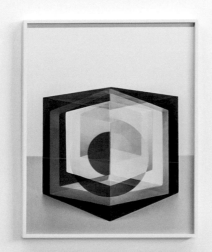

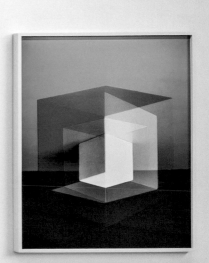

jessica eaton

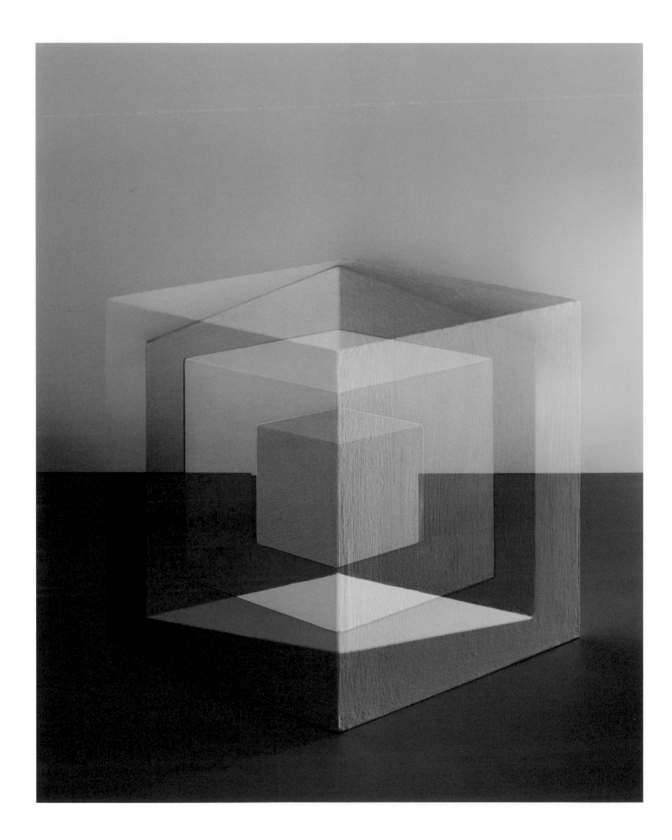

are you experienced?

cfaal 384, 2013.
archival pigment print, 127 x 102 cm.

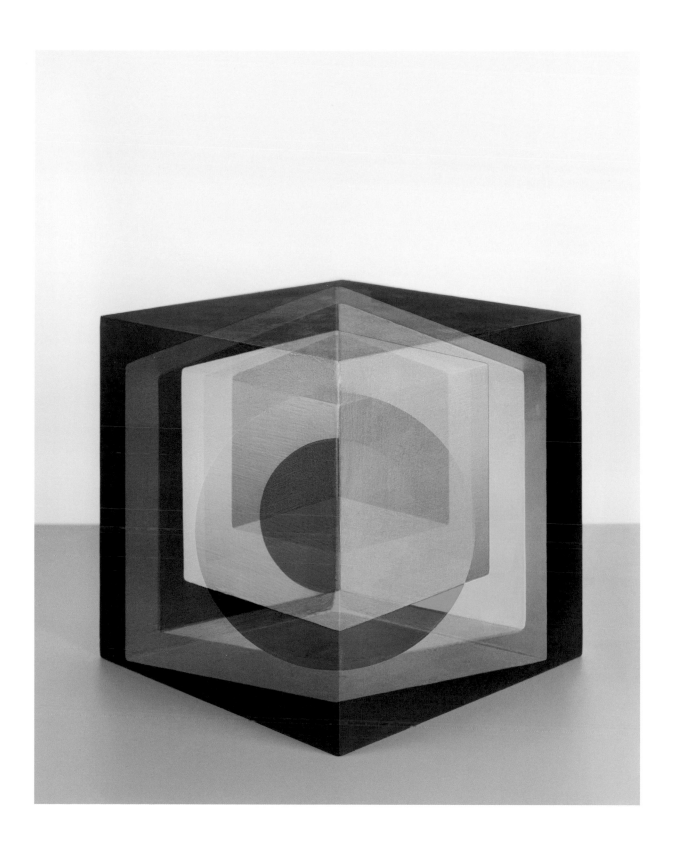

jessica eaton

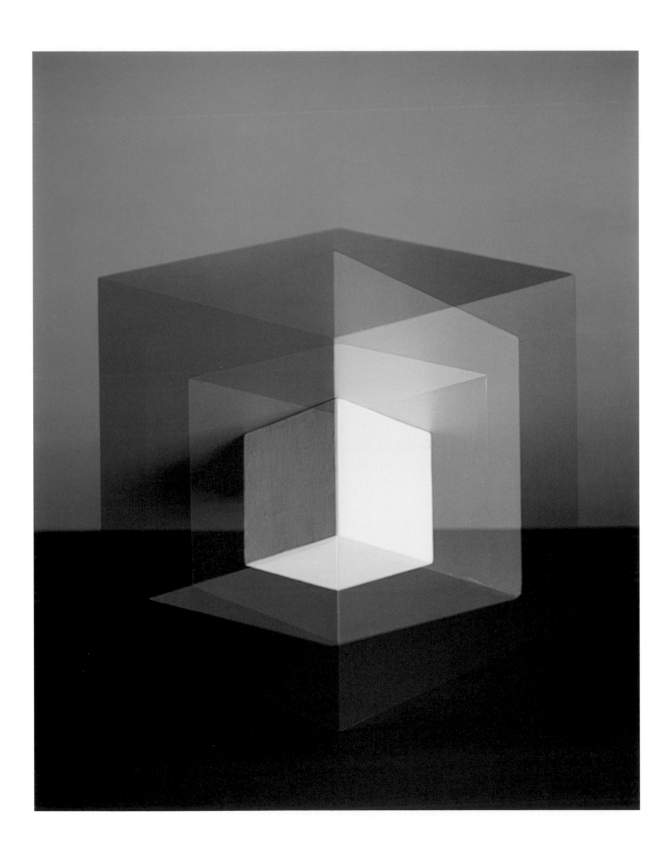

are you experienced?

jessica eaton

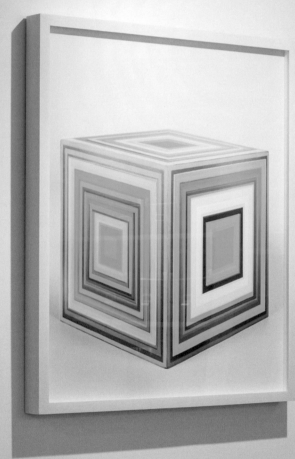

are you experienced?

cfaal 321 (G Study), 2013.
archival pigment print, 64 x 51 cm.

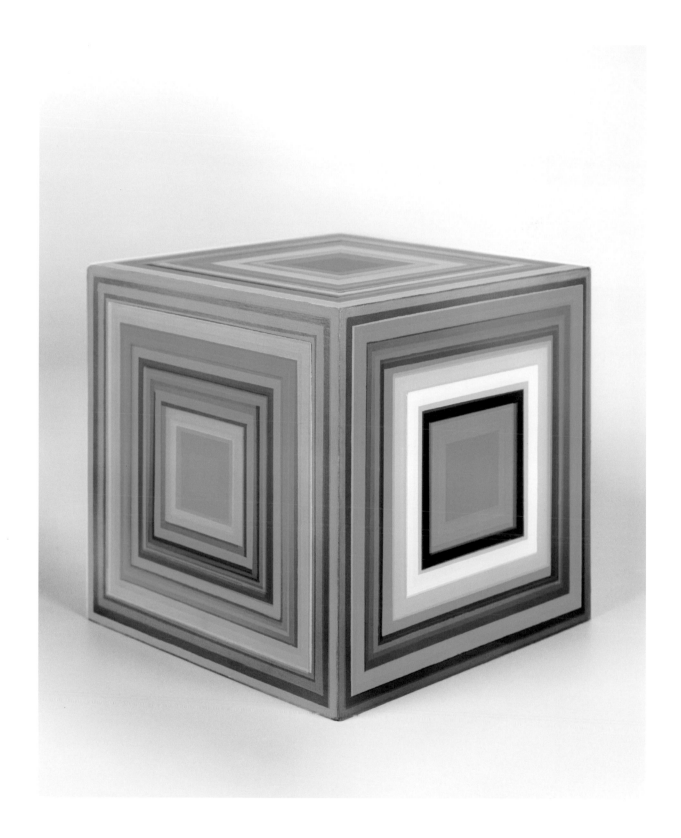

cfaal 323 (B Study), 2013.
archival pigment print, 64 x 51 cm.

cfaal 320 (R Study), 2013.
archival pigment print, 64 x 51 cm.

jessica eaton

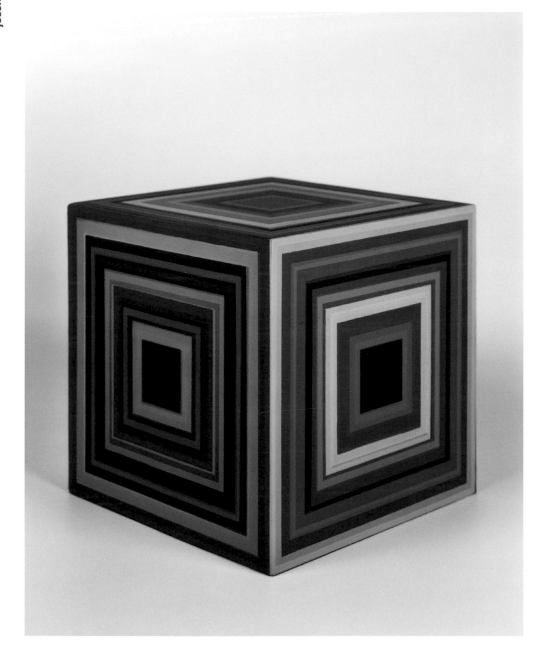

are you experienced?

cfaal 324 (Y Study), 2013.
archival pigment print, 64 x 51 cm.

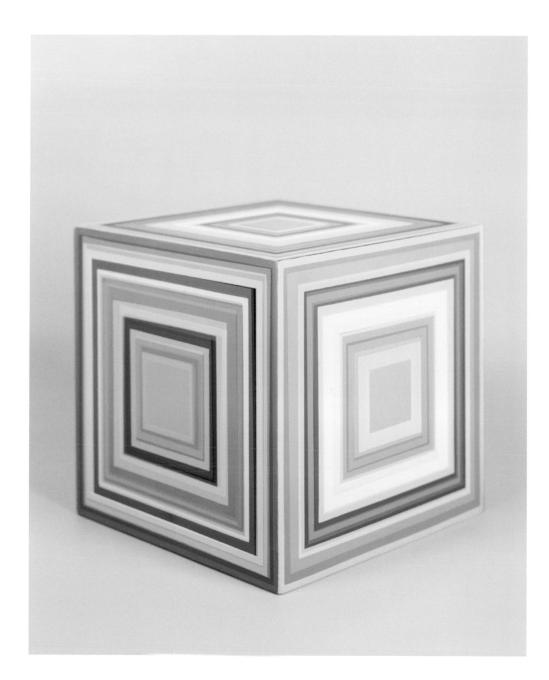

Jessica Eaton, installation view,
Jessica Eaton: New Works, Jessica
Bradley Gallery, 1–31 May 2014.

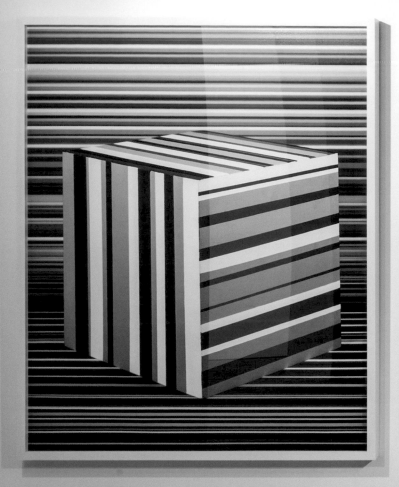

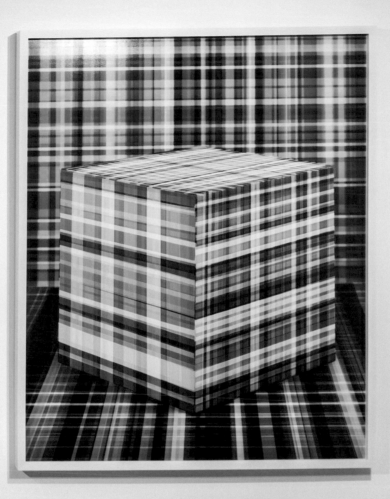

108_06, 2009.
archival pigment print, 126 x 102 cm.

p162 *cfaal 403*, 2014.
archival pigment print, 127 x 102 cm.

p163 *cfaal 412*, 2014.
archival pigment print, 127 x 102 cm.

p164 *cfaal 344*, 2013.
archival pigment print, 127 x 102 cm.

p165 *cfaal 380*, 2013.
archival pigment print, 127 x 102 cm.

jessica eaton

are you experienced?

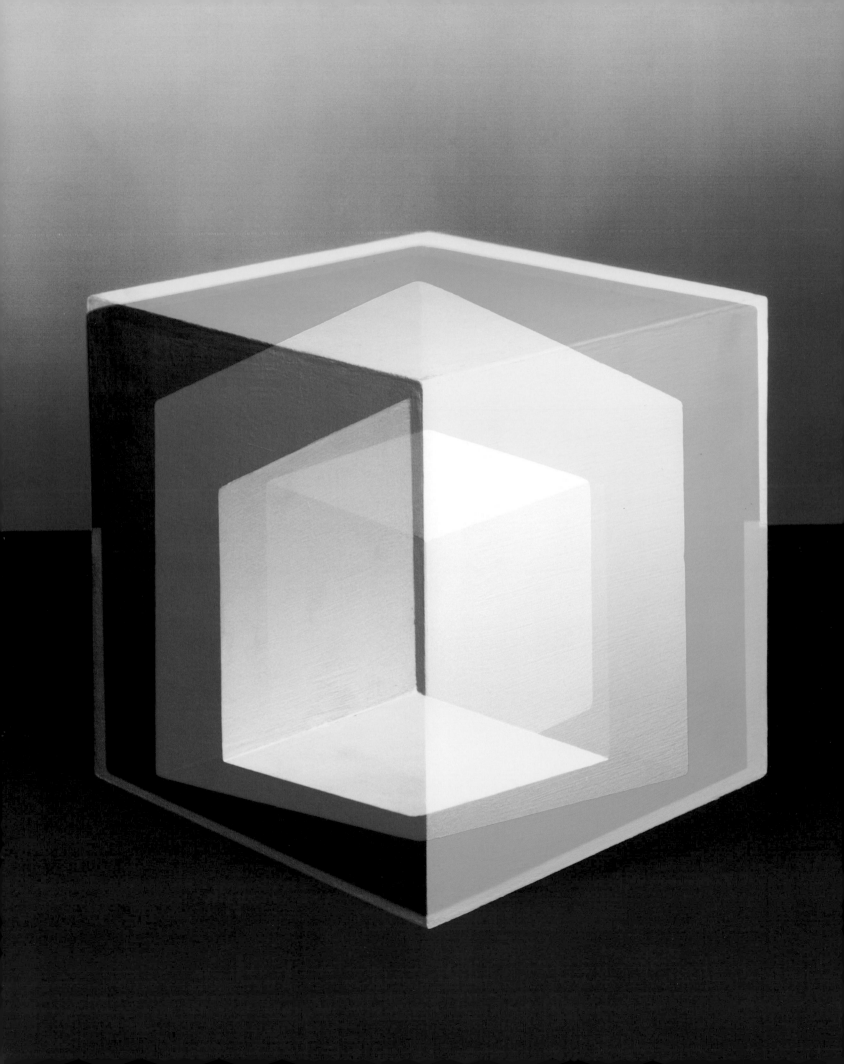

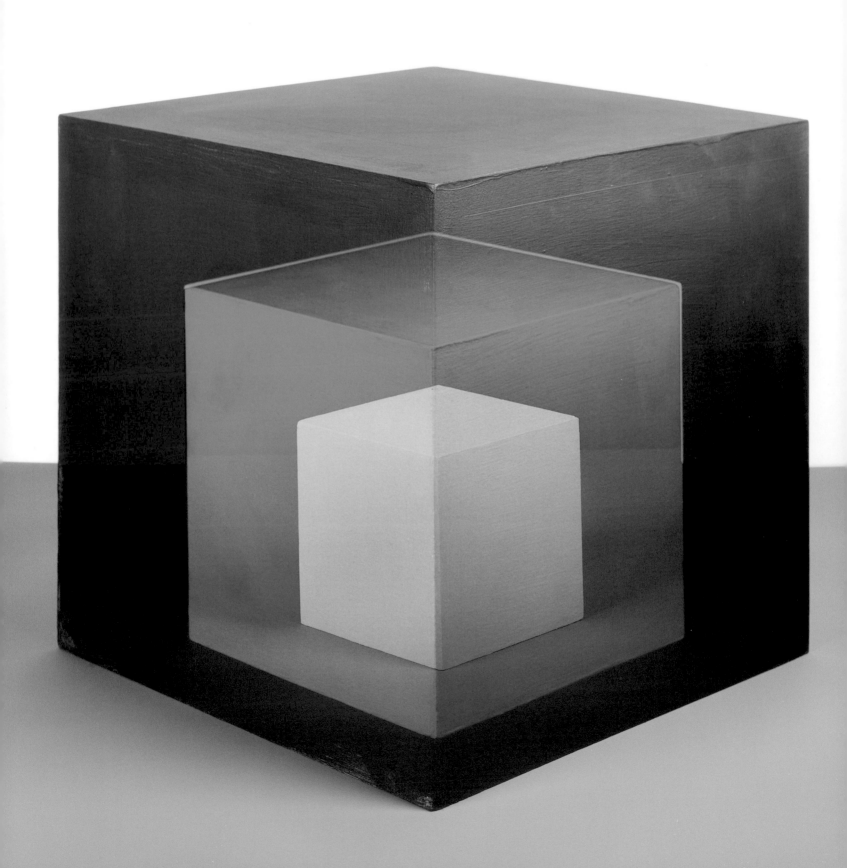

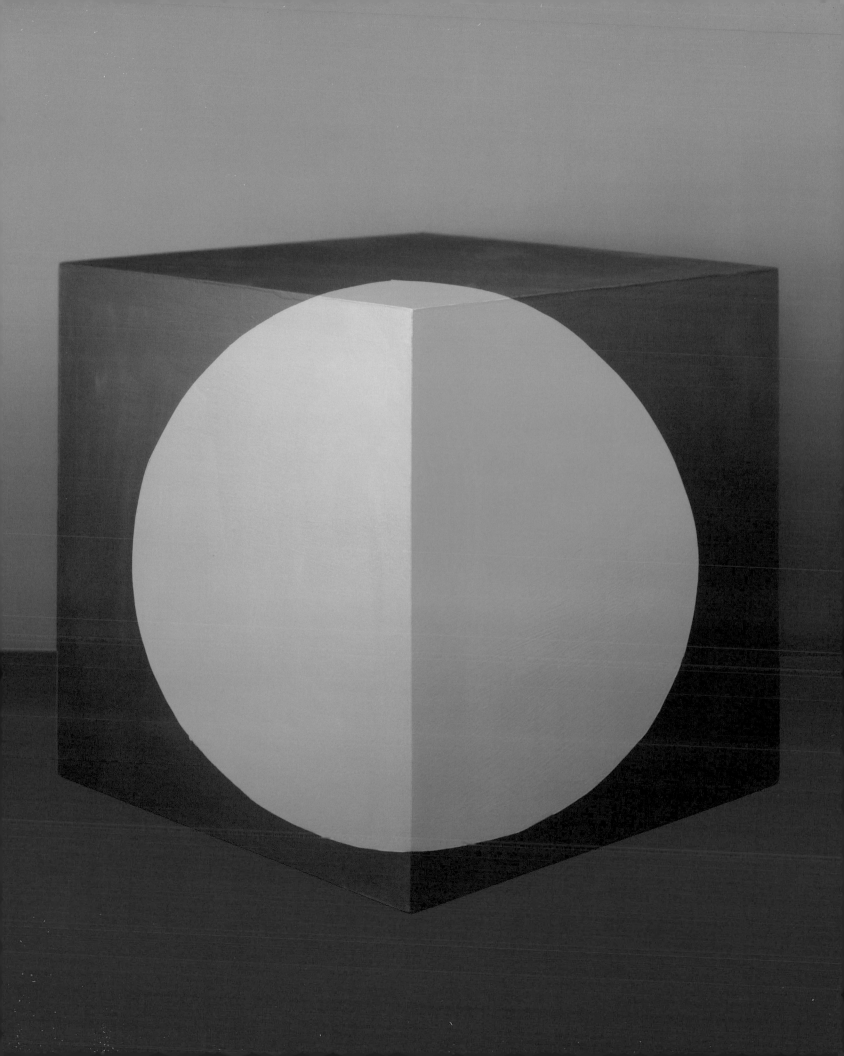

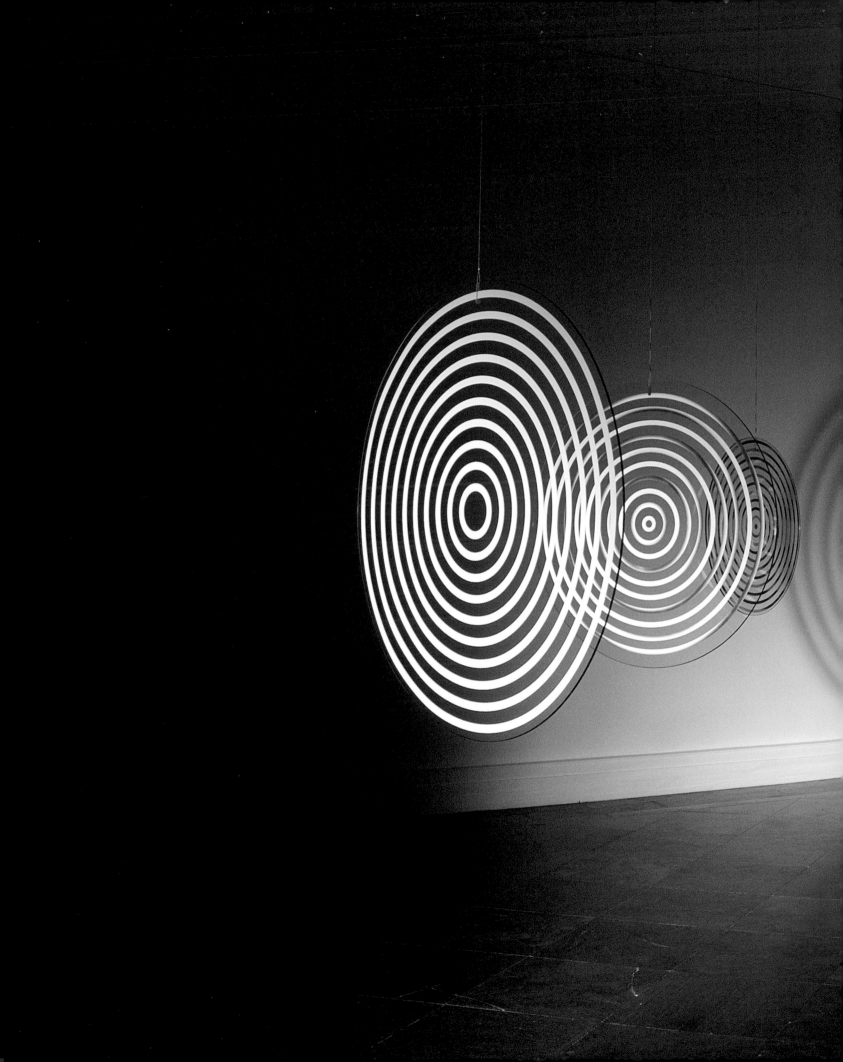

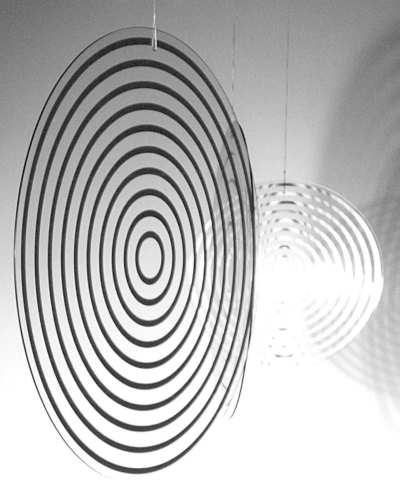

olafur eliasson's *triple ripple*

sally mckay

Olafur Eliasson asks viewers to "see themselves seeing". With these three words, the artist invites audiences to become aware of our own perceptual experiences in his installations. Eliasson's *Triple ripple* suggests to me several angles from which to examine embodied perception in the art experience: the physics of optics, the role of the gallery, new materialism, phenomenology and unknowable dimensions of perception.

the physics

Triple ripple consists of mechanical mechanisms producing complex visual effects. Light projects onto disks that spin about the room.[1] Concentric, mirrored circles create moiré patterns as reflected and projected light overlap and intersect. Diffraction creates fine bands of illumination in the edges of shadow and shadows in the fringes of light.[2] Vision is dazzled and confounded so that the act of seeing becomes a conscious undertaking. In a movie, spectators passively surrender to illusions emanating from a hidden projector. By contrast, Eliasson makes the technical apparatus a visible and integral aspect of the piece, encouraging viewers to consider human perception and machines in relation to one another.[3]

Moiré patterns emerge when regular patterns overlap. Neuroscientist Lothar Spillmann explains:

left **a jagged, vibrating pattern is created by overlaying and slightly rotating one set of vertical lines on top of another.**

right **moiré patterns also occur in images of concentric circles. The viewer can enhance the moiré effect by moving her head. An embodied sense of motion is immanent, even in these static images.**

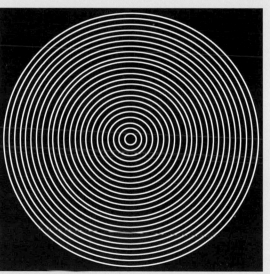

... moirés in "optical line interference" patterns are created by superimposing periodic visual stimuli, eg gratings, and shifting them relative to each other. When two gratings are presented in this manner, small differences in spatial frequency, orientation, and speed are magnified.[4]

According to Spillmann, moiré patterns are not illusions because they can be explained by physics. Nevertheless, he acknowledges an "apparent discrepancy between the stimulus and the percept".[5] In experiencing the illustrations above, readers may "see themselves seeing", because the strange patterns confound an everyday sense of

vision, even if one rationally understands the principles behind the effect. So what sets *Triple ripple* apart from moiré patterns on a printed page?

the gallery

Triple ripple is certainly spectacular. Kinetic, temporal and immersive, the installation produces intense affects by enveloping the viewer in a fully embodied experience. This makes the installation fun; one can transcend the everyday by stepping into an otherworldly environment. I would like to suggest, however, that the context of the art gallery itself is also integral to perception of the piece.

Art galleries offer thresholds. As I go about my day, I frequently neglect to notice my surroundings. Whenever I step into an art gallery, however, my perceptions shift gears. The historical context of the gallery has carved out a zone in the social sphere designed specifically for aesthetic self-awareness. Within museological discourse, the historic role of the art museum has been critically examined as an institution that reinforces social hierarchies and Western power structures. In considering Eliasson's work, it is also worth noting that the institutions of Western science and the museum share roots in the Age of Enlightenment and intersect throughout history as fields of inquiry based on observation. For example, the modernist notion of "art for art's sake" extracts objects from the messy contingencies of daily life and places them in a clean, white cube for contemplation. Similarly, the methodologies of the science lab limit variables in order to effectively position subjects as objects of observation. Eliasson's works leverage these historical conditions by bringing the history of art and the science of vision together within his installations. For him, the self-reflexive space of the museum has a political dimension. "I find it crucial", he says, "that museums focus on the visitor experience, rather than only on the artworks, to unfold their socializing potential and create an important relation between museums and the society in which they take part".[6]

The museum gallery has become, in part, a space for noticing objects and the ways that one's body interacts with them. If one considers the physics of optics, as *Triple ripple* encourages us to do, it becomes apparent that seeing is itself a material process, a physical interaction with the physical world.[7] While the social context of the museum remains politically charged, one of its most active contributions is that it can encourage viewers to adopt a critical, self-reflexive point of view. Eliasson explains:

> The institutional context in which the visitor and artwork are brought together is... essential, and together these form a complex network of elements that constitute the dynamic relationship between visitor, artwork, and institution. What I look at is... not only the experiencing of the artwork itself, or the artwork and institution as one, but also—and even more importantly—the ways in which the visitors may experience themselves experiencing the artwork. The audience should, in other words, be encouraged to see themselves both from a third-person perspective, that is, from the outside, and from a first-person perspective.[8]

To some degree, Eliasson positions his audiences as the subjects of a science experiment, one that takes place within the walls of an art institution rather than a lab. As distinct from the lab, however, here there are no impartial observers collecting data. Rather, by observing their own observations, subjects themselves are the ones who stand to gain knowledge from the experience.

The contemporary gallery frames art experience within historic and social contexts, encouraging critical reflection. Art galleries are public spaces. As we see ourselves seeing, we also see others seeing. While each viewer's perception is unique and individual, these engagements emerge within a rich and rhizomatic field of collective interaction.

new materialism

I have just used the word "interaction", but I would rather say "intra-action". This term was coined by physicist and philosopher Karen Barad who radically reconsiders materiality from a queer, feminist standpoint. For Barad, matter is a process, not a thing.[9] She uses the term intra-action to indicate that material processes are not just pre-existing objects acting on one another, but rather an ongoing entanglement of myriad entities that take their forms through their intra-actions.[10] *Triple ripple* situates the body of the viewer in intra-action with the material processes of moiré and diffraction. These connections extend to the social and ongoing intra-actions of material within our techno-mediated culture. In this way, the piece intersects with a growing field of research on new materialism.

Classical, Cartesian accounts of materiality make a clear distinction between the supposedly objective neutral stuff of the physical world and subjective social processes of conferring meaning. New materialists such as Barad, argue that this is a false dichotomy:[11]

> Meaning is not an ideality; meaning is material. And matter isn't what exists separately from meaning. Mattering is a matter of what comes to matter and what doesn't. Difference isn't given. It isn't fixed. Subject and object, wave and particle, position and momentum do not exist outside of specific intra-actions that enact cuts that make separations—not absolute separations, but only contingent separations —within phenomena.[12]

For Barad, the intra-actions of matter are concomitant with non-binary contingencies of queer identity and matters of social justice. In her recent essay on diffraction, quoted above, she examines the way that light operates as both a wave and a particle, confounding binary notions of this *or* that and self *or* other.

While *Triple ripple*, for me, connects to new materialist ideas, it also intra-acts with other artworks and art historical investigations. First, it resonates with the other art in the exhibition, a collection of works that each, in their own way, emphasize heightened perceptual awareness. *Triple ripple* also connects to philosophical and art historical inquiry into the subjective experience of perception and embodied response to art.

phenomenology

For philosopher Maurice Merleau-Ponty, art was in itself a form of philosophical investigation.[13] The following passage from his 1948 essay on Paul Cézanne could as easily be applied to Eliasson in the present day:

> Cézanne did not think he had to choose between feeling and thought, between order and chaos. He did not want to separate the stable things which we see and the shifting way in which they appear; he wanted to depict matter as it takes on form, the birth of order through spontaneous organization. He makes a basic distinction not between 'the senses' and 'the understanding' but rather between spontaneous organization of the things we perceive and the human organization of ideas and sciences.[14]

During the postmodern era, phenomenology fell out of favour because it was associated with essentialist and reductive implications.[15] Indeed, even Eliasson has articulated discomfort with phenomenological readings of his work, concerned that his art might be "justified as an isolated event, not having anything to do with anything else".[16] Yet, as the quote above demonstrates, Merleau-Ponty himself articulated entanglements between the senses and social structures. Due in part to the contributions of artists such as Eliasson, Merleau-Ponty's writings have recently been re-considered. Art critic Claire Bishop, for example, situates Eliasson among a group of "phenomenological" artists emerging in 1990s, whose works, she suggests, call for new readings of Merleau-Ponty that acknowledge how he situated the perceiver as an historically inflected subject rather than an objective, neutral observer.[17]

Art historian Amanda Boetzkes also revisits Merleau-Ponty in her analysis of Eliasson's work, and she further references another contentious twentieth-century philosopher, Martin Heidegger, in her suggestion that Eliasson's installations "... render the apparatus for technological enframent transparent...."[18] Enframent is Heidegger's term, attached to his notion that technological systems reduce the material world to mere resource. As we inhabit technological frameworks, their influence is difficult to perceive. *Triple ripple*, I suggest, breaches the invisibility of technological influence by directing viewers' attention to the ways that the apparatus physically impacts vision. While the experience may be fun and pleasurable, it also sparks potential for cultural critique of the ways in which ubiquitous use of technology enframes human perception in the everyday.

I do not know if Eliasson takes direct influence from Merleau-Ponty, although the artist has indicated that he is well read in phenomenology.[19] It is interesting to note, however, a striking similarity between Eliasson's phrase "see yourself seeing" and the following words written by Merleau-Ponty in 1961:

> ... my body simultaneously sees and is seen. That which looks at all things can also look at itself and recognize, in what it sees, the "other side" of its power of looking. It sees itself seeing; it touches itself touching; it is visible and sensitive for itself. It is a self, not by transparency, like thought, which never thinks anything except by assimilating it, constituting

it, transforming it into thought—but a self by confusion, narcissism, inherence of the see-er in the seen, the toucher in the touched, the feeler in the felt—a self, then, that is caught up in things, having a front and a back, a past and a future....[20]

Far from isolating vision as an empirical zone of clarity, Merleau-Ponty here embraced the murky contingencies of embodied experience. In the context of *Triple ripple*, the experience of seeing oneself seeing shifting moirés and diffracted light in motion may not provide a moment of understanding, so much as an acknowledgment that vision entails dimensions of experience that defy reason.

unknowable dimensions

Art historian Rosalind Krauss has acknowledged illegible aspects of art that emerge when sensing bodies engage with material works. In her book, *The Optical Unconscious*, 1998, she challenges Clement Greenberg's notion of transcendent vision, detached not only from the other senses, but also from cultural and historic conditions.[21] Krauss' version of Modernism, written "against the grain" of Greenberg, is concerned with the unchartable "blind, irrational space of the labyrinth" rather than the clean and tidy optics of the modernist grid.[22] She coined the term "optical unconscious" to describe temporal, carnal and irrational aspects of vision that haunt the modernist paradigm.

Krauss develops her notion of the optical unconscious through an analysis of Marcel Duchamp's *Rotary Demisphere (Precision Optics),* a kinetic sculpture, created in 1924, that is remarkably similar to Eliasson's *Triple ripple*. *Rotary Demisphere* consists of a motorized stand, its simple mechanics exposed to view. A hemisphere spins at eye-level, painted in black and white concentric circles. The spinning circles appear as an undulating spiral that rises toward the viewer, as if emanating up from within a volumetric space, and then recedes, sliding back down the outer sides.[23] For Krauss, the piece produces a phenomenon that she calls its "temporal pulse":

> It is in that languidly unreeling pulsation, that hypnotically erotic, visual throb of Duchamp's *Precision Optics*, that one encounters the *body* of physiological optics' seeing fully enmeshed in the temporal dimension of nervous life, as it is also fully awash in optical illusion's 'false induction.' But it is here, as well, that one connects to this body as the site of libidinal pressure on the visual organ, so that the pulse of desire is simultaneously felt as the beat of repression.[24]

Krauss indicates here that vision entails the body, and that the body inflects vision with corporeal desire. Furthermore, she suggests that this seeing body also incorporates and constitutes the brain and its cognitive processes:

> The cerebral cortex is not above the body in an ideal or ideated remove; it is, instead, *of* the body, such that the reflex arc of which it is a part connects it to a whole field of stimuli between which it cannot distinguish.[25]

Thus, in Krauss' formulation, the illegible embodied aspects of perception not only haunt vision, but thought as well.

The imagery of Eliasson's *Triple ripple*, like Duchamp's *Rotary Demisphere*, consists only of spinning disks. And yet, as the moiré patterns above indicate, even an abstracted visual experience may be haunted with inarticulate sensations; the mysterious, emergent patterns of sensing bodies intra-acting the world.

Triple ripple makes the instability of vision apparent, giving rise to feelings of contingency within the body. Indeed, human bodies are here construed as processes rather than fixed objects, developing in concert with the world in such a way that external conditions can never be fully extricated from the subjective self. In this way, *Triple ripple* supports a new materialist standpoint, in which the perceiving subject is not the sole source of meaning, but rather produces meaning in concert with other material agencies. This standpoint, owing much to the history of phenomenological thought, opens doors for us to critically configure our technological frameworks in new ways, aware of our intra-actions as immanent, earthly, social bodies. Within the self-reflexive context of the gallery, Eliasson's viewers are invited to become aware of perception as an embodied social phenomenon; individual, collective, and worthy of care.

1 Eliasson gives a nod to the historical context of the moiré in his title, *Triple ripple*. The term "moiré" means "watered" in French. Historically, the word was used to refer to silk fabrics that had a rippled appearance.

2 In her recent essay on diffraction, Karen Barad describes the phenomenon thus, "Bands of light appear inside the shadow region—the region of would-be total darkness; and bands of darkness appear outside the shadow region. There is no sharp boundary separating the light from the darkness: light appears within the darkness within the light within." See Barad, Karen, "Diffracting Diffraction: Cutting Together-Apart", *parallax*, vol 20, no 3, 2014, p 170.

3 Amanda Boetzkes has eloquently addressed the critical potential of Eliasson's transparent use of technology, "The goal is therefore not to recover nature in a disenchanted modern environment but rather to show how technology might be redirected toward the destabilization of habitual ways of perceiving natural events and can be the basis of a sensitive interaction with the earth." See Boetzkes, Amanda, *The Ethics of Earth Art*, Minneapolis and London: University of Minnesota Press, 2010, p 131.

4 Spillmann, Lothar, "The perception of movement and depth in moiré patterns", *Perception*, vol 3, no 22, 1993, p 287.

5 Spillmann, "The perception of movement and depth in moiré patterns", p 289.

6 Eliasson, Olafur, "Some Ideas about Colour", *Olafur Eliasson: Your Colour Memory*, Ismail Soyugenc and Richard Torchia eds, exhibition catalogue, Glenside: Arcadia University Art Gallery, 2006, pp 75–83.

7 Jennifer Fisher discusses the entanglement of vision and touch in "Relational sense: towards a haptic aesthetics", *Parachute: Contemporary Art Magazine* 87, July–September 1997, pp 4–11.

8 Eliasson, "Some Ideas about Colour", pp 75–83.

9 Barad, Karen, "Posthumanist Performativity: Toward an Understanding of How Matter Comes to Matter", *Signs: Journal of Women in Culture and Society*, vol 28, no 3, 2003, p 822.

10 Barad, "Posthumanist Performativity: Toward an Understanding of How Matter Comes to Matter", p 815.

11 Jane Bennett is perhaps the most influential new materialist philosopher. See her book, *Vibrant matter: a political ecology of things*, Durham, NC: Duke University Press, 2010.

12 Barad, "Diffracting Diffraction: Cutting Together-Apart", p 175.

13 For an in-depth analysis of Merleau-Ponty's writings on art, see Matthews, Eric, *The Philosophy of Merleau-Ponty*, Montreal: McGill-Queen's University Press, 2002, pp 133–171.

14 Merleau-Ponty, Maurice, "Cézanne's Doubt", *Sense and Non-Sense*, Hubert L Dreyfus and Patricia Dreyfus eds, Evanston, Ill: Northwestern University Press, 1964, p 13.

15 Pamela Lee acknowledged such concerns in her essay for Eliasson's *Take Your Time* exhibition catalogue, explaining the postmodern turn against phenomenological thought: "Indeed, critiques of phenomenology hold that its putative subject is timeless and universal, unmarked by any number of influences that shape one's experience of the world, whether economic, social, ethnic, national or gendered." Lee, Pamela, "Your Light and Space", *Take Your Time: Olafur Eliasson*, San Francisco, California: San Francisco Museum of Modern Art; New York, NY: Thames & Hudson, 2007, p 35.

16 Olafur Eliasson quoted in Griffin, Tim, "In Conversation: Daniel Buren & Olafur Eliasson", *Artforum International*, 43, no 9, May 2005, p 213.

17 Bishop, Claire, *Installation Art*, London: Tate Publishing, 2010, c 2005, p 76.

18 Boetzkes, *The Ethics of Earth Art*, p 137.

19 For more on Eliasson's thoughts on phenomenology, see Griffin, "In Conversation: Daniel Buren & Olafur Eliasson".

20 Merleau-Ponty, Maurice, "Eye and Mind", *The Merleau-Ponty Aesthetics Reader*, Galen A Johnson ed, Evanston: Northwestern University Press, 1993, p 124.

21 Krauss, Rosalind, *The Optical Unconscious*, Cambridge, MA and London: The MIT Press, 1998, p 7.

22 Krauss, *The Optical Unconscious*, p 21.

23 Video documentation of Marcel Duchamp's *Rotary Demisphere (Precision Optics)* in operation is available online at http://www.youtube.com/watch?v=6MpcOWSoFOc

24 Krauss, *The Optical Unconscious*, p 138.

25 Krauss, *The Optical Unconscious*, p 124.

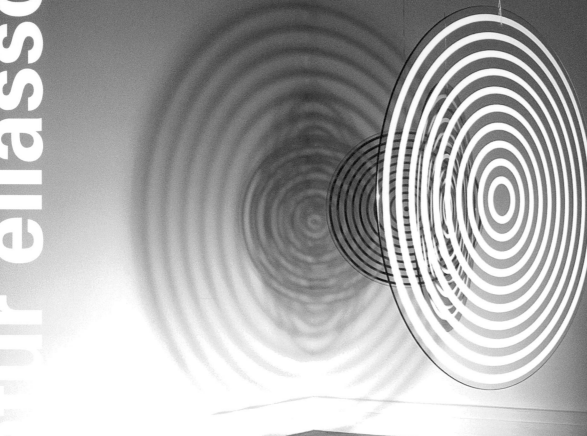

olafur eliasson

are you experienced?

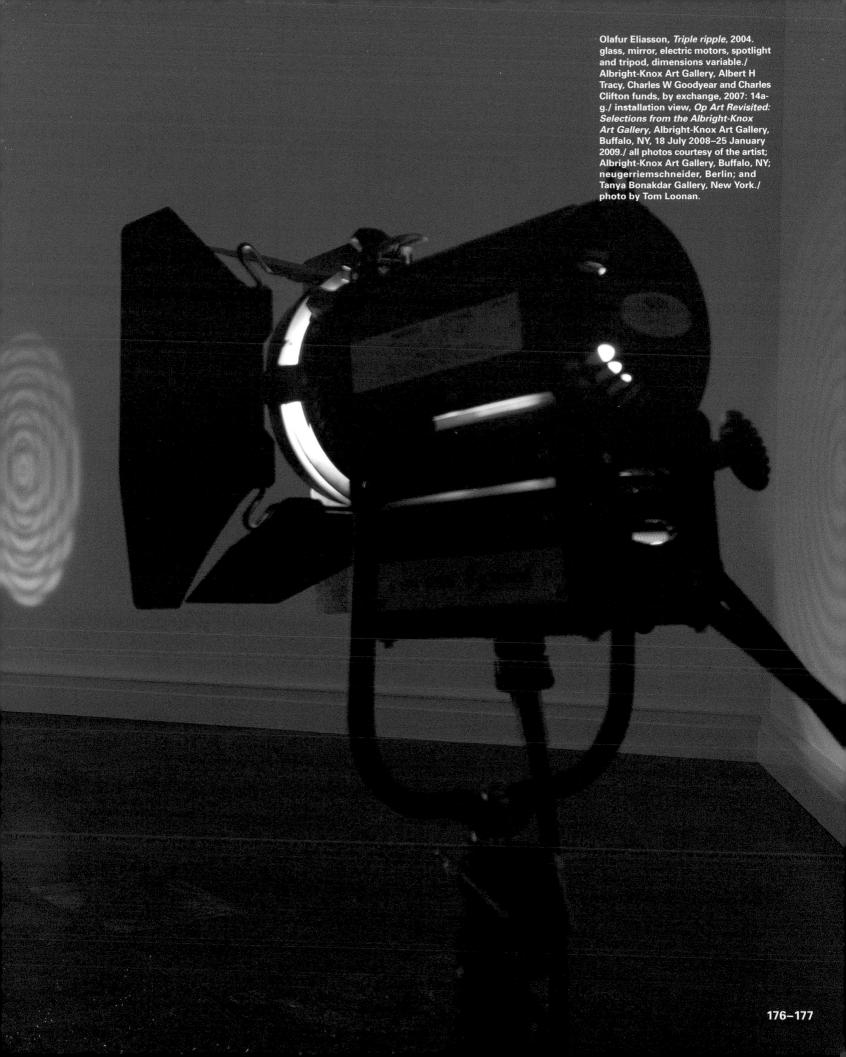

Olafur Eliasson, *Triple ripple*, 2004. glass, mirror, electric motors, spotlight and tripod, dimensions variable./ Albright-Knox Art Gallery, Albert H Tracy, Charles W Goodyear and Charles Clifton funds, by exchange, 2007: 14a-g./ installation view, *Op Art Revisited: Selections from the Albright-Knox Art Gallery*, Albright-Knox Art Gallery, Buffalo, NY, 18 July 2008–25 January 2009./ all photos courtesy of the artist; Albright-Knox Art Gallery, Buffalo, NY; neugerriemschneider, Berlin; and Tanya Bonakdar Gallery, New York./ photo by Tom Loonan.

Triple ripple, 2004.
collection of Albright-Knox Art Gallery./
installation view, *Op Art Revisited:
Selections from the Albright-Knox Art
Gallery,* Albright-Knox Art Gallery,
Buffalo, NY, 18 July 2008–25 January
2009./ photo by Tom Loonan.

are you experienced?

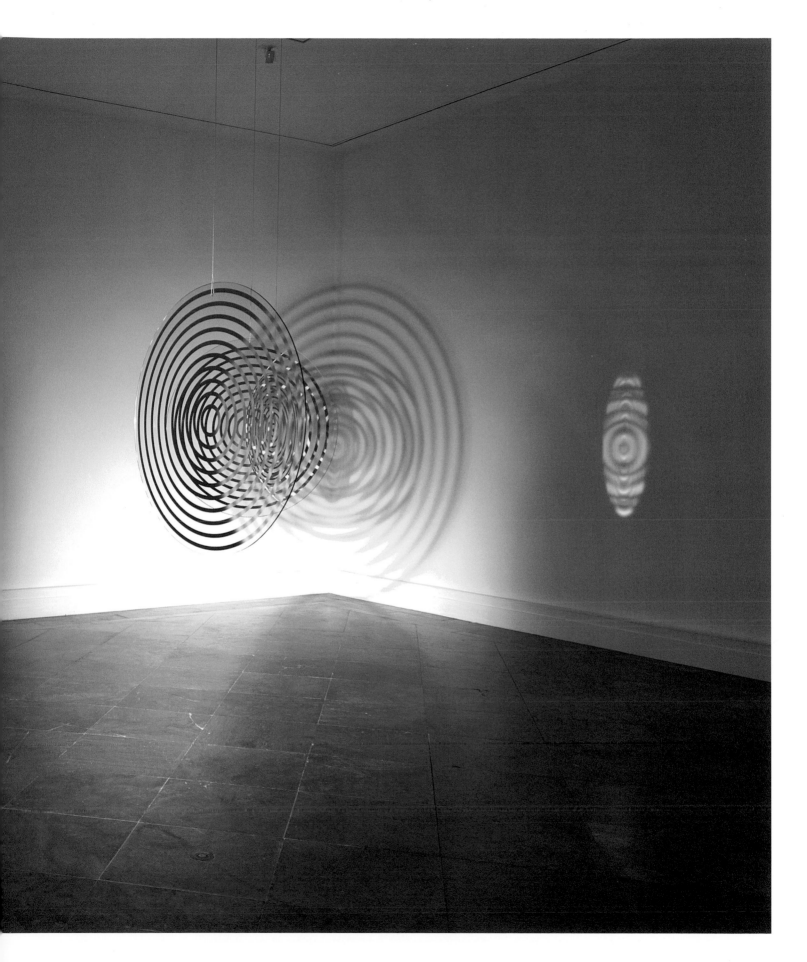

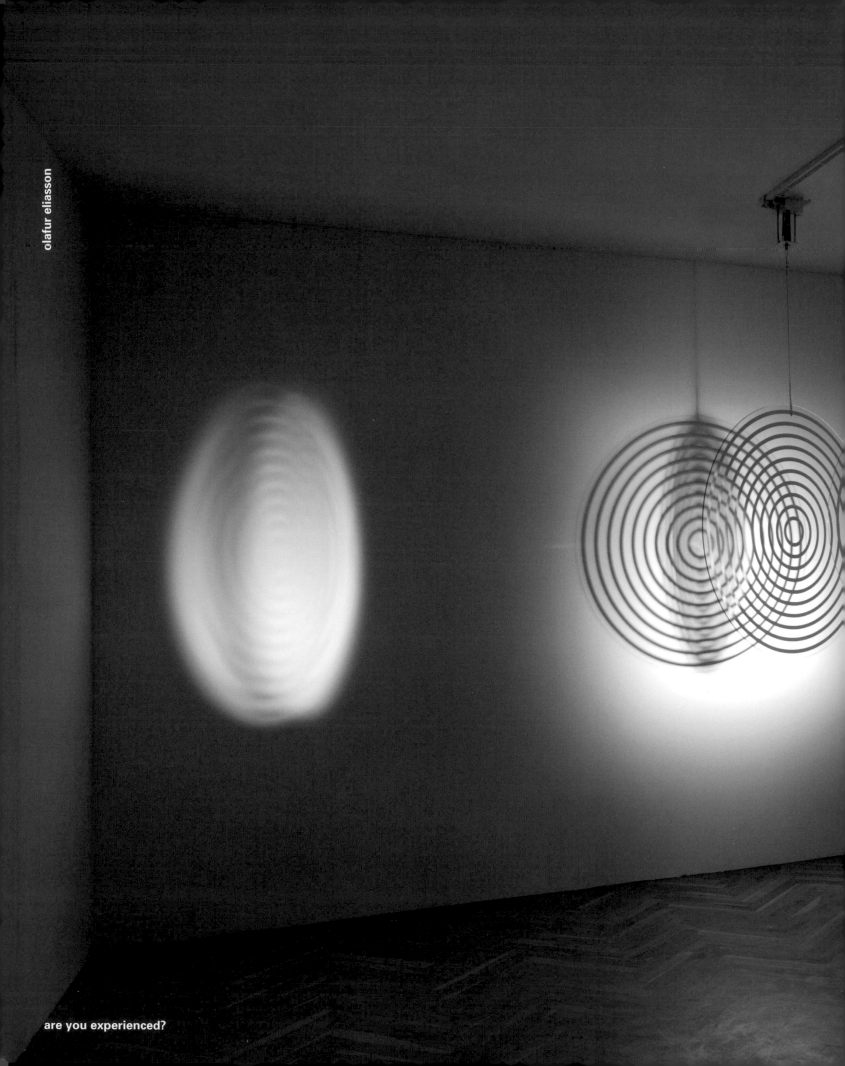

olafur eliasson

are you experienced?

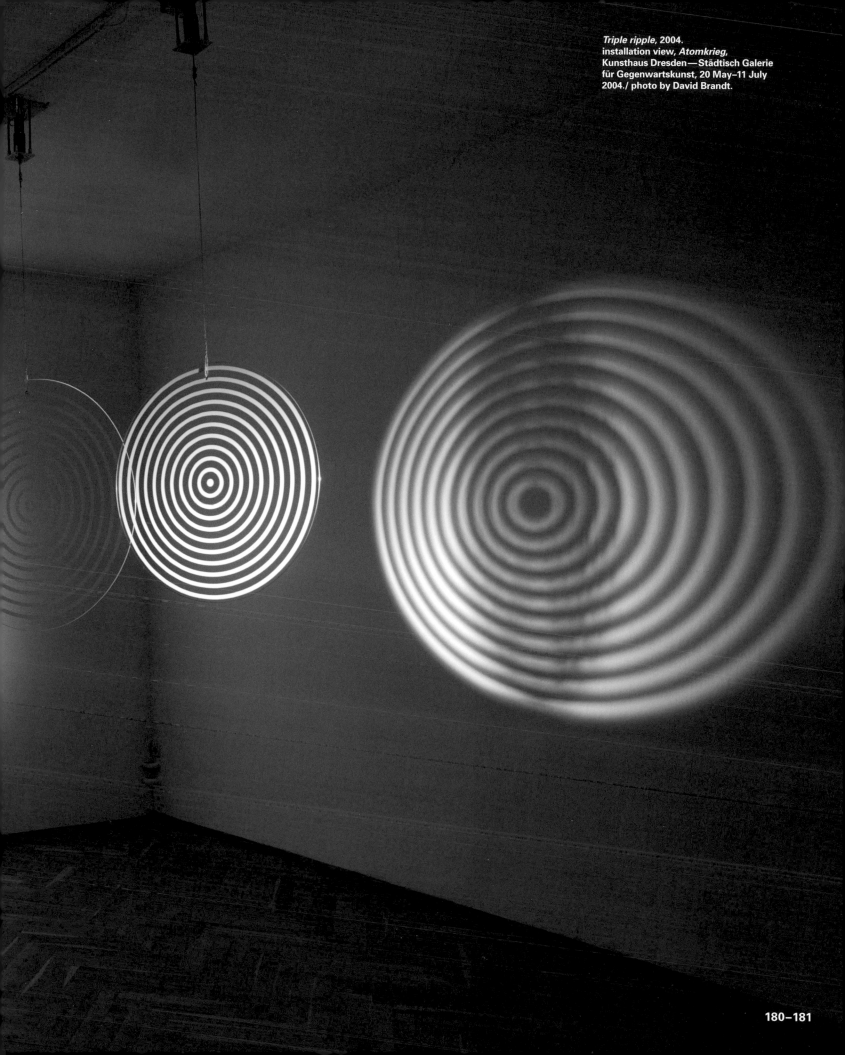

Triple ripple, 2004.
installation view, *Atomkrieg*,
Kunsthaus Dresden—Städtisch Galerie
für Gegenwartskunst, 20 May–11 July
2004./ photo by David Brandt.

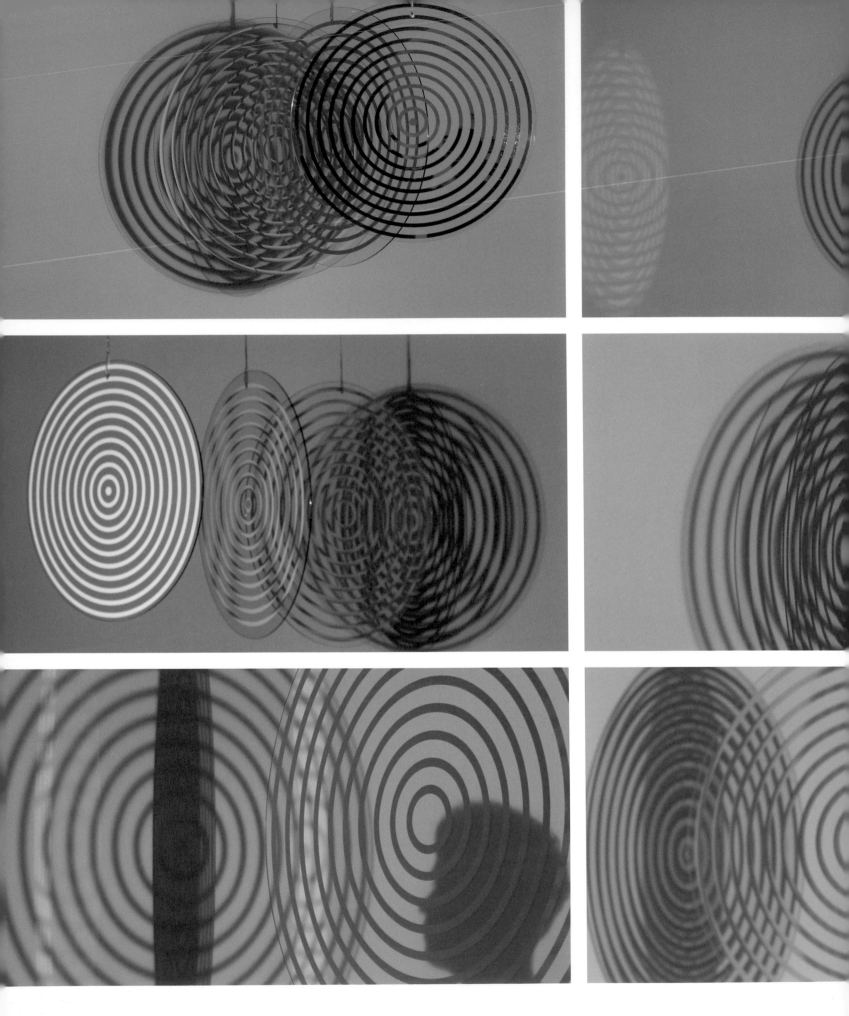

are you experienced?

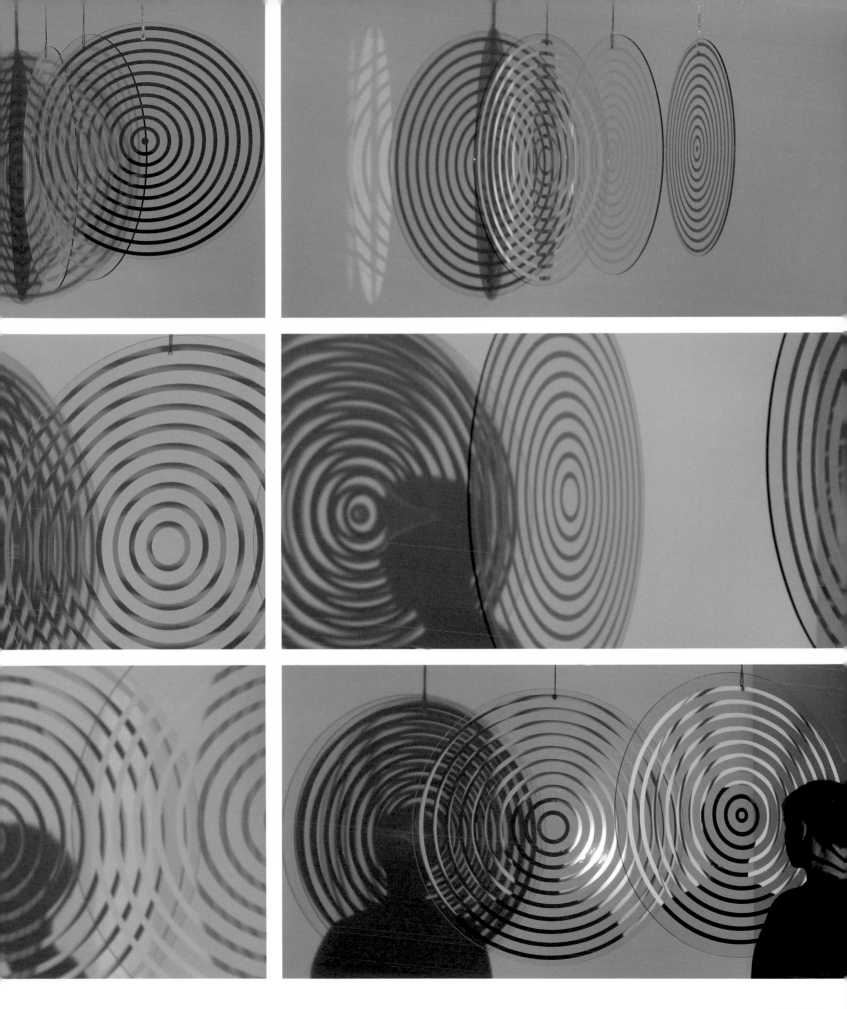

previous pages
Triple ripple, 2004.
installation view, *Atomkrieg*,
Kunsthaus Dresden—Städtisch Galerie
für Gegenwartskunst, 20 May–11 July
2004./ photos by Silke Heneka.

right *Triple ripple*, 2004.
installation view, ARoS Aarhus
Kunstmuseum, Denmark, 2004./
photo by Poul Pedersen.

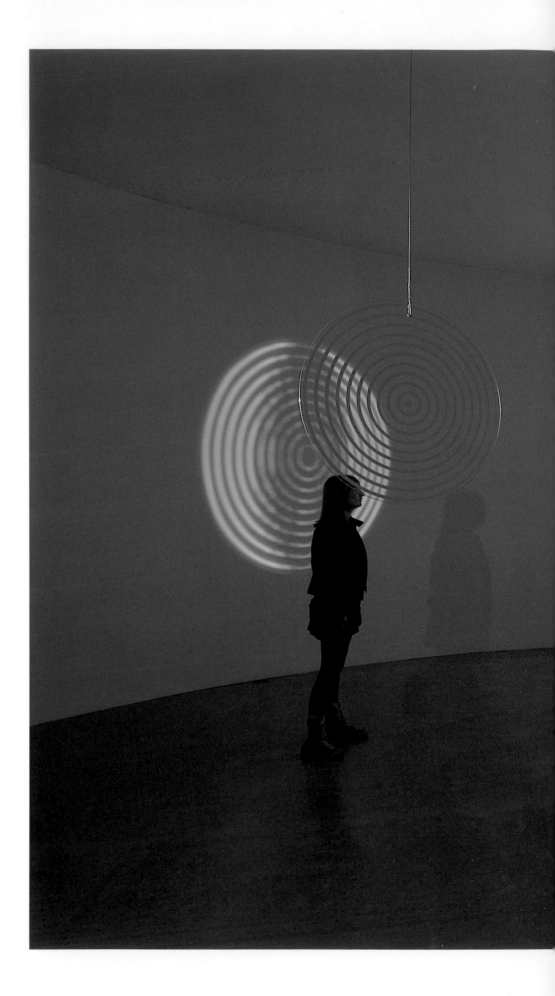

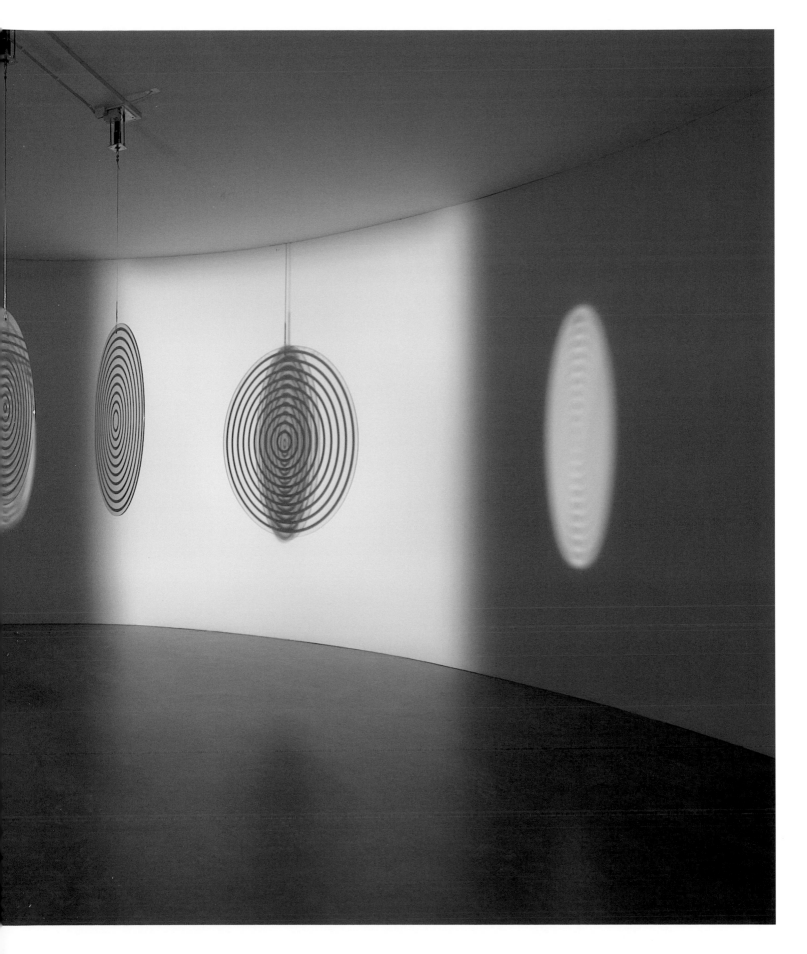

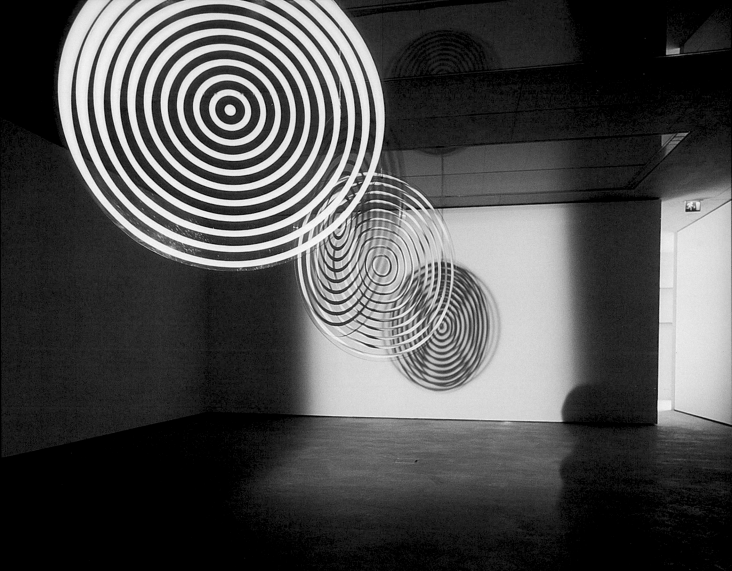

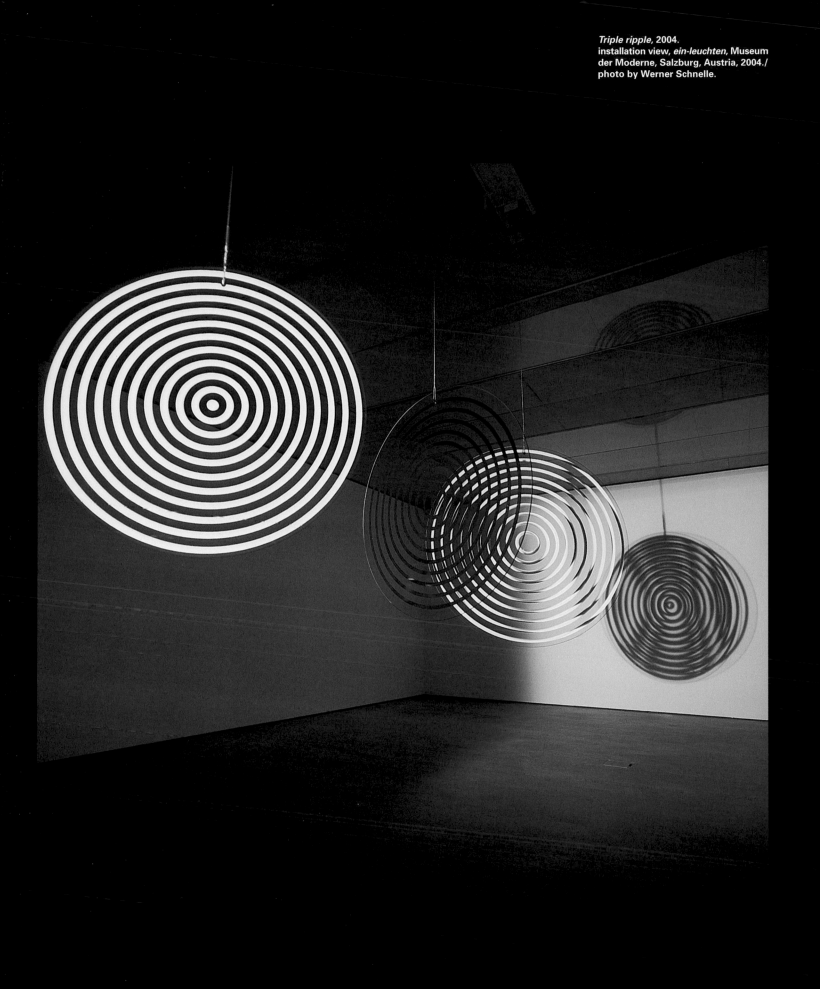

Triple ripple, 2004.
installation view, *ein-leuchten*, Museum
der Moderne, Salzburg, Austria, 2004./
photo by Werner Schnelle.

artist and contributor biographies

nadia belerique (b 1982 canada)

Nadia Belerique constructs installations that engage with the poetics of perception and asks how images perform in contemporary culture. Primarily invested in questions around materiality and dematerialization through the illusion of photographs, her image-based works are often interrupted by sculptural objects. She received her MFA from the University of Guelph, and has recently exhibited at such venues as Daniel Faria Gallery in Toronto, and Kunsthalle Wein in Vienna. She was awarded the BMW Exhibition Prize during Scotiabank CONTACT Photography Festival in 2014. She has an upcoming exhibition at Tomorrow Gallery in New York and a collaborative exhibition with Laurie Kang and Lili Huston-Herterich at The Power Plant, Toronto. She lives and works in Toronto.

jessica eaton (b 1977 canada)

Jessica Eaton lives and works in Montreal. Eaton's photographs dissect chemical and optical phenomena, the materiality of film, and the language of light itself. Eaton came to international acclaim through her *Cubes for Albers and LeWitt* (commonly referred to by the acronym *cfaal*)—a series of vibrant photographs that deconstruct her studio practice. Like the majority of Eaton's works, these optically charged images are made by taking multiple in-camera exposures of common studio supplies. Through her abundant use of traditional analogue photography practices—such as colour-separation filtering and in-camera masking—Eaton imbues her large-format images with an aesthetic more reminiscent of the paintings and drawings of hard-edge geometric abstraction than the photographs of traditional studio work. Eaton received a BFA from Emily Carr Institute of Art + Design in 2006. She has shown across Canada and internationally, including at Presentation House Gallery, Foam Fotographiemuseum, the Quebec Triennial and the Daegu Photo Biennale.

olafur eliasson (b 1967 denmark)

Throughout the past two decades, Olafur Eliasson's installations, paintings, photographs, films, and public projects have served as tools for exploring the cognitive and cultural conditions that inform our perception. Described by the artist as "devices for the experience of reality", his works and projects prompt a greater sense of awareness about the way we engage with and interpret the world. In 2003, Eliasson represented

Denmark at the 50th Venice Biennale with *The blind pavilion*, and, later that year, he opened the celebrated work *The weather project* in Tate Modern's Turbine Hall. Subsequently, the artist's first retrospective, *Take your time: Olafur Eliasson*, opened at the San Francisco Museum of Modern Art in 2007 before traveling to the Museum of Modern Art and PS1 in New York; The Dallas Museum of Art; The Museum of Contemporary Art, Chicago; and The Museum of Contemporary Art, Sydney, through 2010. Eliasson has also produced a number of notable permanent installations and site-specific works including the Serpentine Gallery Pavilion, 2007 (designed together with Kjetil Thorsen); The New York City Waterfalls, 2007, in New York; *Your rainbow panorama*, 2011—a 150-metre circular, coloured-glass walkway situated on top of ARoS Museum in Aarhus, Denmark; and Harpa Reykjavik Concert Hall and Conference Centre, for which Eliasson created the facades in collaboration with Henning Larsen Architects. Eliasson lives and works in Copenhagen and Berlin.

dorian fitzgerald (b 1975 canada)

Dorian FitzGerald makes monumental paintings of materially excessive situations. Past subject matter includes the dining room of Stefano Gabbana's yacht; the throne room of the Queluz National Palace in Lisbon; table decorations for a party thrown by Oprah Winfrey for Sidney Poitier; a Fabergé Egg ornamented by a rose trellis; a Cartier bracelet and an image of Elton John's sunglasses collection at his estate in Old Windsor, England. Recent and upcoming group exhibitions include MOCCA (Toronto), Galerie de l'UQAM and the Musée des beaux-arts de Montréal. He is a 2001 graduate of the Art and Art History Program of the University of Toronto Mississauga and Sheridan College, and lives and works in Toronto where he is represented by Clint Roenisch Gallery.

hadley+maxwell (b 1973 canada, b 1966 canada)

Hadley+Maxwell's installations, performances and writings employ diverse media to rework iconic images and traditional forms as they are expressed in pop-cultural, artistic and political movements. They cut into reified narratives via direct touch, transposition and refiguration, putting into play the absences cast in relief.

Hadley+Maxwell have been collaborating since they met in Vancouver, Canada, in 1997. Public presentations of their work have included solo exhibitions at: Artspeak, Vancouver; Contemporary Art Gallery, Vancouver; Künstlerhaus Bethanien, Berlin; Kunstverein Göttingen, Germany; Smart Project Space, Amsterdam; and Project Art Centre, Dublin. Group exhibitions at galleries and festivals include: the Vancouver Art Gallery; Kunstraum München; The Power Plant, Toronto; the National Gallery of Canada; Taipei Fine Arts Museum, the Seattle Art Museum; La Kunsthalle Mulhouse, France; Witte de With, Rotterdam; the 4th Marrakech Biennale; and the 19th Biennale of Sydney. They are represented by Jessica Bradley, Toronto, and live and work in Berlin, Germany.

do ho suh (b 1962 korea)

Do Ho Suh is an internationally renowned Korean artist whose site-specific installations and meticulously crafted sculptures question boundaries of identity and conventional notions of scale and space in both its physical and metaphorical manifestation. Suh studied at Seoul National University, Rhode Island School of Design and Yale University School of Art. He currently maintains studios in London, Seoul, and New York.

Suh's thought-provoking works have been represented in many of the world's leading museums, including: the Museum of Modern Art, the Guggenheim Museum, and the Whitney Museum of American Art in New York; the Tate Modern and Serpentine Gallery in London; the National Museum of Modern and Contemporary Art and Artsonje Center in Seoul; and Museum of Contemporary Art and Mori Art Museum in Tokyo. In 2001, Suh represented Korea at the Venice Biennale and in 2010 participated in the Venice Biennale Architecture Exhibition and the Liverpool Biennial. His most recent exhibitions and projects include: *Do Ho Suh*, 2014–2015, at the Contemporary Austin; *Hanjin Shipping Box Project: Do Ho Suh—Home within Home within Home within Home within Home*, 2013–2014, at National Museum of Modern and Contemporary Art, Korea; *The Perfect Home*, 2012–2013, at 21st Century Museum of Contemporary Art, Kanazawa; *Fallen Star*, 2012, in Stuart Collection, University of San Diego; and *Home within Home*, 2012, at Leeum—Samsung Museum of Art, Seoul.

—

melissa bennett is curator of *are you experienced?* and Curator of Contemporary Art at the Art Gallery of Hamilton.

jennifer fisher and jim drobnick curate under the collective name DisplayCult and co-edit the *Journal of Curatorial Studies*. They live in Toronto and teach at York University and OCAD University, respectively.

sally mckay is an artist, writer and curator conducting research at the intersections of art and science. She teaches Art and Art History at McMaster University.

gabrielle moser is a writer, educator, and curator based in Toronto. She contributes regularly to Artforum.com and *Canadian Art* magazine and teaches at OCAD University.

alana traficante is an emerging writer and curator, currently pursuing an MFA in Criticism & Curatorial Practice at OCAD University.

acknowledgements

are you experienced? would not have been possible without the support of many contributors. I wish to thank the artists: Nadia Belerique, Jessica Eaton, Olafur Eliasson, Dorian FitzGerald, Hadley+Maxwell and Do Ho Suh for their critical practices. Their brilliance has provided us with fresh understanding, and ways of seeing, within the gallery.

The exhibition is supported by our lenders, and we are grateful to our partners: Felicia Cukier, Kitty Scott, Debbie Johnsen, Matthew Teitelbaum, Sean Weaver, Art Gallery of Ontario; Stéphane Aquin, Nathalie Bondil, Marie-Claude Saia, Montreal Museum of Fine Arts; Catherine Scrivo Baker, Kelly Carpenter, Holly E Hughes, Dr Janne Sirén, Albright-Knox Art Gallery. We thank the artists' galleries and studios for their research and facilitating work: Jessica Bradley, Jane Hutchison, Leah Turner, Jessica Bradley Gallery; Nick Brown, Jessica Eaton studio; Clint Roenisch, Clint Roenisch Gallery; Kristin North, Gregory La Rico and Stephanie Smith, Lehmann Maupin; Joanne Koo, Josette Chiang, Suh Art; Shawna Cooper, Annie Rochfort, Tanya Bonakdar Gallery; Kajana Wagner and Biljana Joksimovic-Große, Studio Olafur Eliasson; Dory Smith, Daniel Faria, Daniel Faria Gallery; Emer Lynch, Project Arts Centre. We are also very thankful to the private collectors who have agreed to lend their work for the purposes of this exhibition.

The exhibition is predicated on myriad ways of seeing, and the works are truly illuminated in the essays by Jennifer Fisher and Jim Drobnick, Sally McKay, Gabrielle Moser and Alana Traficante. Thank you for adding your insight to the ways in which these artists are working. I am grateful to Joan Padgett for her thoughtful edits to my essay.

I am indebted to the staff at the Art Gallery of Hamilton, including Louise Dompierre, former President and CEO, for her early support and insight on the project, and to Shelley Falconer, our new President and CEO, for her enthusiasm and facilitation of this major undertaking. My colleagues have provided immeasurable support on all tasks from the idea stage, to editing, to logistics and installation. Their dedication and commitment to the village is what moves this not-so-simple project forward. I thank Tobi Bruce for all her encouragement of the project and her feedback on my writing. I am grateful for the behind-the-scenes work of Christine Braun, Greg Dawe, Paula Esteves Mauro, Laurie Kilgour-Walsh, Lela Radisevic and Benedict Leca; and the marketing and communications team: Janet Mowat, Steve Denyes and Megan Olynik. Thank you to Stefan Nicoloff for his research assistance and to Larissa Ciupka for her suggestion of the exhibition title.

For their early support and commitment to seeing this project take shape, I am grateful to Kieran C Dickson, Pierre Karch and Mariel O'Neill-Karch, Robert Munroe and John and Ginny Soule. The exhibition idea arrived through a long research process, and it was developed in part through conversations with artists and friends including Stefan Hancherow, Graeme Patterson, Tyler Tekatch, John Haney and Amanda Jernigan.

Thank you to the team at Black Dog Publishing for their fine work on the publication, including Duncan McCorquodale, Rachel Pfleger, Leanne Hayman, Lauren Whelan, James Brown and others.

I also thank my family; Cathy and Jon; Paul and Steve and their families; and Marco D'Andrea and Aria Catherine D'Andrea, to whom this book is dedicated.

publication sponsors

Kieran C Dickson; Pierre Karch and Mariel O'Neill-Karch; Robert Munroe; John and Ginny Soule.

—

Black Dog Publishing Limited t. +44 (0)207 713 5097
10A Acton Street f. +44 (0)207 713 8682
London WC1X 9NG e. info@blackdogonline.com

All opinions expressed within this publication are those of the author and not necessarily of the publisher.

Designed by Rachel Pfleger at Black Dog Publishing.
Edited by Melissa Bennett at Art Gallery of Hamilton.

ISBN 978 1 910433 01 0
British Library Cataloguing-in-Publication Data.

A CIP record for this book is available from the British Library.

Black Dog Publishing is an environmentally responsible company. *are you experienced?* is printed on sustainably sourced paper.

TD Bank Group is proud to sponsor the *are you experienced?* exhibition organized by the Art Gallery of Hamilton. TD strives to make a positive impact where we do business and where our customers and employees live and work. For us, that means contributing to the arts and our communities in meaningful and innovative ways. Our hope is that this exhibit encourages visitors and artists of all stages to further their appreciation of the visual arts.

ONTARIO ARTS COUNCIL
CONSEIL DES ARTS DE L'ONTARIO
an Ontario government agency
un organisme du gouvernement de l'Ontario

Canada Council for the Arts **Conseil des Arts du Canada**

Art Gallery of Hamilton

art design fashion
history photography
theory and things

www.blackdogonline.com

black dog publishing

london uk